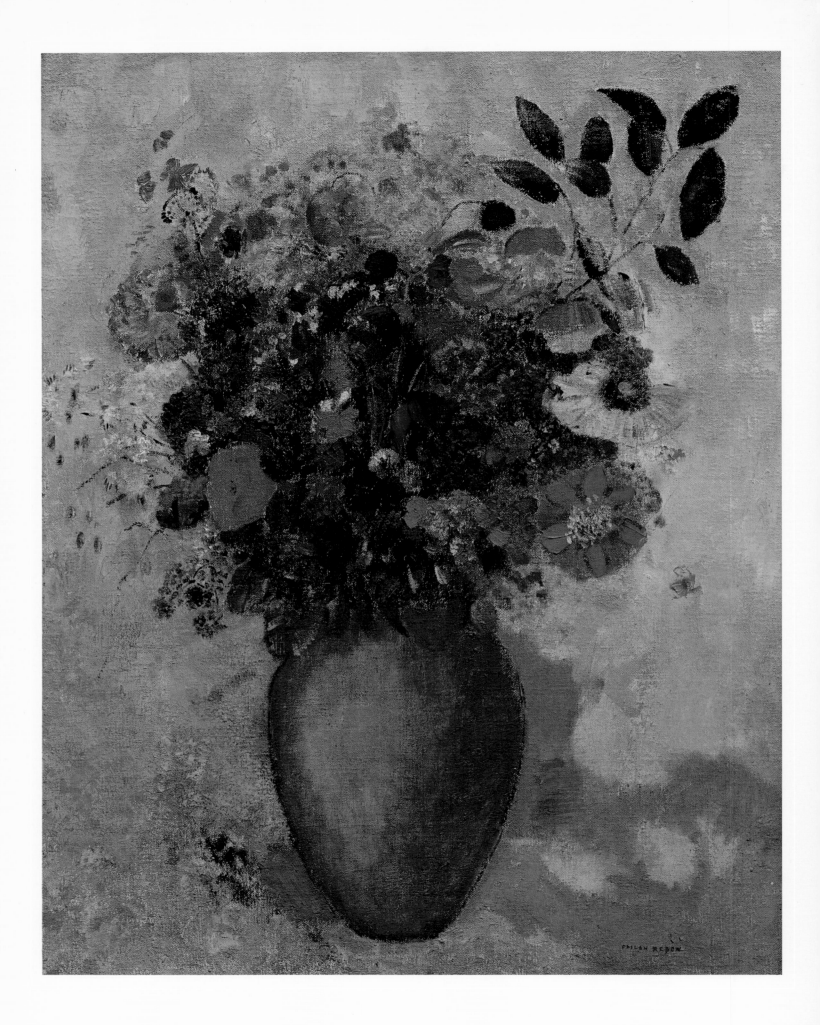

Impressionist Flowers
Art of the Bouquet

By Richard Whelan
Designed by Arnold Skolnick

WITH BOTANICAL IDENTIFICATIONS BY
STEVEN CLEMANTS, PH.D.
DIRECTOR OF SCIENCE, BROOKLYN BOTANIC GARDEN
AND
GRACE MARCKS, M.F.A., ARTIST

FIRST GLANCE BOOKS, COBB, CALIFORNIA

© 1998 O. G. Publishing Corp.
Text © 1998 Richard Whelan

Published in the United States of America
by First Glance Books

Distributed by First Glance Books
P.O. Box 960
Cobb, CA 95426
Phone: (707) 928-1994
Fax: (707) 928-1995

This edition was produced by
Chameleon Books, Inc.
31 Smith Road
Chesterfield, MA 01012

ISBN 1-885440-29-4

Printed in Hong Kong

President: Neil Panico
Vice President: Rodney Grisso
Designer/Picture Editor: Arnold Skolnick
Design Associate: KC Scott
Editorial Assistant: Laura J. MacKay
Copyeditor: Jamie Nan Thaman

(Frontispiece)

ODILON REDON
Bouquet of Flowers with Red Poppies, N.D.
Oil on paper, 26 7/16 x 20 1/4 inches
Courtesy of Christie's Images

ACKNOWLEDGEMENTS

The author and Chameleon Books wish to thank all the
public, private, and corporate collections which supplied
the wonderful images that appear in this book. We would
like to thank Daisy Stroud, Allbright-Knox Art Gallery;
Norbert Ludwig, National Gallery, Berlin; Mary Sluskonis,
Museum of Fine Arts, Boston; Pamela Steudemann, Art
Institute of Chicago; Jennifer Krasinski, Christie's Images;
Cleveland Museum of Art; Jeanne Chvosta, Dallas
Museum of Art; Elizabeth Gombosi, Fogg Art Museum;
Jackie Burns, J. Paul Getty Museum; Margaret Nab-van
Wakeren, Kröller-Müller Museum; Deanna Cross,
Metropolitan Museum of Art; Avril Peck, Museum of
Modern Art; Nancy Stanfield, National Gallery of Art,
Washington, D.C.; Belinda Ross, National Gallery, London;
Jennifer Zapanta, Norton Simon Museum; Kathleen Ryan,
Philadelphia Museum of Art; Melody Ennis, Rhode Island
School of Design; David Kencik, San Diego Museum of
Art; Martha Asher, Sterling and Francine Clark Art
Institute; James Petersen, Timken Museum of Art; Josette
van Gemert, Van Gogh Museum; Amber Woods,
Wadsworth Atheneum; and the staff of Art Resource, Inc.

—Richard Whelan and Arnold Skolnick

CONTENTS

Introduction 7

Eugène Delacroix 14

Jean François Millet 20

Narcisse Virgile Diaz de la Peña 22

Gustave Courbet 24

Henri Fantin-Latour 34

Camille Pissarro 48

Edouard Manet 52

Berthe Morisot 64

Mary Cassatt 66

Edgar Degas 68

Pierre-Auguste Renoir 70

Frédéric Bazille 86

Claude Monet 88

Paul Cézanne 96

Paul Gauguin 110

Vincent van Gogh 122

Odilon Redon 136

Pierre Bonnard 146

Edouard Vuillard 152

Henri Rousseau 156

Paul Signac 162

Henri Matisse 164

Bibliography 176

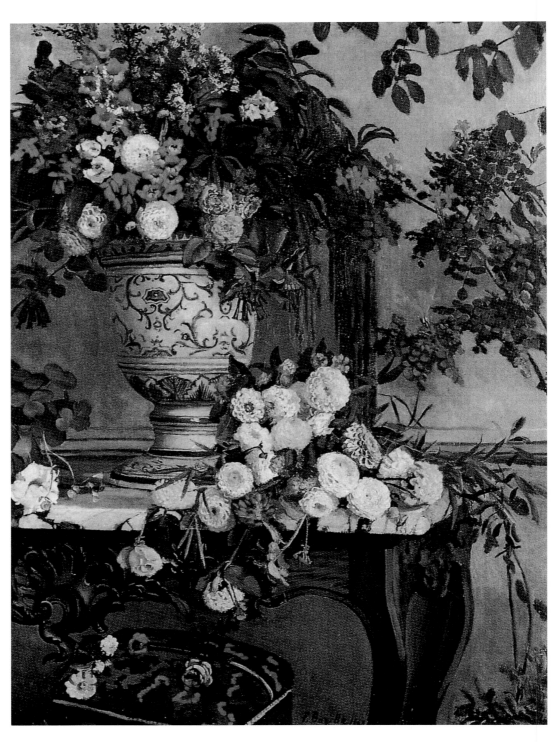

FRÉDÉRIC BAZILLE
Flowers, 1868
Oil on canvas, 51 1/4 x 38 1/4 inches
Musée de Peinture et de Sculpture, Grenoble

Introduction

*T*o the Impressionists—who delighted in the glorious colors of nature and who strove to capture on canvas their fleeting subtleties—what subject could possibly have been more apropos than the delicate pyrotechnics of cut flowers, whose beauty fades so rapidly unless preserved in oil and pigment? Although some writers have belittled floral canvases by the great French artists of the nineteenth century as lovely but minor homages to tradition, we can see in retrospect that insofar as painting bouquets provided an opportunity to experiment with color and form in a manner approaching abstraction, the resulting works are among the most daringly innovative of the period.

The tradition of paintings in which a bouquet is the main subject goes back to sixteenth-century Holland, where, as a result of the Protestant Reformation, religious subjects were forbidden. For centuries flowers had played an important symbolic role in depictions of Christ and of his mother. The rose was the flower of the Virgin Mary, who was called "the rose without thorns." A white rose stood for her purity; a red one foreshadowed the blood that would be shed by her crucified son. Lilies or irises (the latter were also called lilies) were associated with the Annunciation. Columbines, named for their supposed resemblance to doves in flight, symbolized the Holy Ghost, which was often depicted as a dove.

Because this symbolic use of flowers was condemned as Catholic, Protestant artists developed the purely secular painting of bouquet still lifes. Their hardheaded bourgeois patrons, many of whom took up the novel practice of cultivating private gardens, demanded a virtuosic level of realism. Although Calvinism disapproved of all sensuous pleasure or outward show of beauty, having a floral painting hanging on one's wall could be justified on the grounds that it was a memento mori—a reminder of how quickly beauty fades and dies.

During the sixteenth century, European fascination with flowers was greatly increased by the importation of dozens of new species from lands newly discovered or recently opened up to trade. By the early seventeenth century the Dutch were monopolizing the flower bulb industry. For several years in the mid-1630s their tulip trade attracted speculators who were soon paying vast sums for a single bulb of an especially rare hybrid; when the bubble of this so-called

CLAUDE MANET
Vase of Dahlias, N.D.
One of Six panels
Oil on canvas, 50 5/8 x 14 1/2 inches
Private collection

Tulipomania burst it nearly destroyed the Dutch economy.

The continuing arrival of new species fostered upper-class interest in botany and created a market for lavishly illustrated books about flowers. The greatest of the artists in this specialty was Pierre-Joseph Redouté, who became known as the Raphael of Roses. Born in the Ardennes in 1759, he began working, at the age of thirteen, as an itinerant decorative painter. In Holland he encountered the work of the great Dutch flower painters, and that experience was decisive. He went to Paris in 1782 to study engraving and color printing. While sketching flowers and plants in the Jardin du Roi, he met the wealthy botanist Charles Louis L'Héritier de Brutelle, who took the artist with him to London in 1787 to work on a study of rare plants at Kew Gardens. Redouté then became the official painter for the French Académie des Sciences, from 1789 to 1799; thereafter the Empress Josephine appointed him her *Peintre de Fleurs* and had him make drawings and watercolors of plants in the garden of her favorite residence, Malmaison.

Redouté worked primarily in pencil and watercolor on vellum, a medium that allowed him great accuracy and subtlety in his unparalleled depictions of individual flowers. He made thousands of watercolors to be reproduced in dozens of books, climaxed by *Les Liliacées* (the lily family, a work issued in installments between 1802 and 1816) and *Les Roses* (1817-1821).

Inspired by Redouté, many elegant ladies took up the genteel art of painting watercolors of flowers from their gardens. Lower on the economic scale, flower painting became a specialty of designers for the Lyons silk industry and for the artisans who handpainted the decoration on porcelain produced in Limoges.

IN REVIEWING THE OFFICIAL Paris salon of 1847, one critic dismissed the late Redouté's flowers as waxen but praised those in a painting exhibited by Eugène Delacroix, leader of the Romanticists. Delacroix celebrated flowers for the sheer exuberance of their color and the fantastic eccentricities of their forms. He was reacting directly against the cool tones and the geometric precision of Classicism, which tended to regard nature as an inconvenience that could be tolerated only when it had been reorganized and pruned in conformity with the principles of Reason.

Gustave Courbet, greatest of the paradoxically radical bourgeois Realists, drew much inspiration for his landscapes, nudes, and genre scenes from the works of the seventeenth-century Dutch

painters. It was, then, quite natural for Courbet to extend his admiration to the floral still lifes that are among the triumphs of that earlier period. Like other French artists throughout the nineteenth century, Courbet often painted bouquets as gifts for his friends at whose country estates he passed many a pleasant month.

Almost every great French painter of the nineteenth century painted at least an occasional bouquet, though only three signed floral canvases by Camille Corot are known. Even Eugène-Louis Boudin, generally known exclusively for his seaside and harbor views, painted a few flower-pieces.

During the second half of the nineteenth century Henry Fantin-Latour—who was friendly with the Impressionists but did not participate in their movement—stood out as the preeminent painter of flowers. He turned somewhat unwillingly to this lucrative specialty out of financial necessity. Early in his career he complained, "I have never had more ideas than now and am obliged to paint flowers! While doing so, I keep thinking of Michelangelo." Later in life, however, Fantin-Latour said that he loved painting flowers as much as he loved listening to music.

He painted flowers as individuals sitting for their portraits, and, indeed, he painted only "from life." One British critic wrote, "It is in his intimate feeling for nature and growth and the personality of flowers that the charm of Fantin-Latour's pictures consists. In his chosen apprehension (which is more akin to that of the poet than to that of the peeping botanist) the life of the flowers, with what they have of refreshment and consolation to the human spirit, is rendered intelligible and expressive." And the great Marcel Proust wrote of Fantin-Latour, "The painter looks and at the same time seems to see deep inside himself and inside the bouquet of flowers, where the delicately scented roses multiply in a thousand other perfumes."

During the 1860s a number of painters who were in their twenties—including Claude Monet, Auguste Renoir, and Frédéric Bazille—rebelled against the stifling academicism of their teachers. They aspired to make paintings from daily life, not from plaster casts of ancient sculptures. They admired the work of several slightly older artists who were leading the way: Edouard Manet, Camille Pissarro, and Edgar Degas, whose innovative works were repeatedly rejected by the official salon.

By 1863 protest from many such artists had become so vocal that the Emperor Napoleon III felt compelled to authorize a Salon des Refusés that year for those whose work had not been accepted for

CLAUDE MANET
Vase of Dahlias, ND.
One of Six panels
Oil on canvas, 50 5/8 x 14 1/2 inches
Private collection

hanging by the elite jury.

The Salon des Refusés brought together, either as exhibitors or as visitors, most of the artists who would join forces together for an independent exhibition in 1874. Inspired by the title of one of Monet's paintings in the show—*Impression, Sunrise*—a critic promptly dubbed the group the Impressionists. With a changing roster of participants, they would hold seven more group exhibitions, the last of them in 1886.

Impressionism was an eminently middle-class style, largely devoted to depicting the milieu and the pleasures of bourgeois life in the city and in the countryside. Gardens and cut flowers were an essential element of that comfortable life, and so were a natural subject for the Impressionists, many of whom were passionate gardeners. Foremost among them was Monet, who created a magnificent garden, recently restored to its former beauty, on the grounds of his home at Giverny, north of Paris.

Some Impressionist floral canvases were painted to raise money in moments of need, but others were created as gifts for friends, and

CLAUDE MONET
Two Vases of Chrysanthemums, 1888
Oil on canvas, 28 3/4 x 36 1/4 inches
Private collection

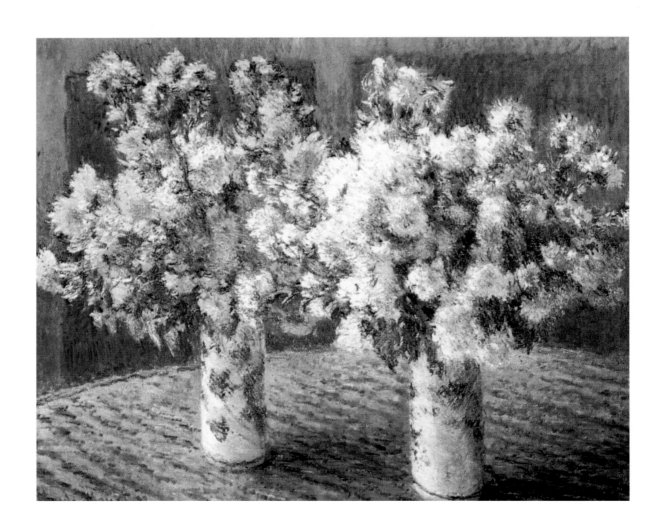

they sometimes reflect a practical decorative informality that would have been inappropriate to other subjects. For instance, Renoir's *Three Bouquets,* now in the Philadelphia Museum of Art, was originally intended to be hung as high as possible on a wall in a room with a ceiling supported by heavy timber beams; the canvas was notched to fit around one of the beams.

AFTER IMPRESSIONISM, French flower painting took many directions and was embraced by the Post-Impressionists (represented in this book by Gauguin, van Gogh, and Cézanne), the Nabis (Bonnard and Vuillard), the Symbolists (Redon), the Neo-Impressionists (Signac), and the Fauves (Matisse). Among these the most dedicated flower painter was Odilon Redon, who wonderfully summed up the appeal of floral paintings when he wrote, "Flowers are born where the two rivers, image and memory, meet. They are the very land of art, the good earth of reality harrowed and furrowed by the spirit."

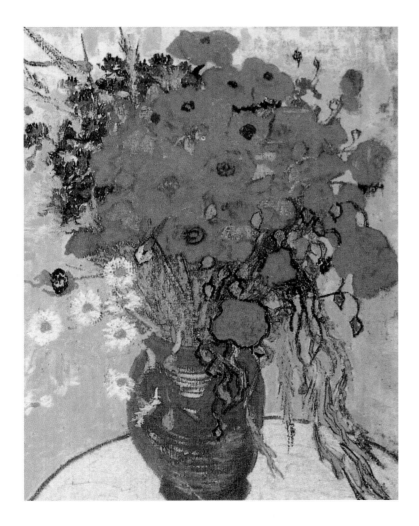

VINCENT VAN GOGH
Red poppies and Daisies, 1890
Oil on canvas, 25 1/2 x 19 5/8 inches
Private collection

The Bouquets

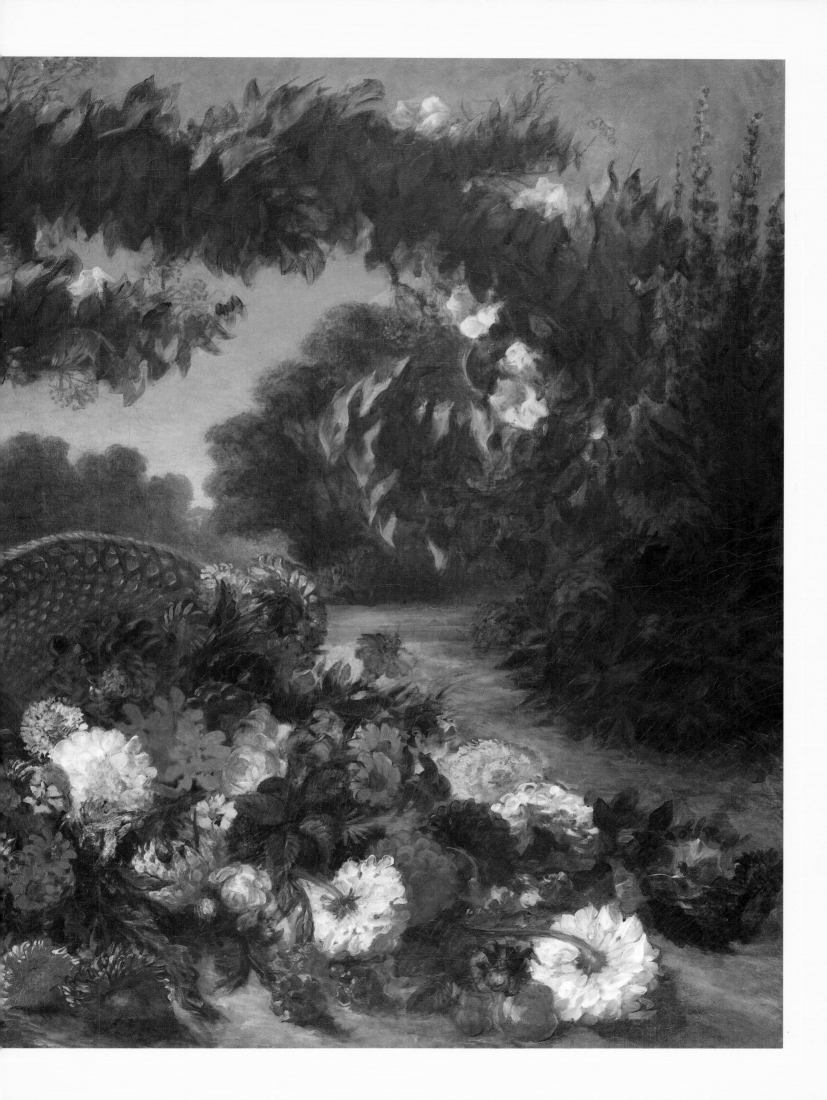

Eugène Delacroix

was born in 1798. His ostensible father was an official who occupied a succession of high posts in the French government, but rumor has always had it that the artist's true father was Talleyrand, Napoleon's foreign minister. Delacroix received a classical education and developed great love for music and the theater. In 1815 he entered the Parisian studio of a fashionable academic painter, Baron Pierre-Narcisse Guérin. Delacroix was influenced by Rubens and by the Romanticism of his young contemporaries Géricault and the Englishman Francis Parkes Bonington, whose personality and work were the sensations of Paris. Rebelling against the coldness of Ingres, Delacroix sought to make paintings that would be expressive symphonies of form, light, and color. During a visit to London in 1825 he met Turner, Constable, and Lawrence; and these acquaintances increased Delacroix's freedom in his handling of paint and in his use of color.

A trip to Morocco in 1832 was decisive. There the artist found himself surrounded by the intensity of light and color, the gracefulness of form, and the passionate tenor of life that he craved. As a dedicated history painter, he was elated to find himself in a culture so similar to what he imagined that of ancient Rome to have been like.

pages 14–15

EUGÈNE DELACROIX
Basket of Flowers, 1849
Oil on canvas, 42 1/4 x 56 inches
The Metropolitan Museum of Art, New York
Bequest of Miss Adelaide Milton de Groot, 1967
Photograph © 1980 The Metropolitan Museum of Art (67.187.60)

Dahlia

Morning Glory

Zinnia

In 1842 Delacroix spent several happy weeks at George Sand's country estate at Nohant. Also there was Chopin, who was Sand's lover. During this stay, intoxicated by the composer's music, Delacroix spent much of his time sketching flowers and painting them in oil. Sand wrote that one day she "came upon him in an ecstasy of enchantment before a yellow lily, whose beautiful architecture (his own happy phrase) he had just understood. He was in a fever to paint it, for he saw that, when it was put into water its flowering became at every moment more complete, and the bloom kept changing its shade and attitude…. He began each day, for the lily became more and more architectural, exhibiting geometrical forms as it dried up…. This led him to draw dried plants, for, as he put it, cut plants are grace in death."

From the mid-1830s until 1861, Delacroix devoted himself mostly to architectural decoration. He turned to flower painting as relief from his exhausting bouts of adorning walls and ceilings with historical and mythological imagery.

Delacroix died in 1863, but his work would be a powerful influence on the great innovators of the late nineteenth and early twentieth centuries, especially Monet, Renoir, Cezanne, van Gogh, and Matisse.

Pages 18–19

EUGÈNE DELACROIX
Bouquet, 1848
Oil on canvas, 24 3/8 x 33 inches
Musée des Beaux Arts de Lille, France
Courtesy Art Resource, New York

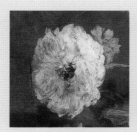

Chrysanthemum *Dianthus* *Poppy*

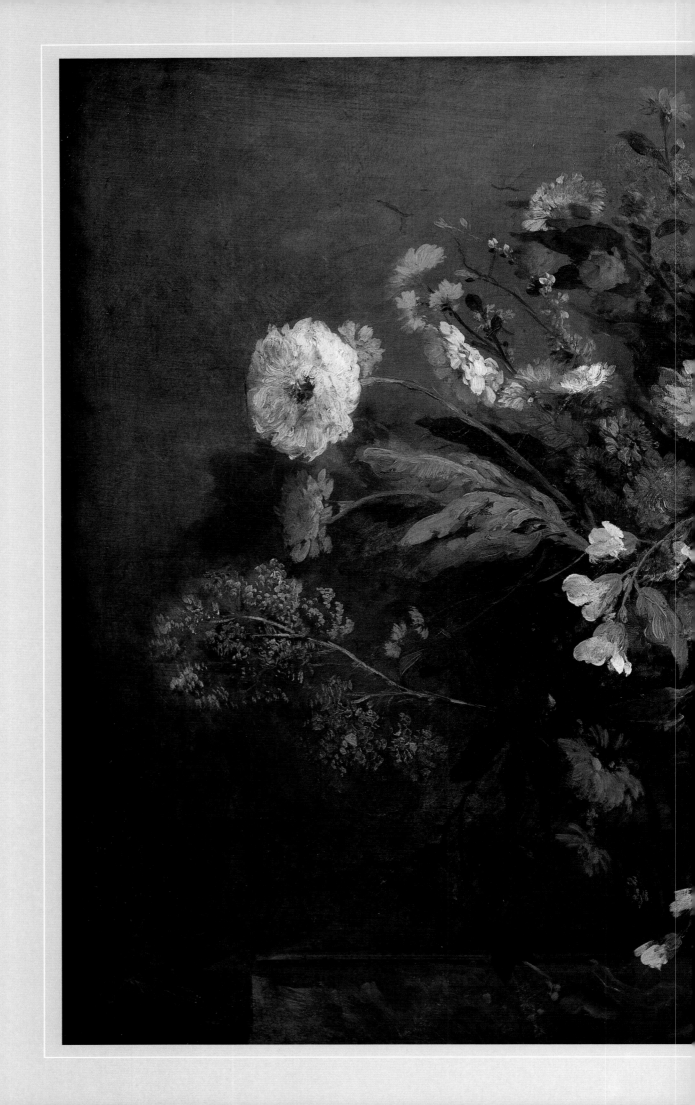

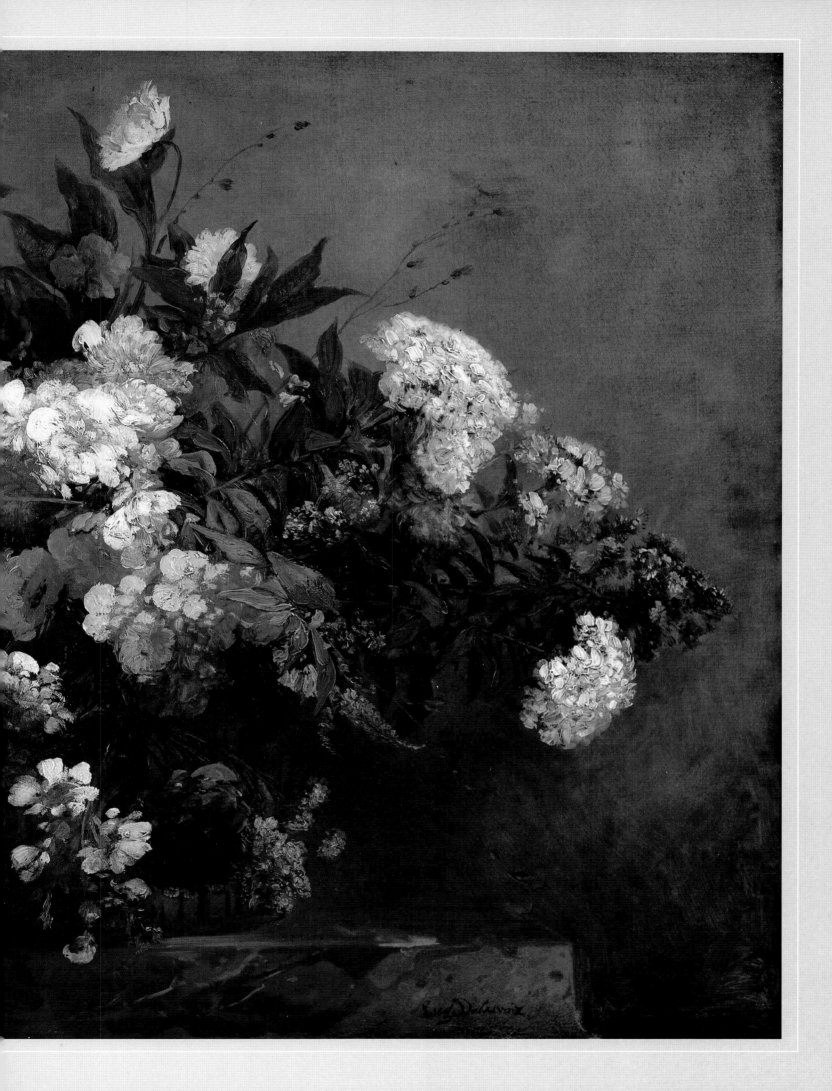

Jean François Millet

was born in 1814 in a farm village in Normandy. He manifested a precocious pictorial talent but worked on his parents' farm until 1833, when he was nineteen, at which time he went to Cherbourg to study painting. Four years later he made his way to Paris, where he studied with Paul Delaroche. Scorned as a country bumpkin by others in the studio, Millet decided to teach himself by copying in the Louvre. He supported himself by painting portraits, biblical scenes, nudes in a saccharine eighteenth-century style, and even signboards. In the late 1840s, after the first of his canvases ennobling the French peasantry led to accusations that he was a socialist, the artist settled in the village of Barbizon, on the edge of the forest of Fontainebleau. Unlike most members of the school, of which he was a leader, he was interested in landscape not for its own sake but rather as the setting for his figures. Calling himself "the peasant of peasants," he dedicated himself to paintings of the lives of farmers—their backbreaking labor, their simple and loving domesticity, and their piety. Although a late-twentieth-century sensibility may find much of Millet's work excessively sentimental, he sought to depict his subjects with honesty and dignity, and he tried to paint them with the sculptural monumentality with which Michelangelo had painted Old Testament prophets. He was not interested in flowers for their own sake, and only depicted them (in pastel rather than in oil) as they figured in the lives of his peasant subjects. Millet died in Barbizon in 1875.

JEAN FRANÇOIS MILLET
The Bouquet of Daisies, 1871–74
Pastel on beige paper, 26 3/4 x 32 3/4 inches
Musée d'Orsay, Paris
Courtesy Art Resource, New York

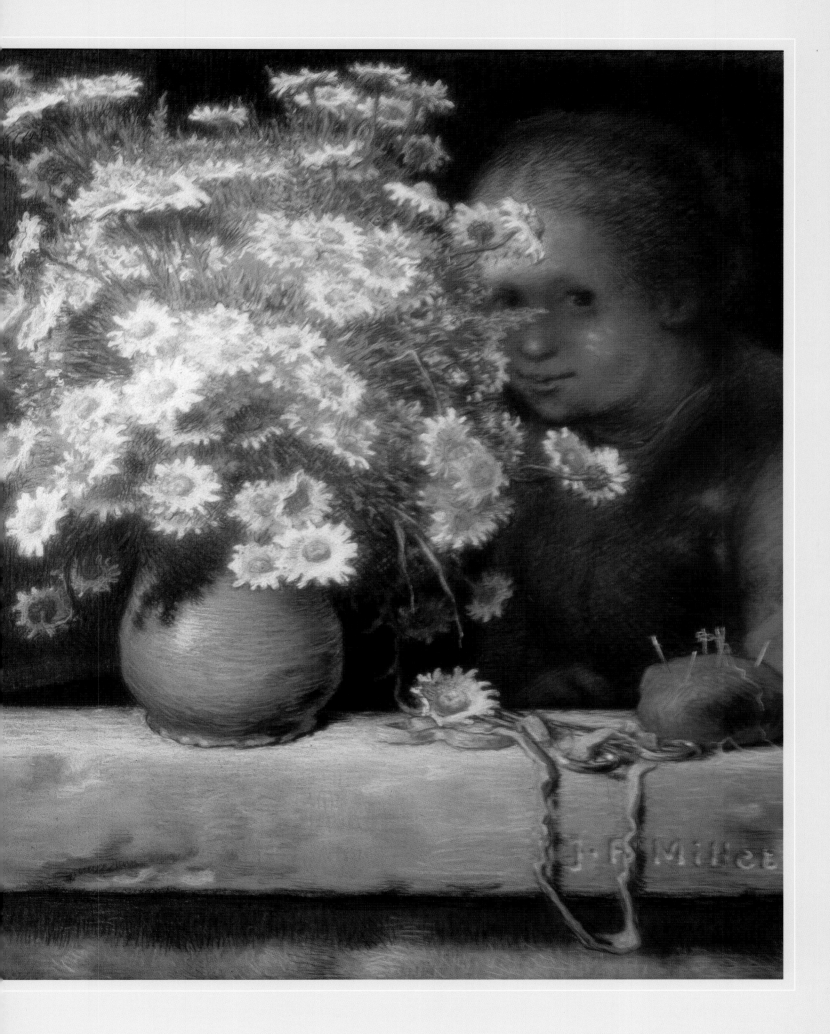

Narcisse Virgile Diaz de la Peña

was born in Bordeaux, in 1807, to Spanish parents. Originally an autodidact, he began working at the age of fifteen as a ceramic painter in the Sèvres porcelain factory, but he eventually managed to study with the academician Alexandre Cabanel. Strongly influenced by Delacroix, Diaz de la Peña began painting Oriental and medieval subjects in a Romantic mode. After having met Millet, he settled about 1840 in the forest of Fontainebleau and became a prolific landscapist of the Barbizon school. He was known especially for his manner of rubbing down a thick impasto to create the impression of sunlight sparkling through dense forest foliage. Alone among the Barbizon painters he peopled his poetic, though also rather academic, landscapes with nymphs, satyrs, and goddesses, as well as gypsies and vagabonds à la Salvator Rosa.

In addition to his landscapes, Diaz de la Peña painted many bouquets, favoring roses and peonies.

His work influenced that of Adolphe Monticelli as well as that of Renoir, who lightened his palette after meeting the older artist at Barbizon in 1861. Diaz de la Peña died in Menton, on the Riviera, in 1876.

NARCISSE VIRGILE DIAZ
DE LA PEÑA
Flowers, N.D.
Oil on canvas, 15 3/4 x 9 7/8 inches
Museum of Fine Arts, Boston
Bequest of Ellen F. Moseley through Margaret
LeMoyne Wentworth and Helen Freeman Hull

Gustave Courbet

was born in 1819. He was the son of a prosperous farmer in Ornans, in the Franche-Comte, whose landscape would be the greatest theme of the artist's work. In the mid-1830s Gustave was initiated into the mysteries of art when a former pupil of the distinguished academic painter Baron Gros began teaching in the school in Ornans. Although Monsieur Courbet intended his son for a career in law, Gustave went to Paris in 1839 to study painting and spent much of his time in the Louvre, copying works by Dutch, Flemish, Venetian, and Spanish masters. His love of Dutch and Flemish painting was reinforced by trips to Holland and Belgium in 1846–47.

Courbet established his reputation as a radical with his large painting *A Burial at Ornans*, the unsentimental realism of which inspired much outrage at the Salon of 1850. In 1855, angered by repeated rejections from the Salon, Courbet had a pavilion constructed near the world's fair then in progress, and he exhibited forty of his paintings; attendance and sales in the pavilion were disappointing.

In 1862 Etienne Baudry, a young collector and man of letters, invited Courbet for an extended visit to his garden adorned estate in the Saintonge, north of the Bordeaux region. During that year and the following, Courbet enjoyed the hospitality not only of Baudry but also of other landowners in the area. In gratitude the artist painted a number of extravagant bouquets to symbolize the glorious pleasures of country life, and he presented some of the canvases to his hosts by way of thanks. But he sold many of the paintings and boasted to a friend that he was "raking in the money with flowers."

Courbet had long been drawn to left-wing politics, and as a result of his involvement in the Parisian revolutionary uprising of 1871, during which he participated in the toppling of the great column in the Place Vendome, he was sentenced to six months in prison. To relieve the grimness of his incarceration, he drew upon his happy memories to paint a few floral canvases, among them *Head of a Woman with Flowers,* though he concentrated mostly on still lifes of fruit.

In 1873, when the government voted to fine Courbet an enormous sum for the reconstruction of the Vendome column, the artist fled into exile in Switzerland, where he remained until his death in 1877.

GUSTAVE COURBET
Hollyhocks in a Copper Bowl, 1872
Oil on canvas, 23 5/8 X 19 1/4 inches
Museum of Fine Arts, Boston
Bequest of John T. Spaulding

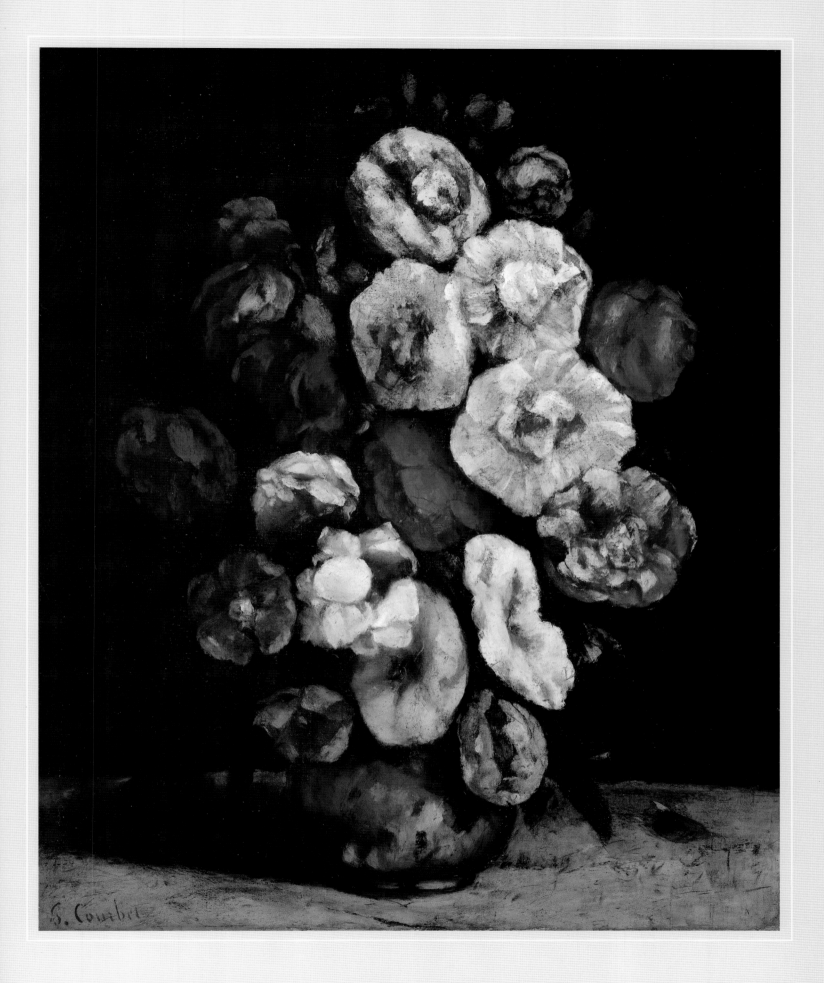

GUSTAVE COURBET
Vase of Mixed Flowers (Lilacs, Roses, and Tulips), 1863
Oil on canvas, 25 1/2 x 21 1/4 inches
Norton Simon Art Foundation, Pasadena, California

Bleeding Heart *Holly*

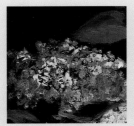

Lilac *Rose* *Tulip*

GUSTAVE COURBET
Bouquet of Flowers in a Vase, 1862
Oil on canvas, 39 1/2 x 28 3/4 inches
The J. Paul Getty Museum, Los Angeles

Chrysanthemum

Freesia

Lilac

Mimosa

Morning Glory

Rose

Veronica

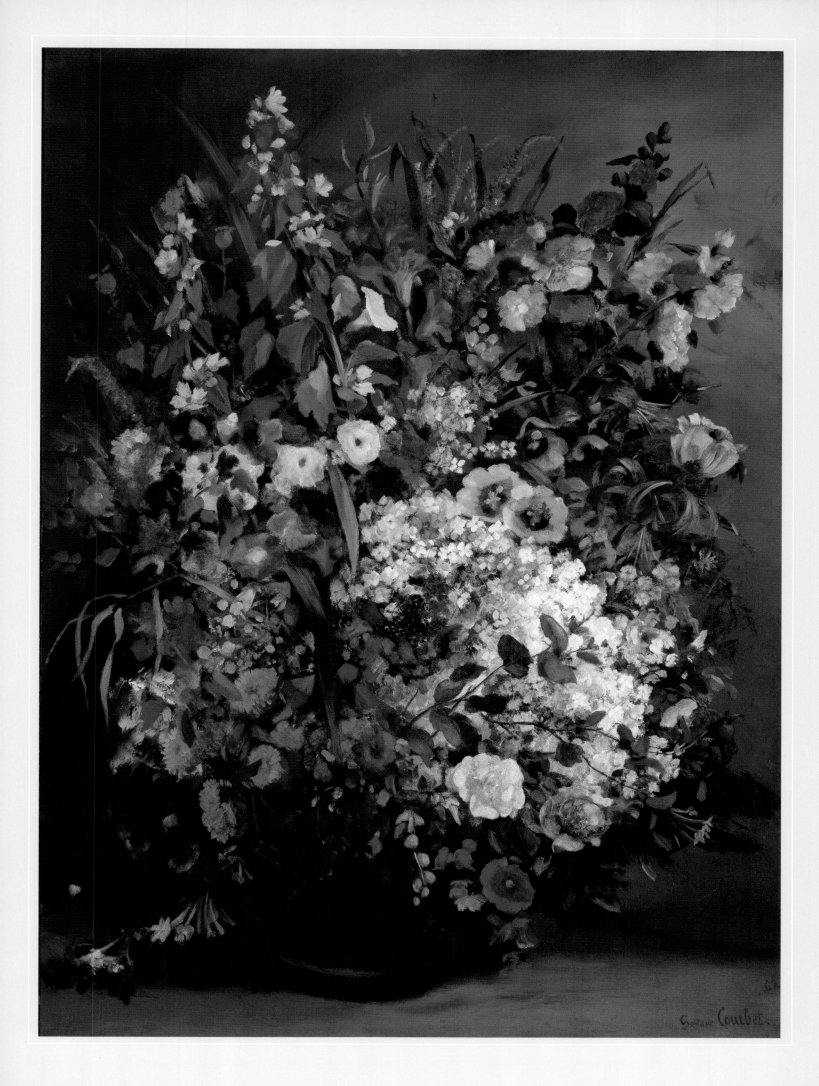

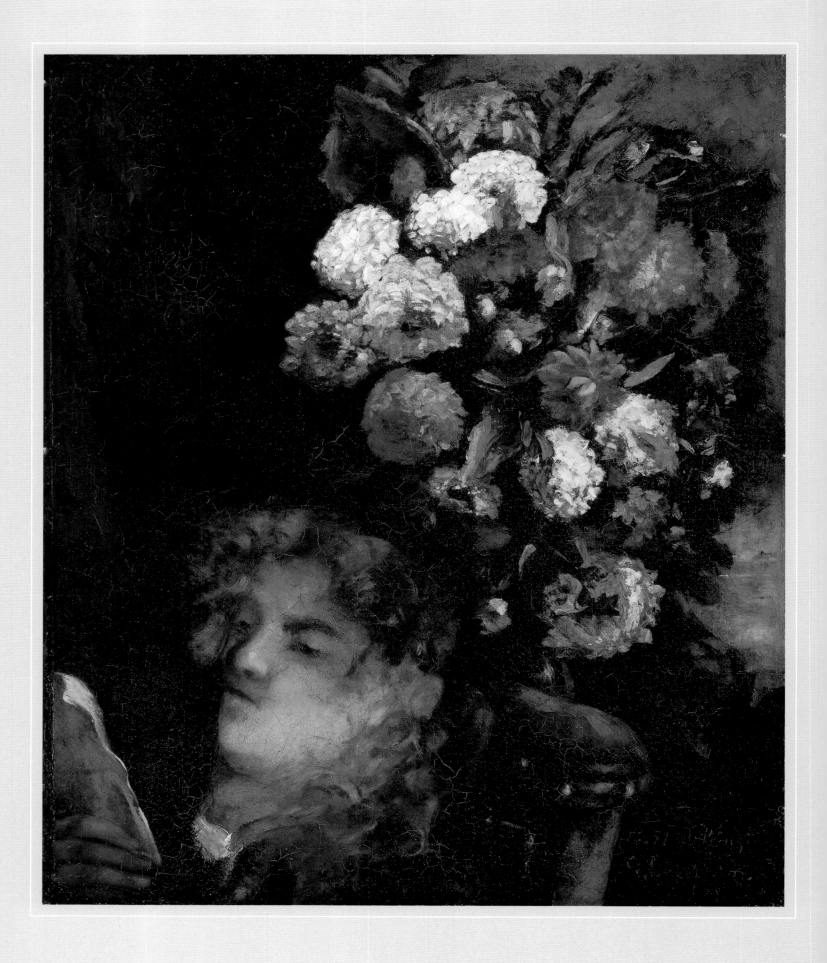

GUSTAVE COURBET

Head of a Woman with Flowers, 1871

Oil on canvas, 21 7/8 x 18 3/8 inches

Philadelphia Museum of Art

Louis E. Stern Collection

GUSTAVE COURBET

Flowers in a Basket, 1863
Oil on canvas, 29 1/2 x 39 3/8 inches
Glasgow Art Gallery and Museum

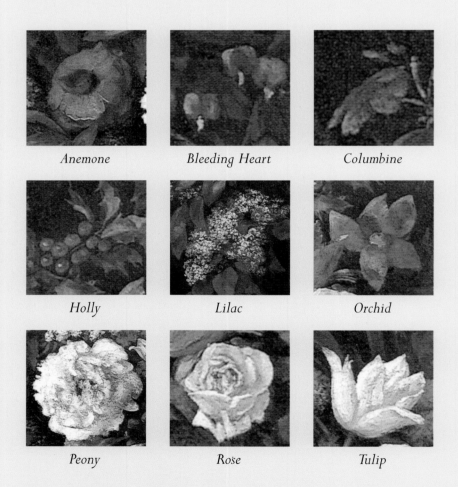

Anemone

Bleeding Heart

Columbine

Holly

Lilac

Orchid

Peony

Rose

Tulip

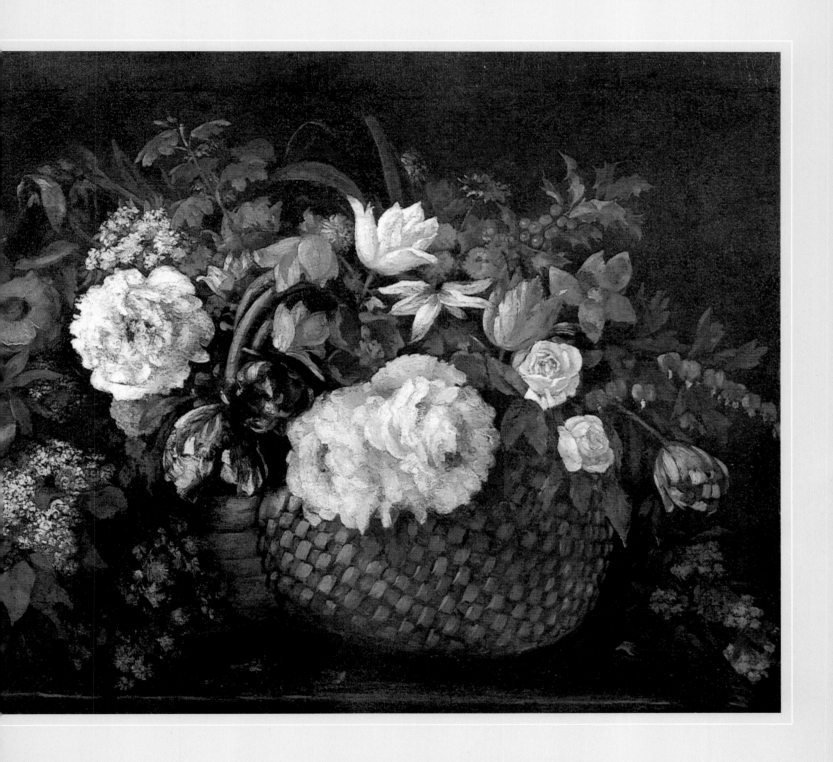

Ignace Henri Jean Théodore Fantin-Latour

was born in Grenoble in 1836. His first artistic instruction was given to him by his father, a painter of portraits, landscapes, and occasional bouquets. After a period at the Ecole des Beaux-Arts, Fantin-Latour enrolled in the studio of the academic painter Gleyre, where he met Whistler and Degas. He barely supported himself by making copies of old-master paintings in the Louvre, and he seems to have turned to flower painting, in 1856, as a potentially lucrative specialty.

Through Whistler, in 1859, he met Edwin Edwards, a wealthy English amateur engraver, who became his lifelong patron, not only buying dozens of his paintings but also encouraging his friends to buy them. The artist often visited the Edwardses at their estate in Sunbury, where he prolifically turned out floral canvases, which appealed greatly to English taste.

Although Fantin-Latour was a close friend of Manet and participated in the Salon des Refusés, in 1863, he stood apart stylistically from the Impressionists, priding himself on his painstaking drawing and brushwork to achieve a semi-photographic realism. In France he was most admired not for his flower paintings but for his group portraits—homages to Delacroix, Manet, Verlaine, and others, similar to Dutch guild portraits.

Fantin-Latour's flower paintings share with Chardin's still lifes a certain bourgeois sobriety, a sense of comfortable intimacy, and a cool balance of tones. In all, he painted something like five or six hundred flower canvases, in which his subjects, most often arranged in a drinking glasses of one sort or another, are carefully observed and meticulously rendered.

In 1876 Fantin-Latour married Victoria Dubourg, who was herself a flower painter. They lived at her house in the French countryside, where there was a lovely garden.

During the last years of his life Fantin-Latour increasingly turned to lithography on allegorical and musical themes, the latter primarily inspired by Wagner and Berlioz, though he continued making flower paintings until 1903, the year before his death.

HENRI FANTIN-LATOUR

White and Pink Mallows in a Vase, 1895

Oil on canvas, 21 x 19 1/2 inches

Norton Simon Foundation, Pasadena, California

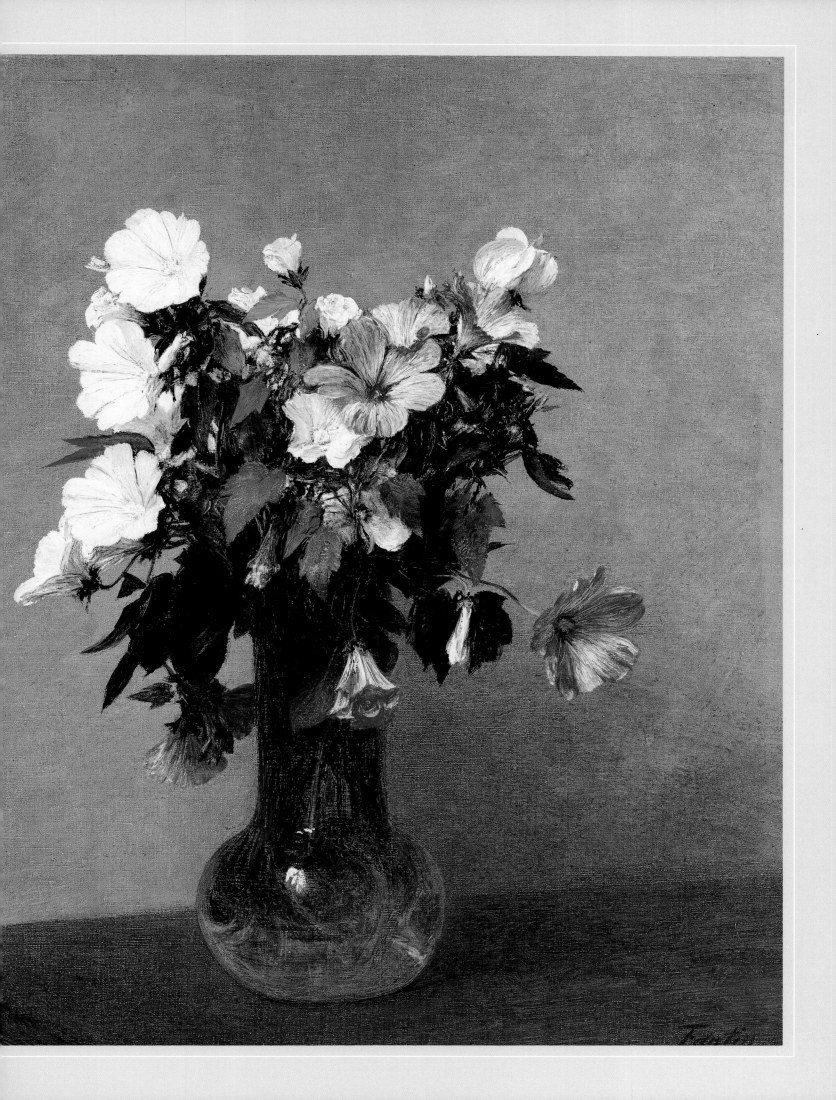

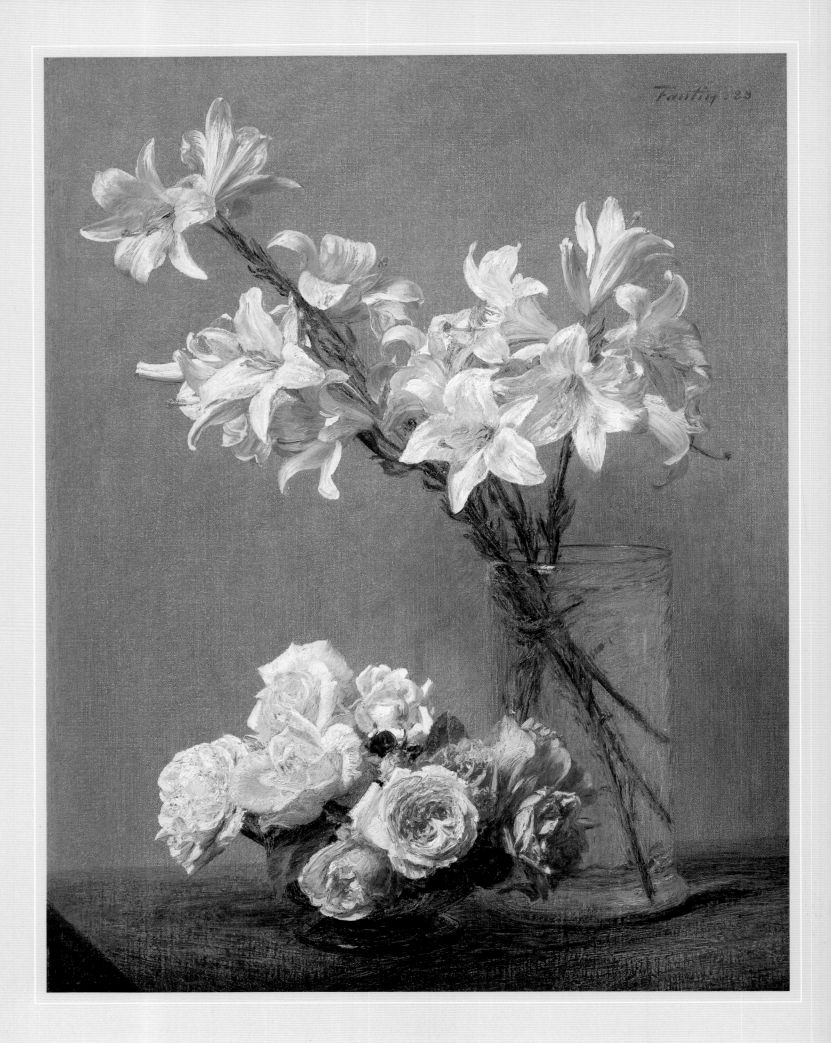

HENRI FANTIN-LATOUR

Still Life with Chrysanthemums, 1862

Oil on canvas, 18 1/8 x 21 7/8 inches

Philadelphia Museum of Art

The John G. Johnson Collection

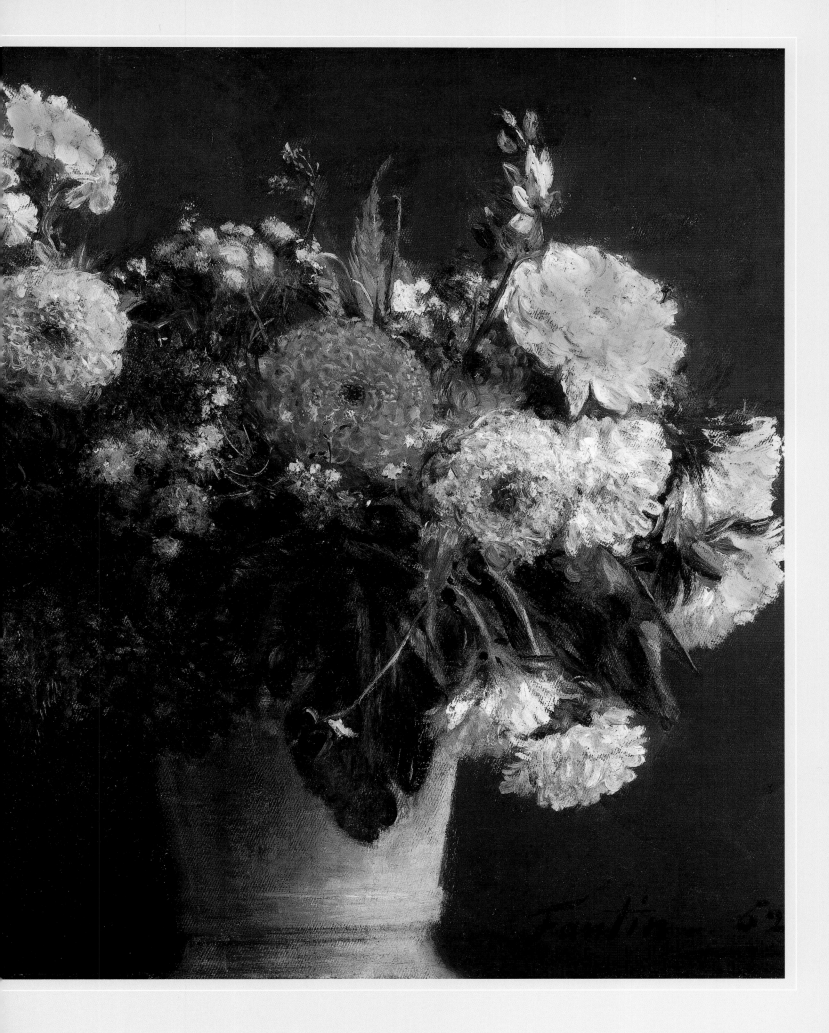

HENRI FANTIN-LATOUR

Vase of Flowers, 1872

Oil on canvas, 18 1/2 x 15 1/4 inches

Courtesy Christie's Images

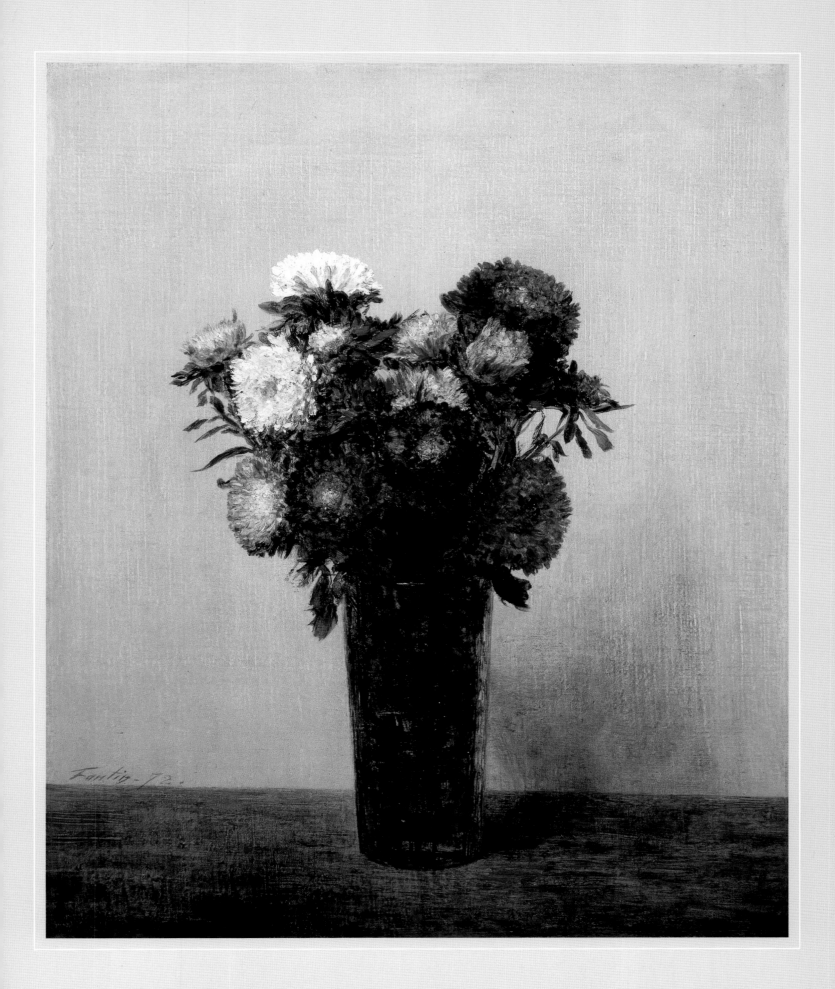

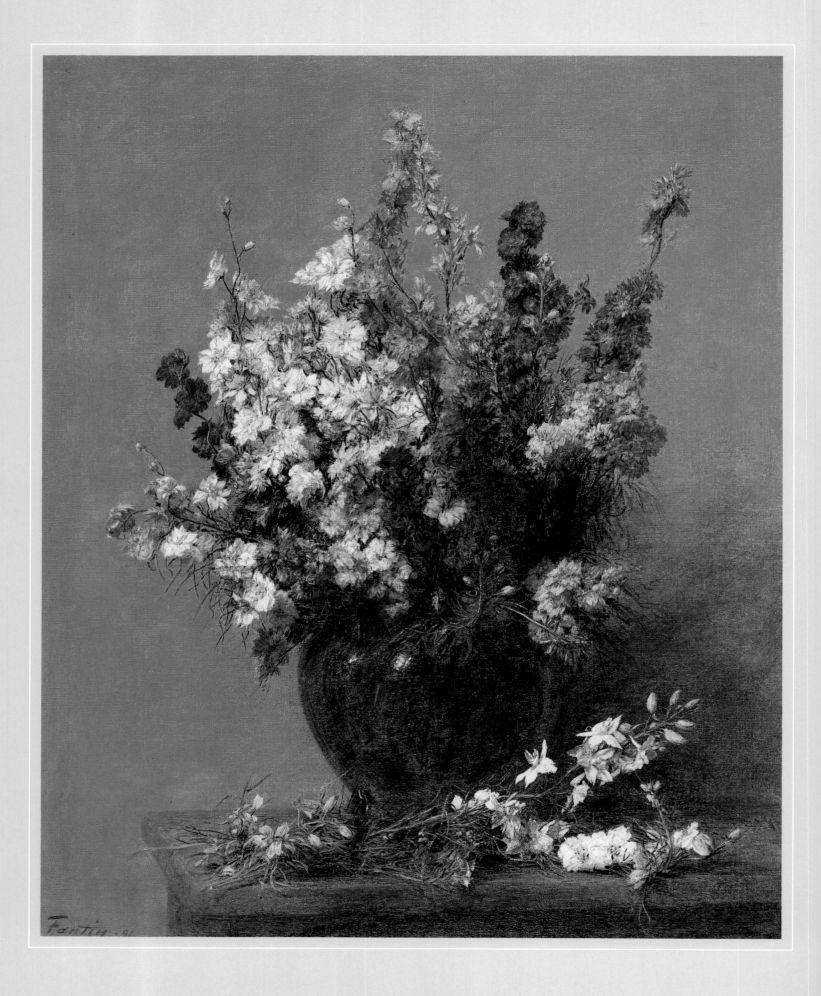

HENRI FANTIN-LATOUR
Still Life with Imperial Delphiniums, 1891
Oil on canvas, 29 13/16 x 24 5/8 inches
Philadelphia Museum of Art
The Charlotte Dorrance Wright Collection

HENRI FANTIN-LATOUR

Large Bouquet with Three Peonies, 1879

Oil on canvas, 16 3/8 x 13 1/4 inches

Courtesy Christie's Images

Dame's Rocket *Hydrangea*

Peony *Rose*

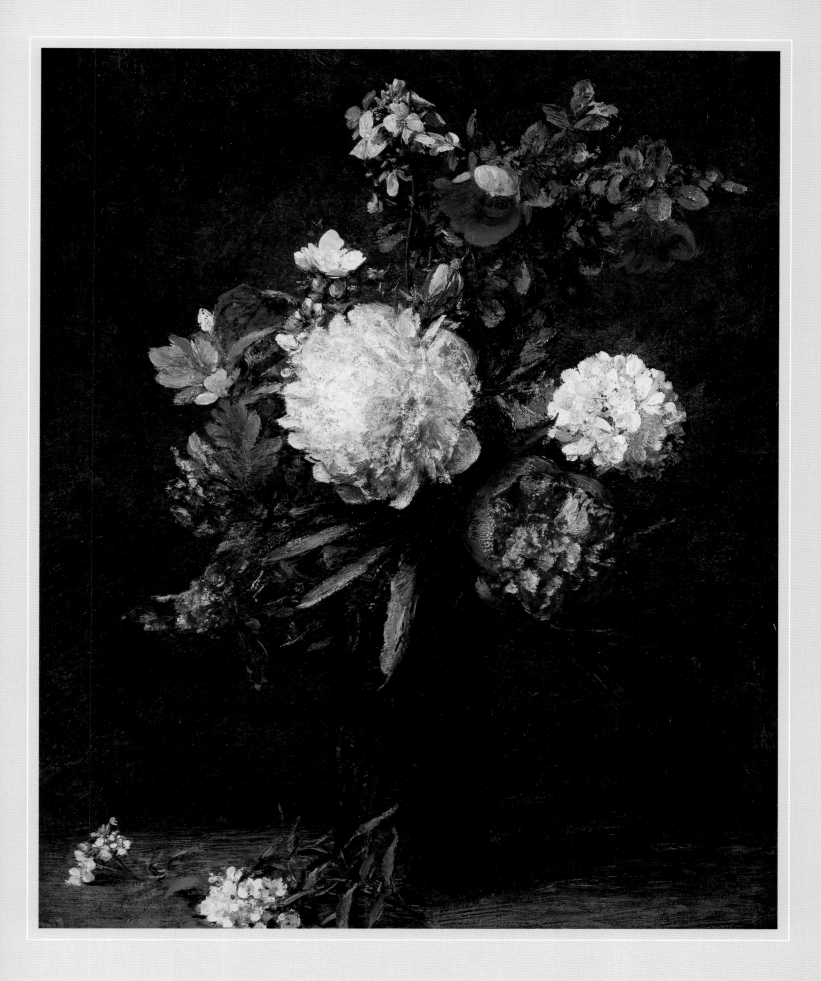

HENRI FANTIN-LATOUR
Roses in a Bowl, 1882
Oil on canvas, 46 1/2 x 36 inches
Musée d'Orsay, Paris
Courtesy Art Resource, New York

Camille Pissarro

was born in 1830 to a prosperous Jewish merchant and his Creole wife on the island of St. Thomas, in what were then the Danish West Indies. In 1855 he went to Paris and entered the Ecole des Beaux-Arts, but he was so disappointed by the instruction there that he sought out Camille Corot, who took him on informally as a pupil. During the 1860s Pissarro was a member of the pivotal group of artists and intellectuals who met at the Café Guerbois, and he had three landscapes in the landmark Salon des Refusés (1863). In 1870, to escape from the invading Prussians—who would destroy his house, as well as his studio and most of its contents—Pissarro joined his close friend Monet in England, where he was inspired by the work of Constable and Turner. Older than most of the other Impressionists, Pissarro was regarded as the patriarch and theorist of the group. He was the only artist who was represented in every one of the eight Impressionist exhibitions, held between 1874 and 1886.

Pissarro concentrated almost entirely on landscape and cityscapes, though he also painted scenes of country life reminiscent of Millet, whom he admired. He painted flowers mainly when rainy weather kept him indoors. His wife, who supplied him with subjects for his floral canvases worked for a florist.

Pissarro was universally respected as an exceptionally kind man, as a superb artist, and as a brilliant and influential teacher—indeed, Mary Cassatt once remarked that he could have taught stones to draw. In 1872 he settled in the village of Pontoise and worked closely with Cézanne, who lived nearby and who loved Pissarro as a father. The two of them painted side by side outdoors, even on bitterly cold winter days.

It was Pissarro who introduced Paul Gauguin to the Impressionists. And during the 1880s Pissarro was so impressed by Seurat's work that he briefly took up a Pointillist style.

About 1896 the worsening of a chronic eye infection forced Pissarro to give up painting outdoors. During the last seven years of his life he painted as he sat by windows overlooking streets in various French cities. He died in Paris in 1903.

CAMILLE PISSARRO

Bouquet of Flowers: Chrysanthemums in a China Vase, c. 1873

Oil on canvas, 23 1/4 x 19 1/2 inches

The National Gallery of Ireland, Dublin

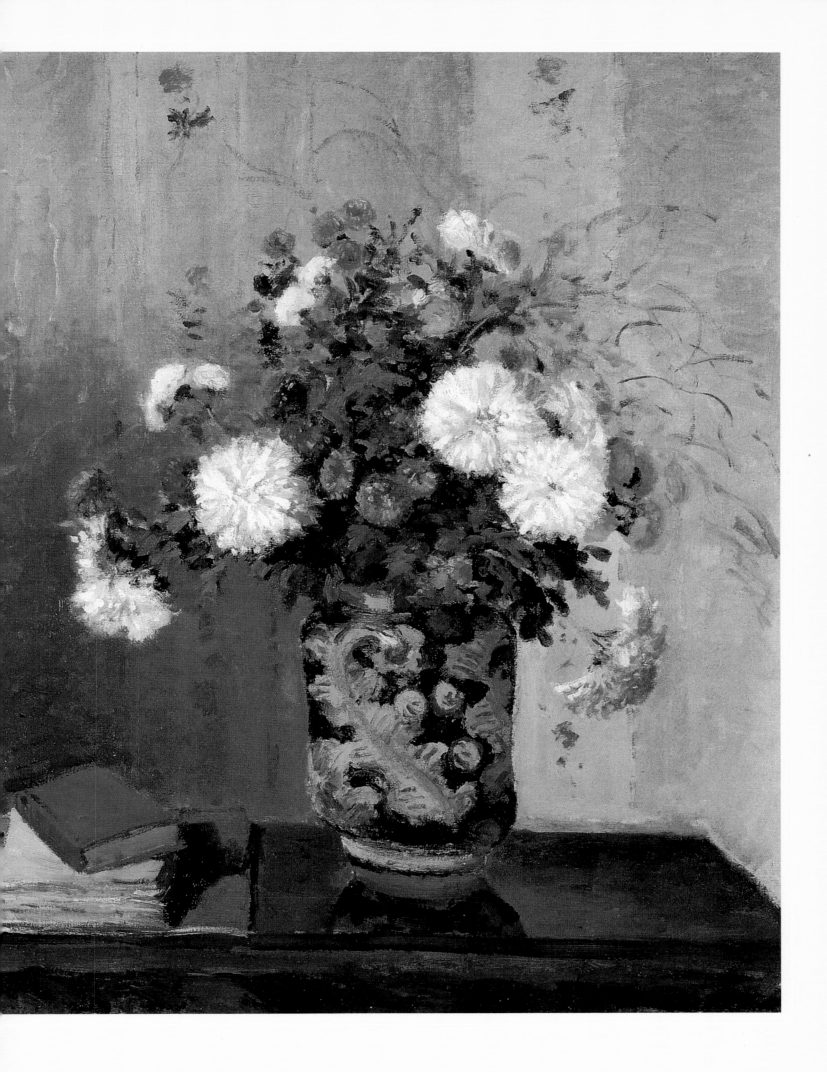

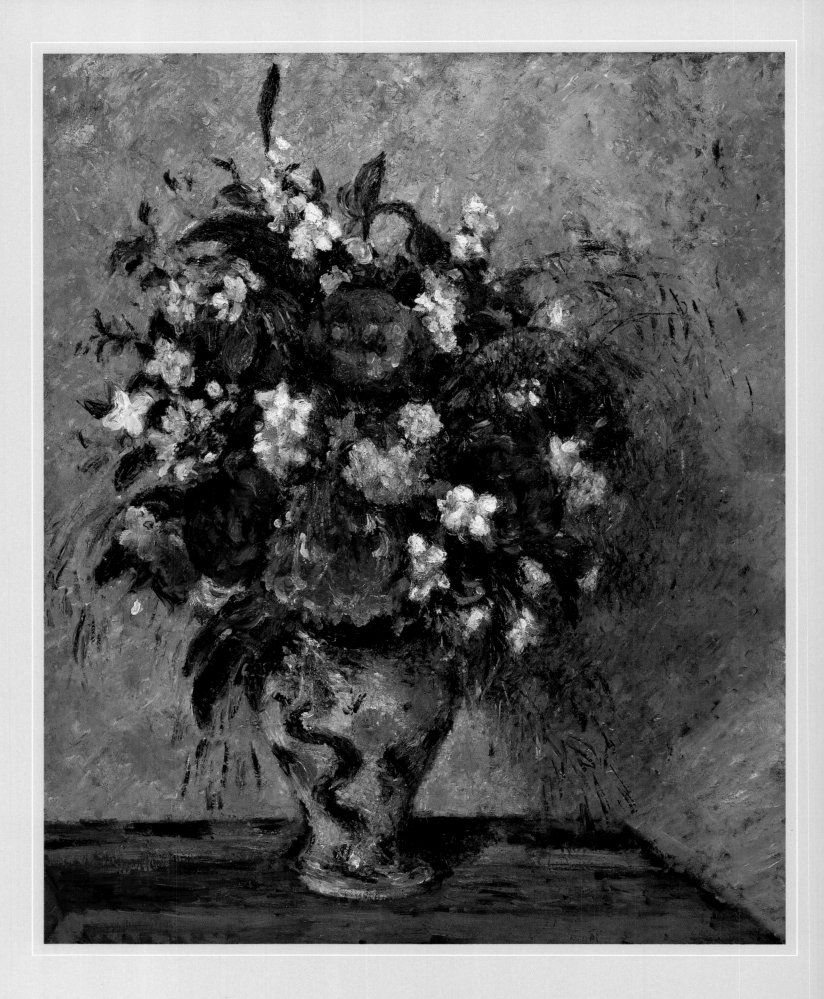

CAMILLE PISSARRO

Vase of Flowers, c. 1877–78

Oil on canvas, 32 x 25 1/2 inches

Sara Lee Corporation, Chicago

Edouard Manet

was born in Paris in 1832. His father was a high official in the Ministry of Justice. At an early age Edouard showed a talent for drawing, and during his studies at the Collège Rollin, he often went to the Louvre. When he was sixteen, he failed the entrance examination for the Naval School but signed on as a midshipman on a ship bound for Rio de Janeiro. When he failed the examination again after his return, his family consented to a career in art. He then entered the studio of Thomas Couture, whose instruction was somewhat more innovative than the usual academic curriculum. During the 1850s Manet traveled widely in Europe to visit museums and was especially impressed by Dutch and Spanish painting. While copying in the Louvre, he met Henri Fantin-Latour and Edgar Degas. In 1863 he exhibited at the Salon des Refusés his first masterpiece, *Le Déjeuner sur l'herbe* (Luncheon on the Grass), which scandalized the public because of its depiction of a naked woman seated with two men in modern dress.

The following year, Manet painted, in addition to a number of still lifes of fish or fruit, a series of peonies, of which *Peonies in a Vase on a Stand* (Musée d'Orsay) is the most ambitious. It translates the traditional theme of the Stages of Life into floral terms, moving from the buds on the right to the freshly cut flower on the table, then to the full blooms at the left and center in the vase, which are doomed to suffer very soon the fate of the dying flower beside them, which is already dropping its browning petals onto the table.

In 1865 Manet showed his notorious *Olympia*, in which a naked prostitute looks boldly at the viewer, and in which a black maidservant presents a splendid bouquet from an admirer. Manet did not paint flowers again until the end of his life, concentrating instead on portraiture and scenes of social life.

Although Manet opened the door to Impressionism, he did not deign to participate in the Impressionist exhibitions, held between 1874 and 1886. He aspired only to a place of honor in the official Salon.

Beginning in 1880, ill health forced Manet—the most sophisticated of urbanites—to rent a series of houses in the Parisian suburbs for fresh air and rest. In 1881 he wrote from Versailles, "I've had to content myself with painting only my garden, which is the unloveliest of gardens."

During the last two years of his life, the housebound Manet painted a series of small bouquets in glass vases or drinking glasses, which are among the most superbly painterly of his works, or, indeed, of any flowers ever painted. He died in 1883.

EDOUARD MANET
Roses and Tulips, 1882
Oil on canvas, 22 x 14 1/4 inches
Private collection
Zurich, Switzerland

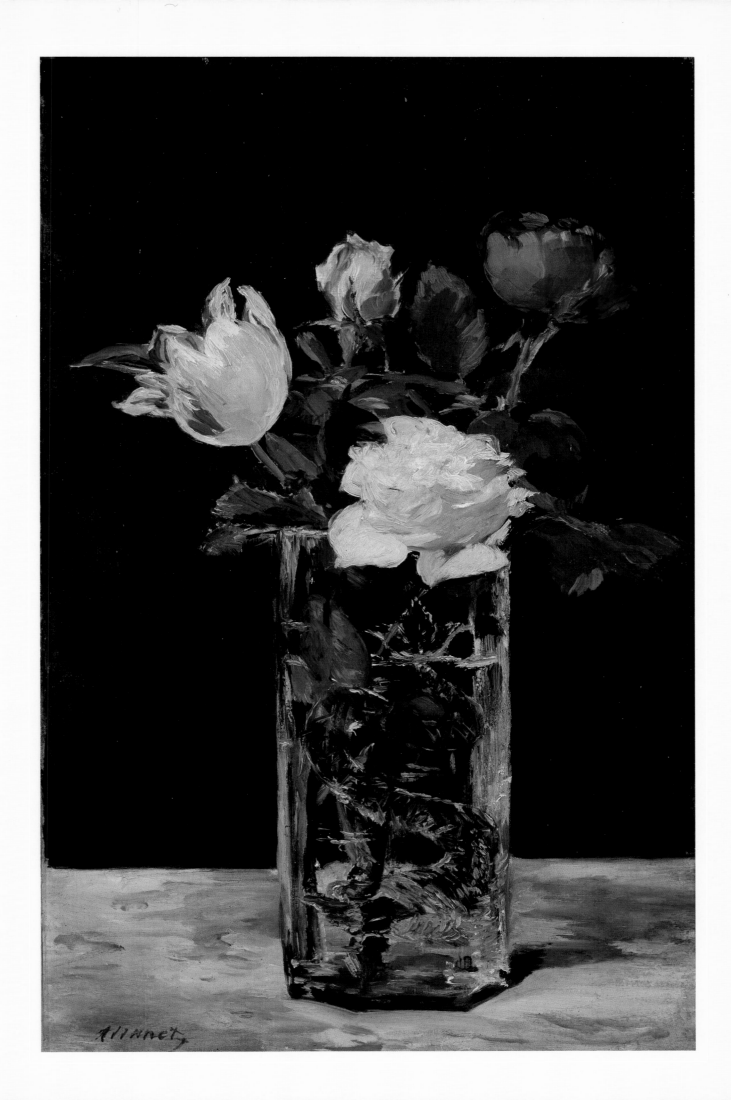

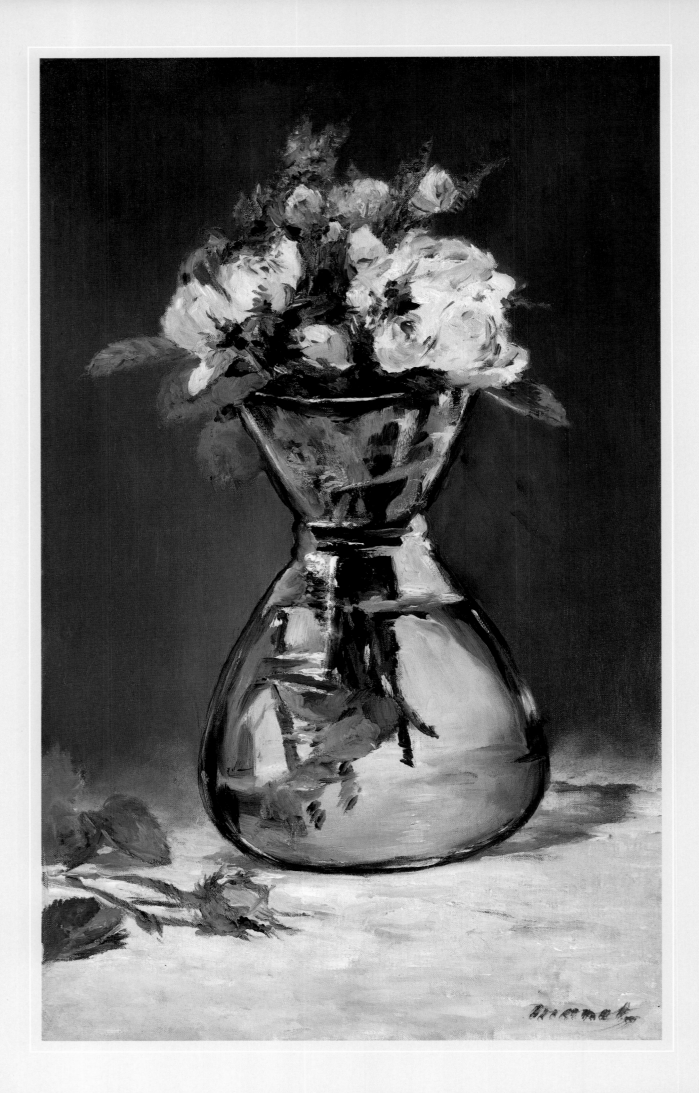

EDOUARD MANET

Moss Roses in a Vase, 1882 or 1883

Oil on canvas, 22 x 13 1/2 inches

© Sterling and Francine Clark Art Institute,

Williamstown, Massachusetts

EDOUARD MANET

Bouquet of Peonies on a Pedestal, 1864

Oil on canvas, 37 x 27 1/2 inches

Musée d'Orsay, Paris

Courtesy Art Resource, New York

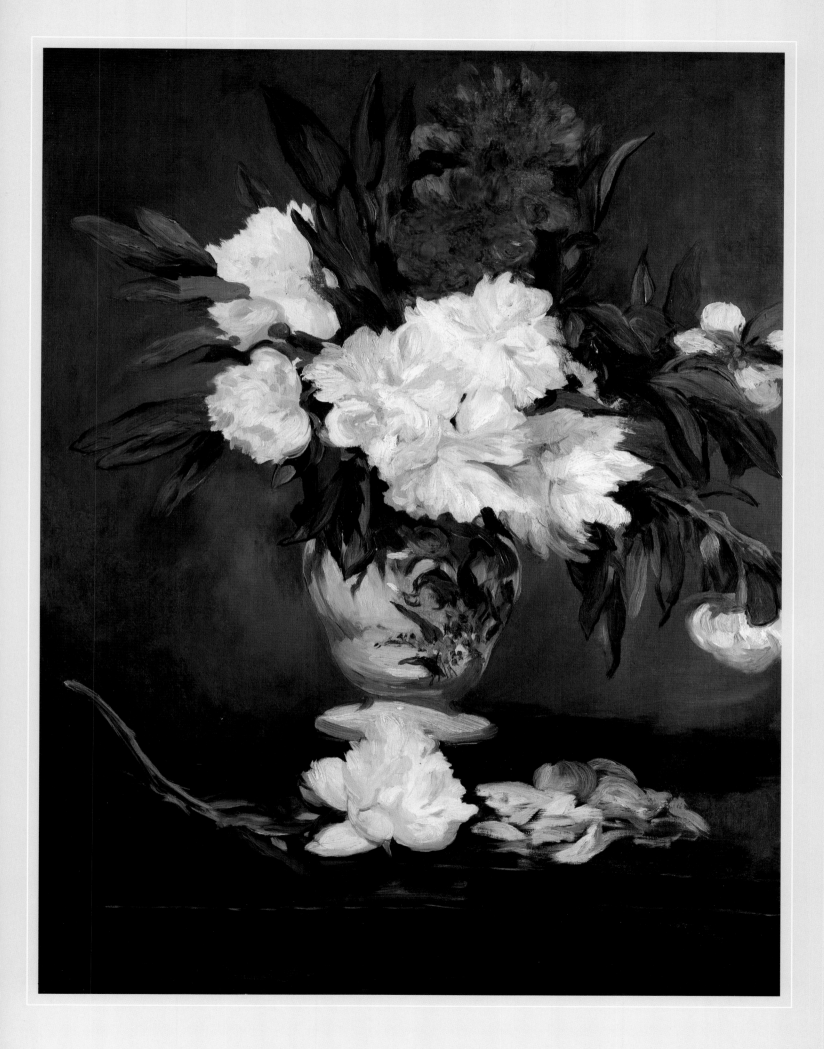

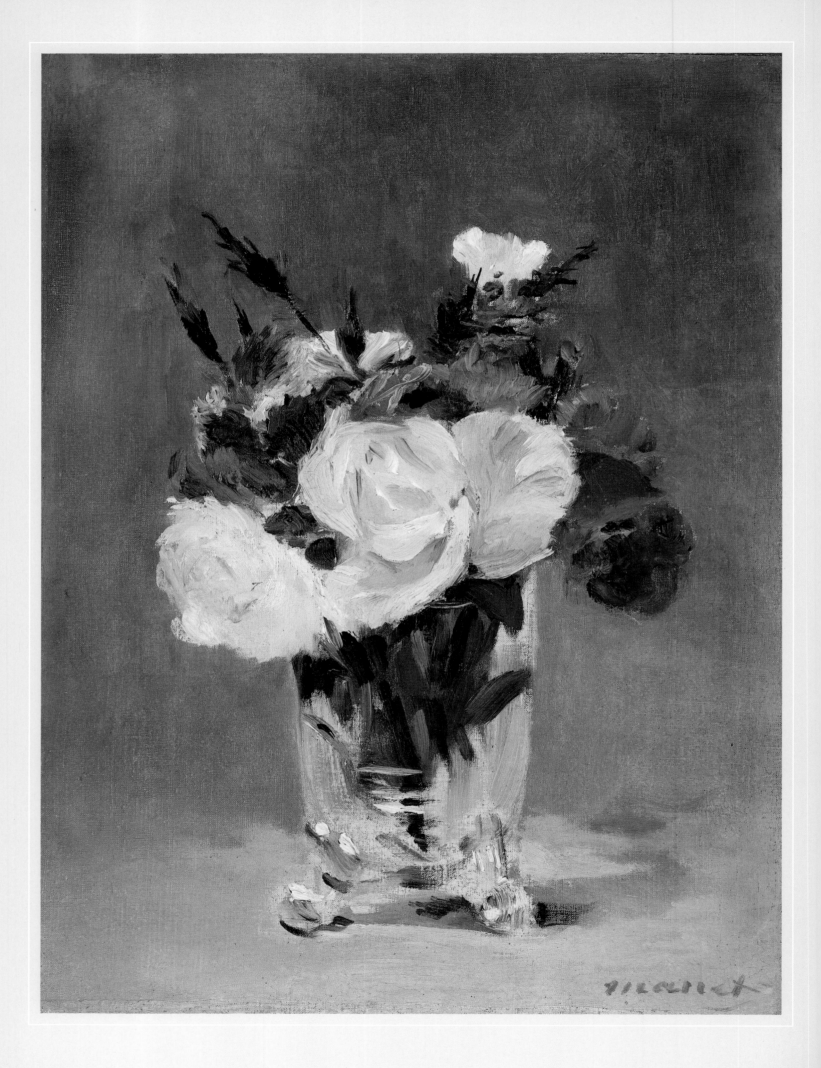

EDOUARD MANET

Flowers in a Crystal Vase, 1882 or 1883

Oil on canvas, 12 7/8 x 9 5/8 inches

National Gallery of Art, Washington, D.C.

Ailsa Mellon Bruce Collection

© 1997 Board of Trustees, National Gallery of Art

Rose *Pansy*

EDOUARD MANET

Vase of White Lilacs and Roses, 1883

Oil on canvas, 22 x 18 1/8 inches

Dallas Museum of Art

The Wendy and Emery Reves Collection

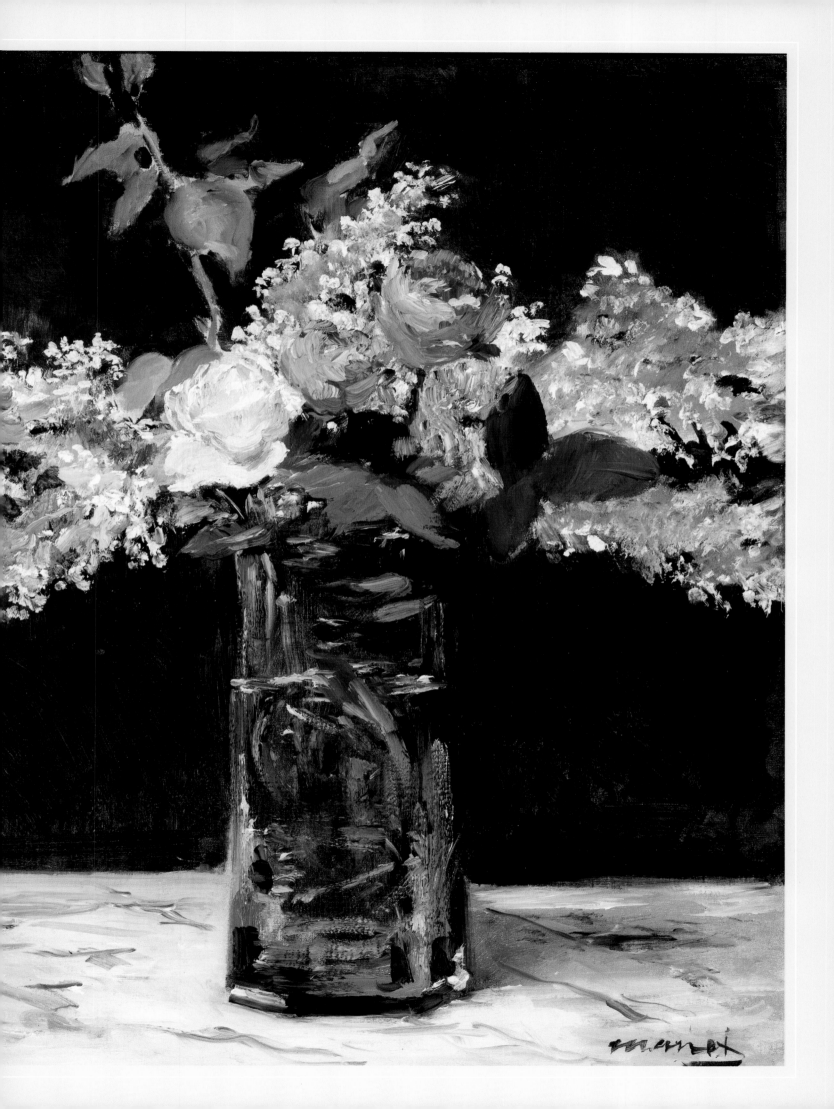

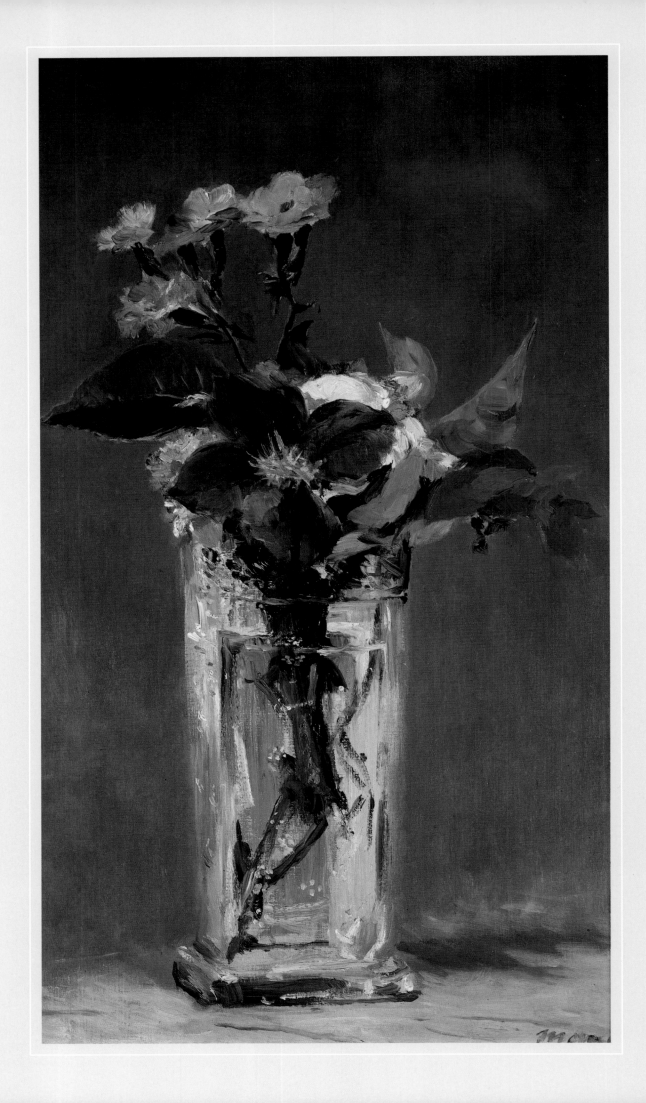

EDOUARD MANET

Pinks and Clematis in a Crystal Vase, 1882

Oil on canvas, 22 x 13 3/4 inches

Musée d'Orsay, Paris

Courtesy Art Resource, New York

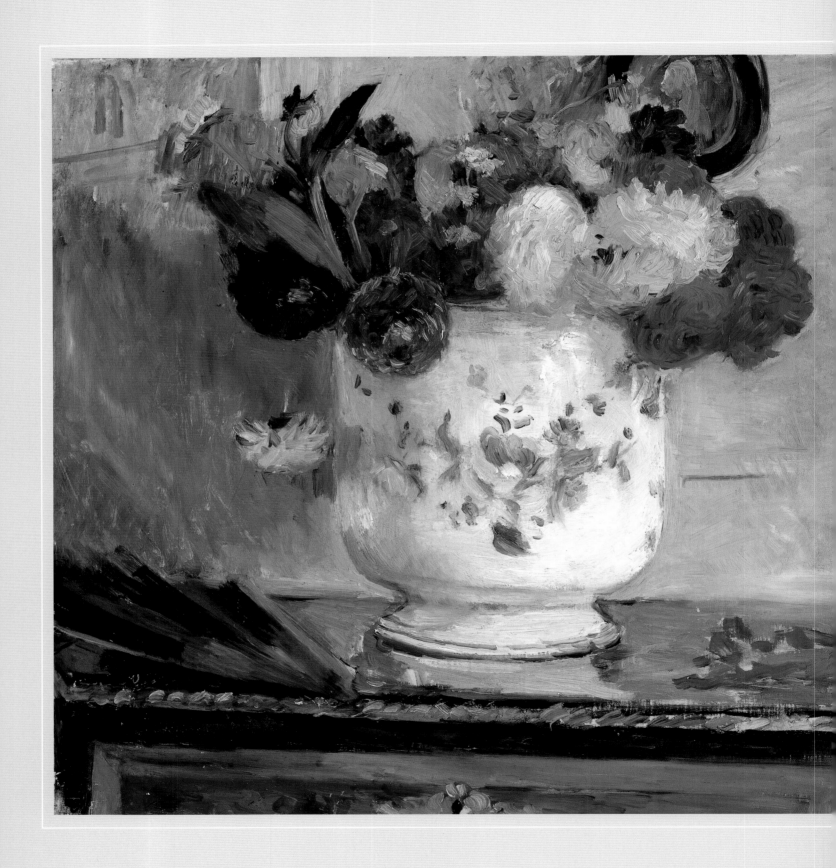

Berthe Morisot

was born in Bourges in 1841. She was a granddaughter of the great Rococo painter Jean Honoré Fragonard, Her father, a high government official who had studied painting and architecture, was the host of one of the important artistic salons of the Second Empire. Nevertheless, it was over his objections that Berthe developed her talents and pursued a serious career in painting. Camille Corot was one of her father's frequent guests, and in 1862 the young woman persuaded the great painter to accept her as a pupil, an arrangement that lasted for six years. She also received instruction from Fantin-Latour, but her most important teacher was Manet, whom she met in 1868. His style was the greatest influence on her work, and many of her paintings could almost be mistaken for his. In 1874 she married his brother, Eugène, who planted a garden in the Bois de Boulogne, where she often painted, and she encouraged Manet to paint outdoors.

In Morisot's most characteristic works, she placed the women and children whom she loved to paint on a lawn of emerald grass, often with flowers in the background or even as a central theme. A charming and cultured person, Morisot was friendly with most of the Impressionists and was represented in all but one of their group exhibitions. After Manet's death, in 1883, Morisot turned to Renoir as her mentor, and it was under his influence that she painted her relatively few cut flowers. She continued painting until shortly before her death, in 1895.

BERTHE MORISOT
Dahlias, c. 1876
Oil on canvas, 18 1/8 x 22 inches
© Sterling and Francine Clark Art Institute,
Williamstown, Massachusetts

Mary Cassatt

was born to a wealthy family in 1844 in Allegheny City, Pennsylvania, which is now part of Pittsburgh. During her childhood her family traveled extensively in Europe, opening her eyes to the wonders of art. Beginning in 1861 she attended the Pennsylvania Academy of the Fine Arts, in Philadelphia, for four years. Against the wishes of her father, she then decided upon a career in art and settled in Paris, where she became a close friend of Edgar Degas and was greatly influenced by him, though she never formally studied with him. At his invitation her work was included in the Impressionist exhibitions from 1879 on. At first, her paintings were mostly of women reading, drinking tea, or attending the theater, but her mature works concentrate largely on the theme of mothers holding or bathing young children. After seeing an exhibition of Japanese prints in 1890, Cassatt incorporated some of their daring composition and graphic boldness into her own work, and she embarked on a beautiful series of color prints.

In 1894 she purchased the eighteenth-century Château de Beaufresne, about forty miles northwest of Paris, where she delighted in tending the thousand rosebushes in her garden. Nevertheless, she painted very few still lifes of flowers.

Cassatt continued painting until 1915, when failing eyesight forced her to stop. She died in 1926 at her beloved Château de Beaufresne.

MARY CASSATT
Lilacs in a Window, c. 1880
Oil on canvas, 24 1/4 x 20 inches
Private collection

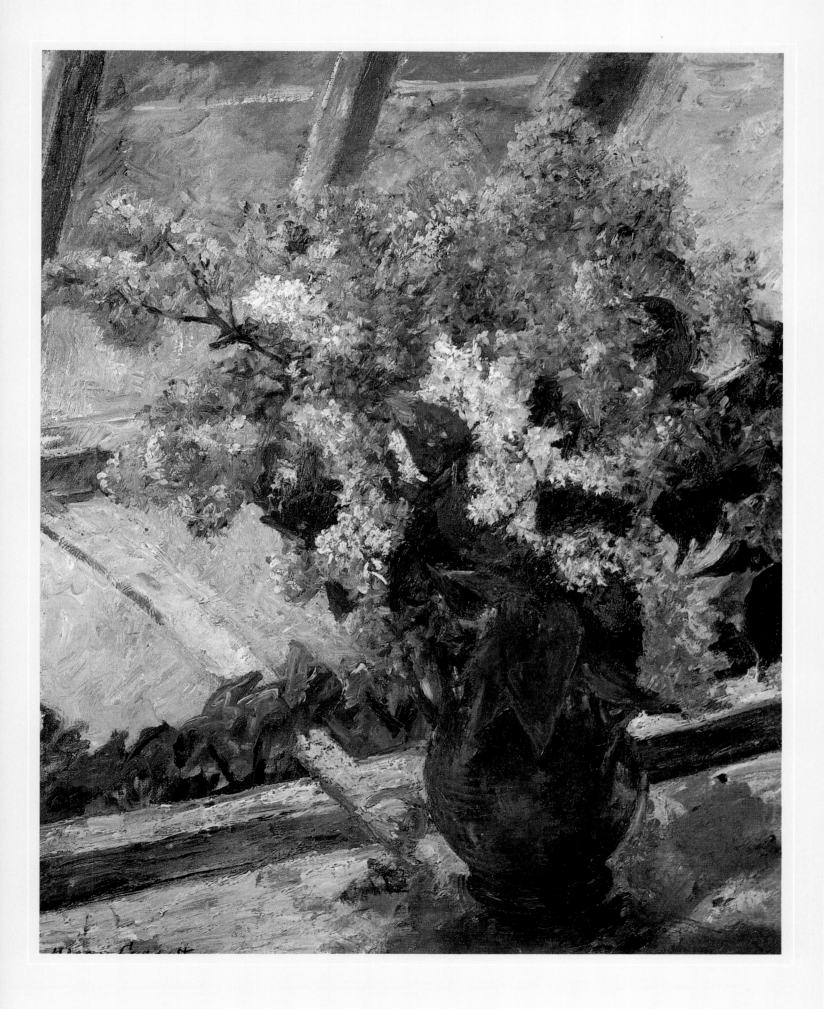

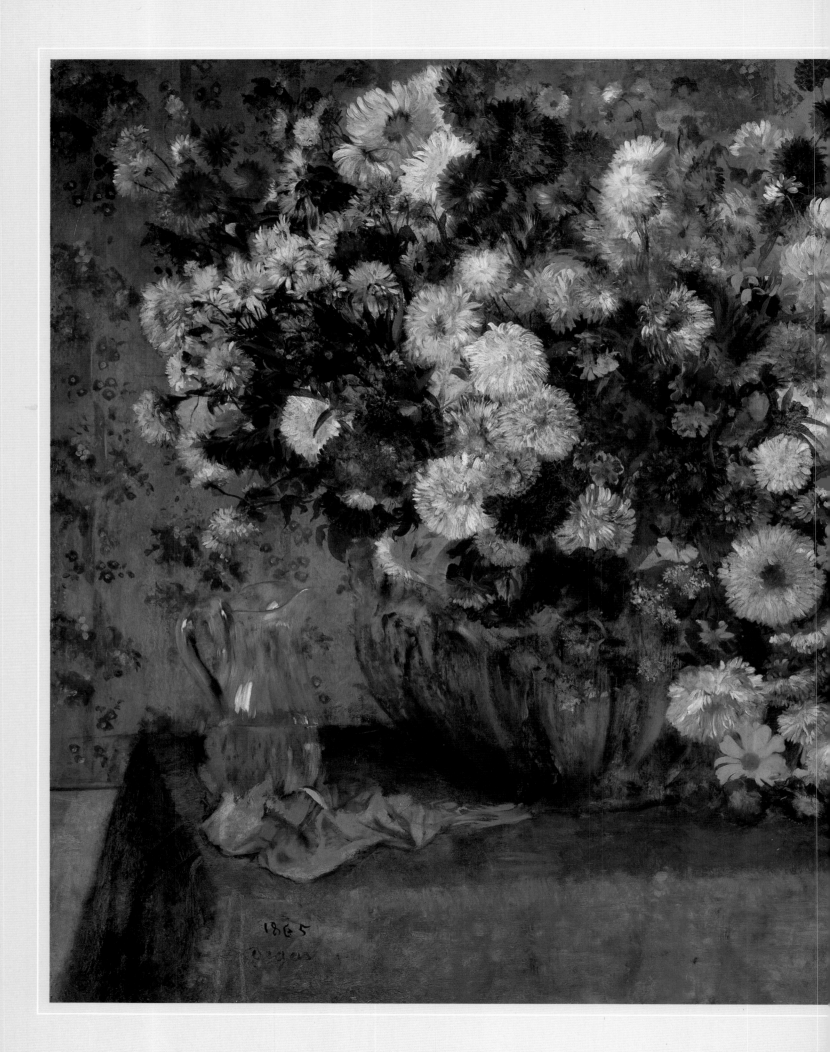

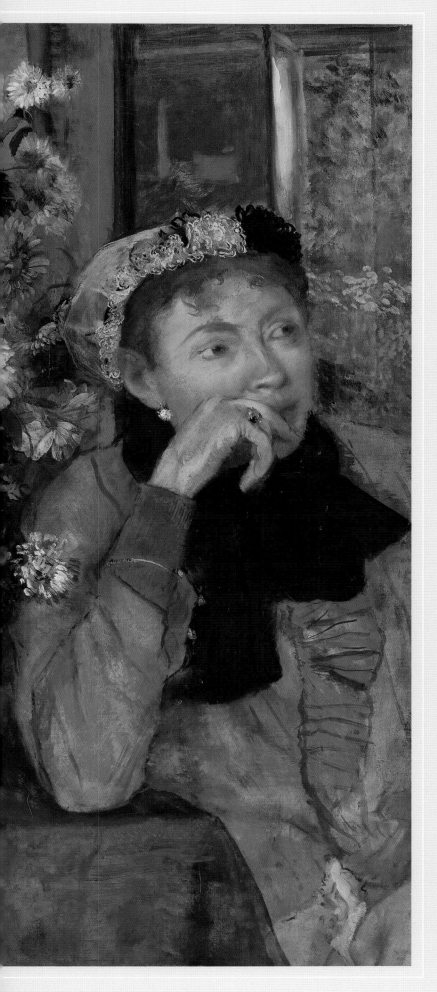

Edgar Degas

was born in 1834 to a wealthy and conservative banking family that intended him for the legal profession. Instead the proud and aloof young man turned to painting and enrolled at the Ecole des Beaux-Arts, where his teacher was Louis Lamothe, who had studied with Ingres. During a two-year stay in Italy (1856–58) Degas copied works by Mantegna, Botticelli, Poussin, and Hans Holbein the Younger, by all of whose classical draughtsmanship he was influenced. His other principal inspiration was the formal daring of Japanese woodblock prints, which he first encountered in the late 1850s.

Although Degas exhibited regularly with the Impressionists, he stands apart from them in many respects. While they were mostly amicable and gregarious, he was rather misanthropic. Although he was a brilliantly original landscapist and portraitist, his most characteristic works depict such human figures as ballerinas, jockeys, or laundresses as inhabitants of exotic worlds in which every detail and gesture thrills the artist. Perhaps his finest works are those he executed in pastel, a medium of pure pigment in which he could render equally the gossamer tulle of a ballerina's skirt and the solid flesh of a woman awkwardly bathing in a small tin tub.

Degas, who claimed to be allergic to flowers, does not seem to have painted any solely floral canvases. *A Woman Seated Beside a Vase of Flowers* (which is often mistakenly called *Woman with Chrysanthemums*) is the finest of his few paintings that feature flowers. Although some art historians have insisted that Degas originally painted his canvas simply as a floral still life, and added the woman as an afterthought some years later, it now seems most likely that the artist actually painted the entire composition at once.

After 1886 Degas lived as a virtual recluse, devoted to painting and sculpture. During the last years of his life he became completely blind in one eye, and almost so in the other. He died in 1917.

EDGAR DEGAS

A Woman Seated Beside a Vase of Flowers, 1865
Oil on canvas, 29 x 36 1/2 inches
The Metropolitan Museum of Art, New York
H. O. Havemeyer Collection,
Bequest of Mrs. H. O. Havemeyer, 1929

Photograph © 1980 The Metropolitan Museum of Art (29.100.128)

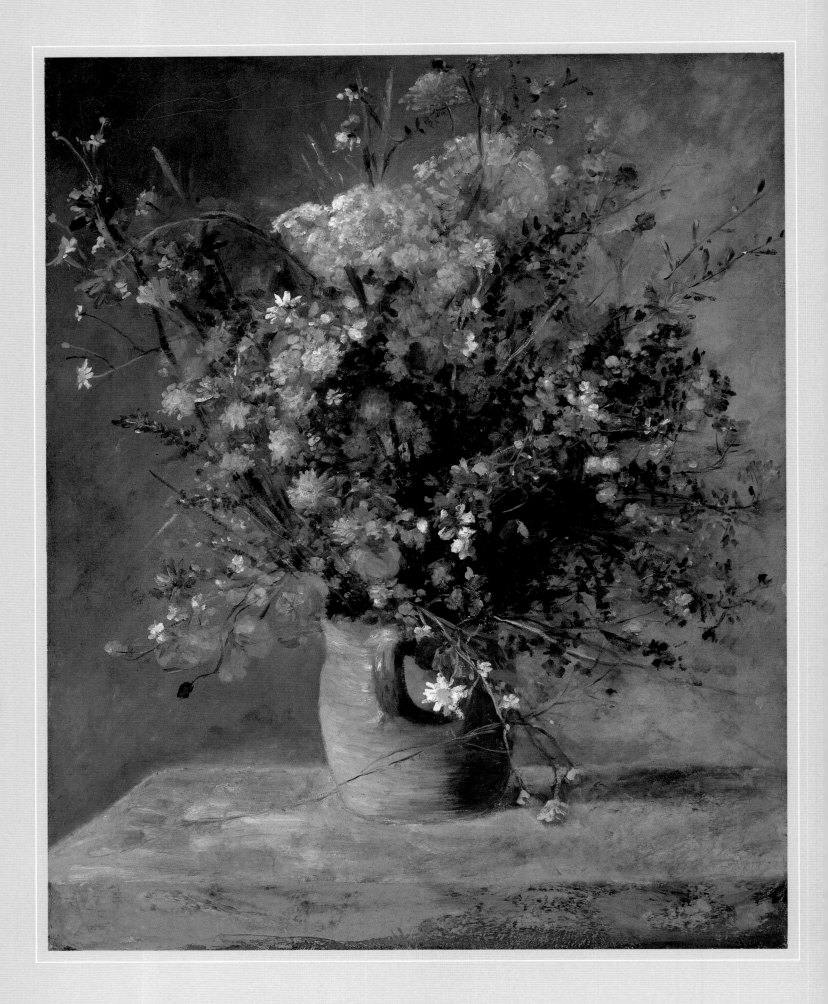

Pierre-Auguste Renoir

was born in 1841, one of a tailor's seven children. Having shown a precocious talent for painting, he was apprenticed at the age of thirteen in a porcelain factory, where he learned to decorate dinner services with bouquets of flowers. After a few years he took up the specialties of painting fans and religious banners.

When he was twenty-one Renoir became a student of the academic painter Gleyre, in whose studio he would meet and form close friendships with the future Impressionists Claude Monet, Frédéric Bazille, and Alfred Sisley. Longing to reject the dead formulas of the academy in favor of spontaneous observation of nature and daily life, Renoir and Monet settled in Chailly, on the outskirts of the forest of Fontainebleau, painting landscapes.

Renoir's principal interests, however, were portraiture, the female nude, and scenes of joie de vivre, all executed in the luminous, shimmering colors of his "rainbow palette," which excluded black. He drew his greatest inspiration from the masters of the Rococo period—Boucher, Watteau, and Fragonard, though he also admired Delacroix's intense pigments.

In addition to his principal subjects, Renoir painted dozens of bouquets over the course of his career. The earliest of them, dating from the middle 1860s—*Spring Bouquet* (1866), for example—resemble Courbet's floral canvases, but those from the 1870s radiate Renoir's distinctive spirit. It should perhaps not be surprising that this supreme painter of lush female nudes especially favored roses and peonies. During the 1880s, Renoir painted many of his most beautiful bouquets on visits to his friend Paul Bérard, who had a fine rose garden on his country estate at Wargemont, near Dieppe.

A leading Impressionist during the 1870s, Renoir turned to a more linear Neoclassical style after a trip to Italy in 1880; he declared that until seeing Raphael's works he had not known how to draw or paint. During the 1890s exposure to the warmth and color of the south of France brought exuberance and sensuality back into Renoir's work. The artist died at Cagnes, on the Riviera, in 1919.

PIERRE-AUGUSTE RENOIR

Flowers in a Vase, c. 1866

Oil on canvas, 32 x 25 5/8 inches

National Gallery of Art, Washington, D.C.

Collection of Mr. and Mrs. Paul Mellon

© 1997 Board of Trustees, National Gallery of Art

Cornflower

Daisy

Poppy

PIERRE-AUGUSTE RENOIR

Spring Bouquet, 1866

Oil on canvas, 41 1/4 x 31 5/8 inches

Fogg Art Museum, Harvard University Art Museums

Bequest of Grenville L. Winthrop

Chrysanthemum *Iris*

Laburnum *Lilac* *Peony*

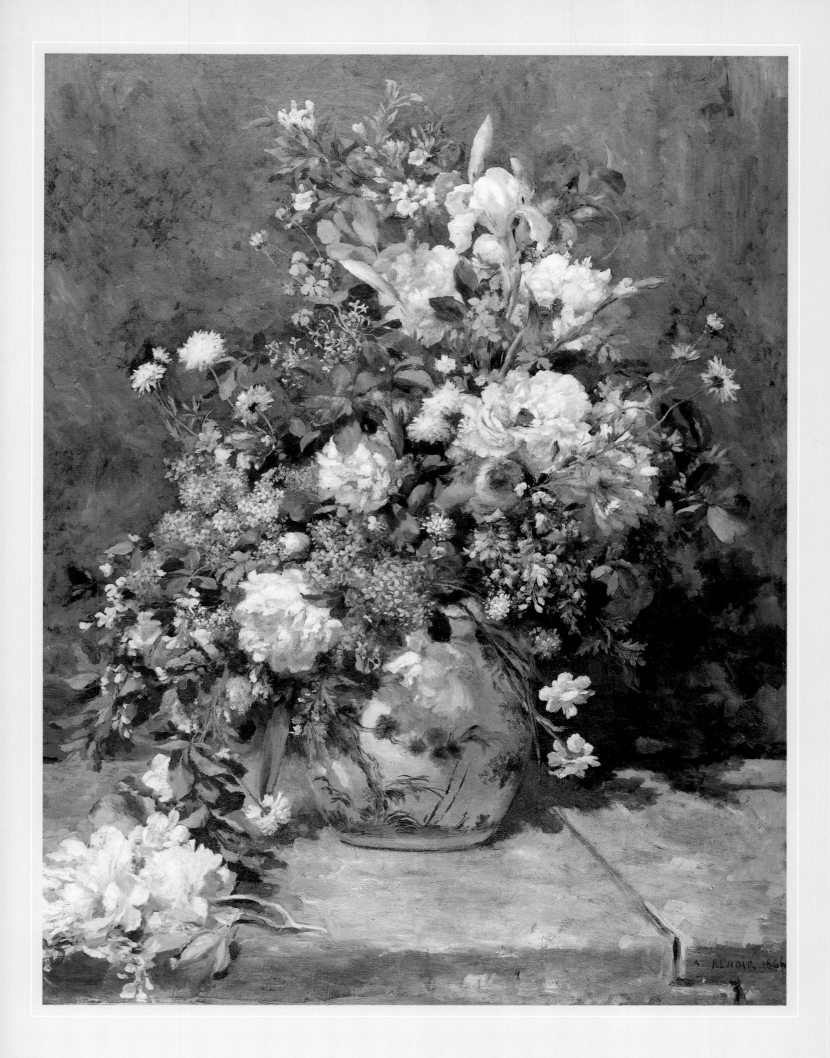

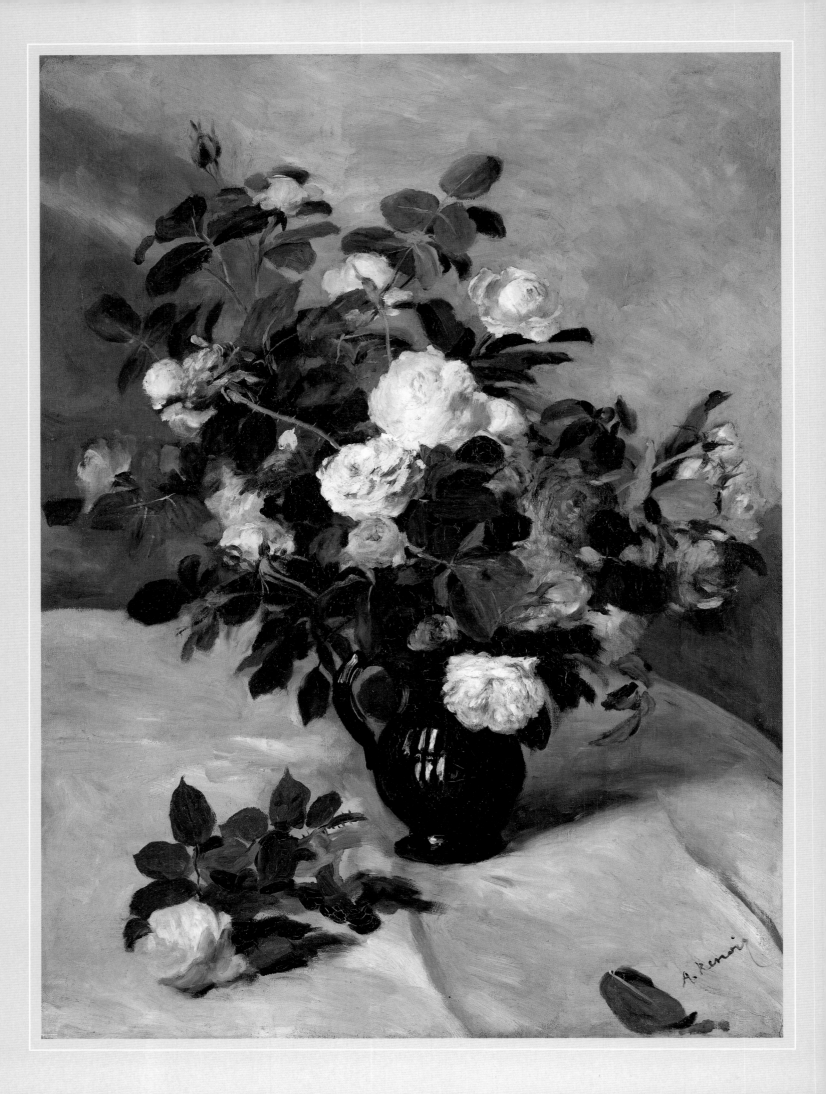

PIERRE - AUGUSTE RENOIR

Still Life with Roses, c. 1866

Oil on canvas, 29 1/8 x 21 7/8 inches

Fogg Art Museum, Harvard University Art Museums

Bequest of Grenville L. Winthrop

PIERRE-AUGUSTE RENOIR

Mixed Flowers in an Earthenware Pot, 1869

Oil on canvas, 25 1/2 X 21 3/8 inches

Museum of Fine Arts, Boston

Bequest of John T. Spaulding

(This is the same bouquet as that in the Monet on pages 90–91)

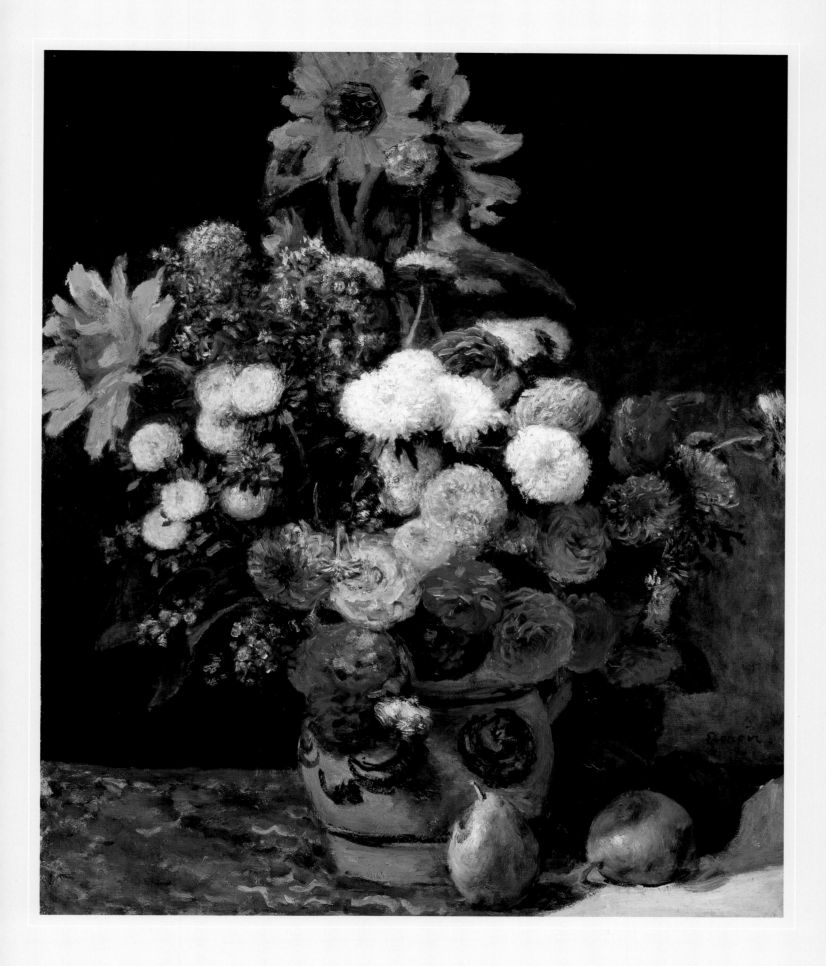

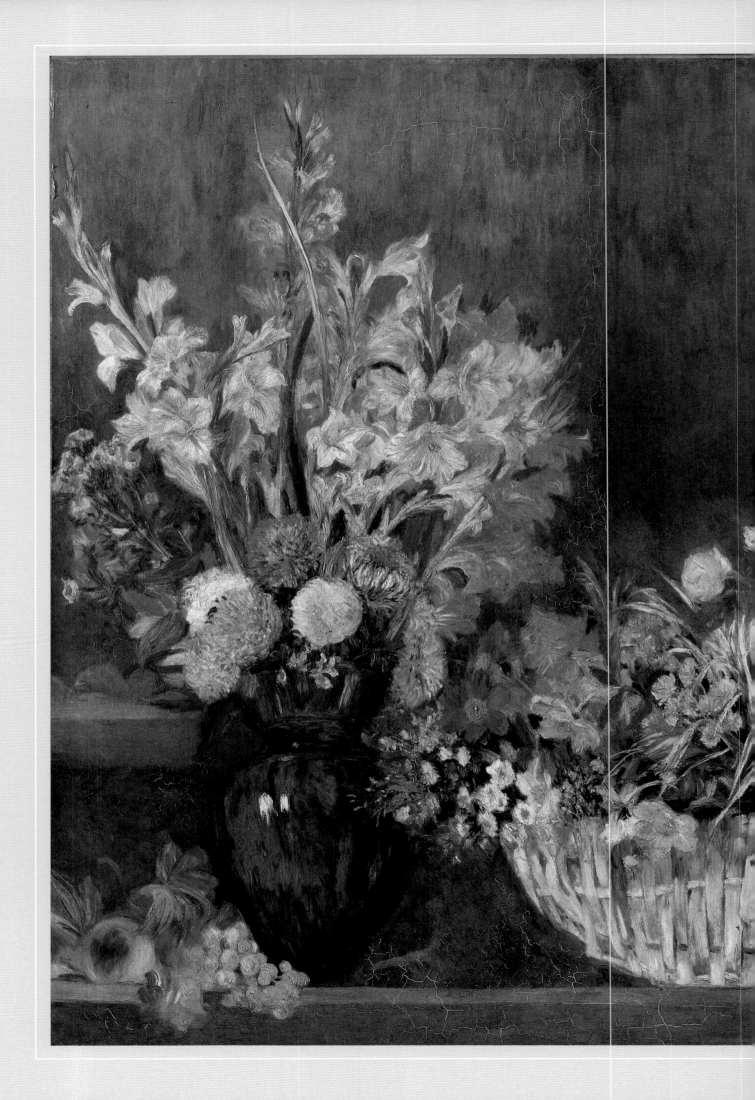

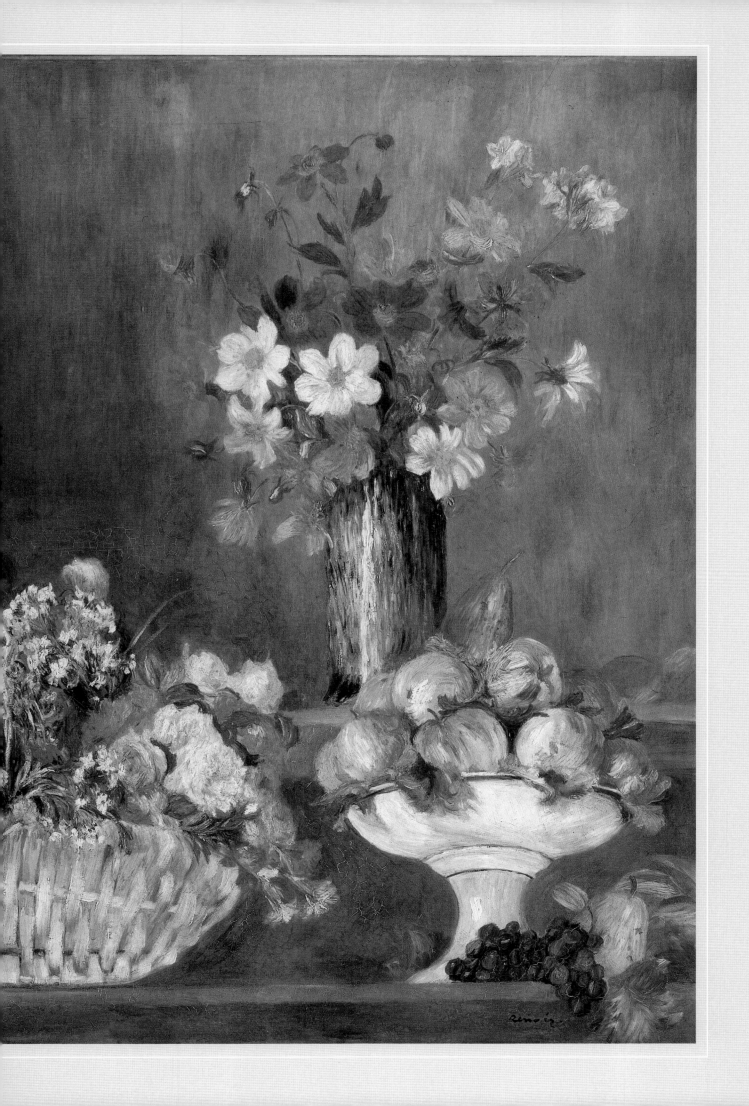

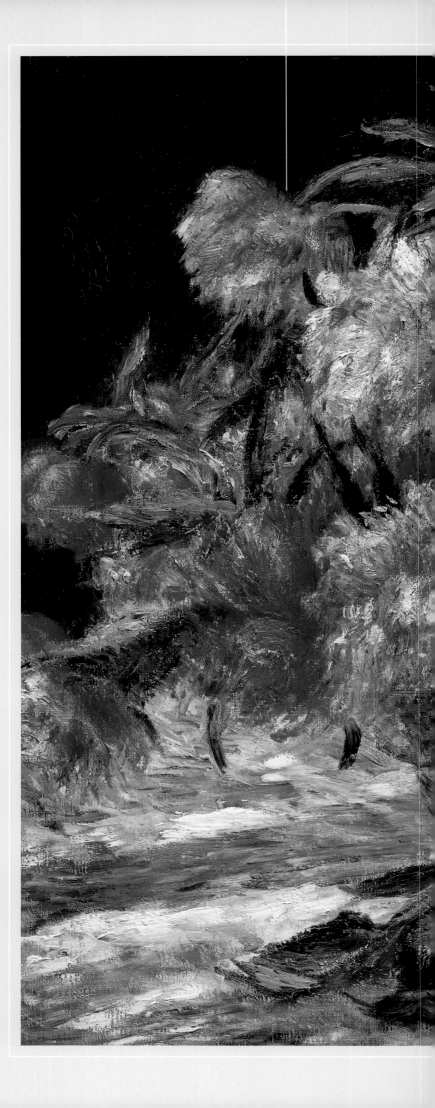

pages 76–77

PIERRE-AUGUSTE
RENOIR

Still Life with Flowers and Fruit, c. 1890

Oil on canvas, 52 1/2 x 68 7/8 inches

Philadelphia Museum of Art

Mr. and Mrs. Carroll S. Tyson Jr. Collection

PIERRE-AUGUSTE
RENOIR

Peonies, c. 1880

Oil on canvas, 21 5/8 x 25 11/16 inches

© Sterling and Francine Clark Art Institute,
Williamstown, Massachusetts

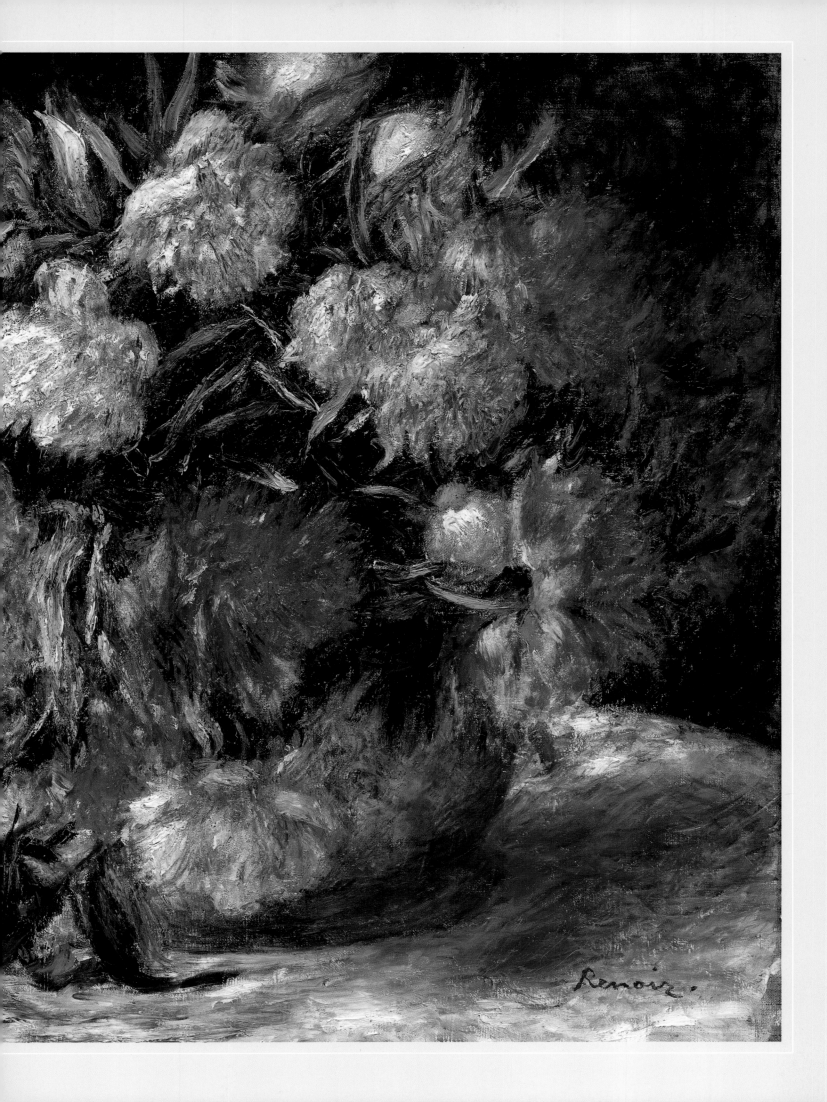

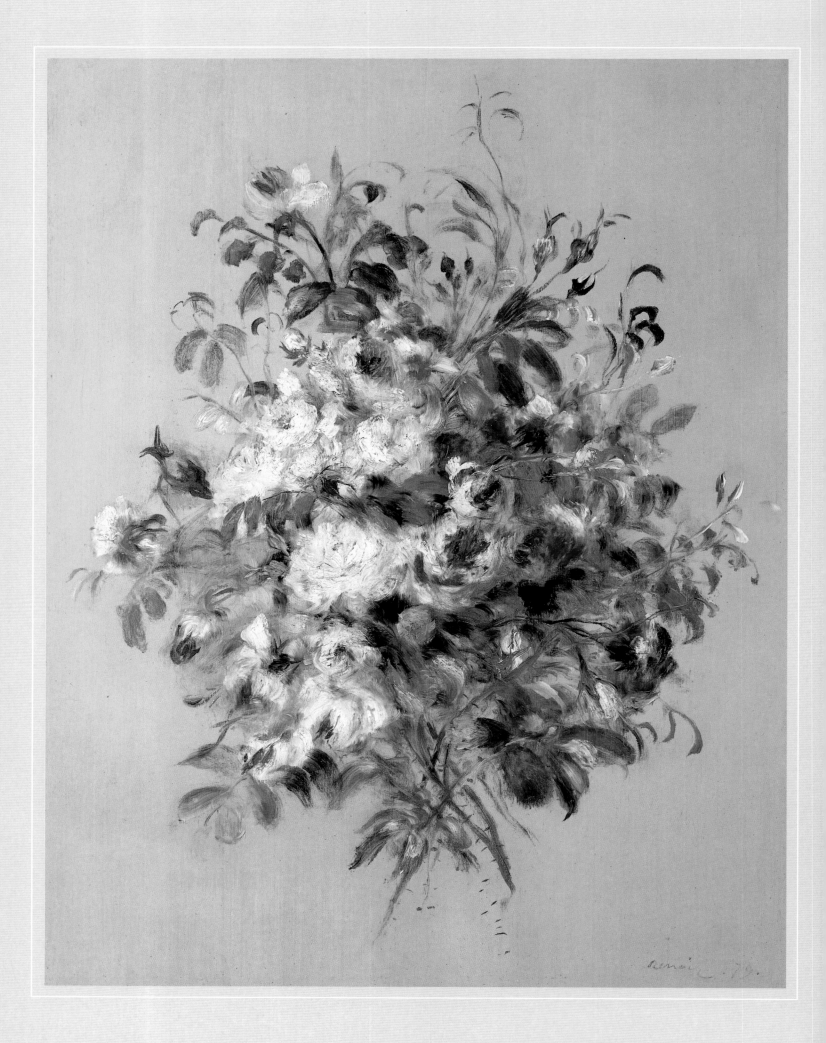

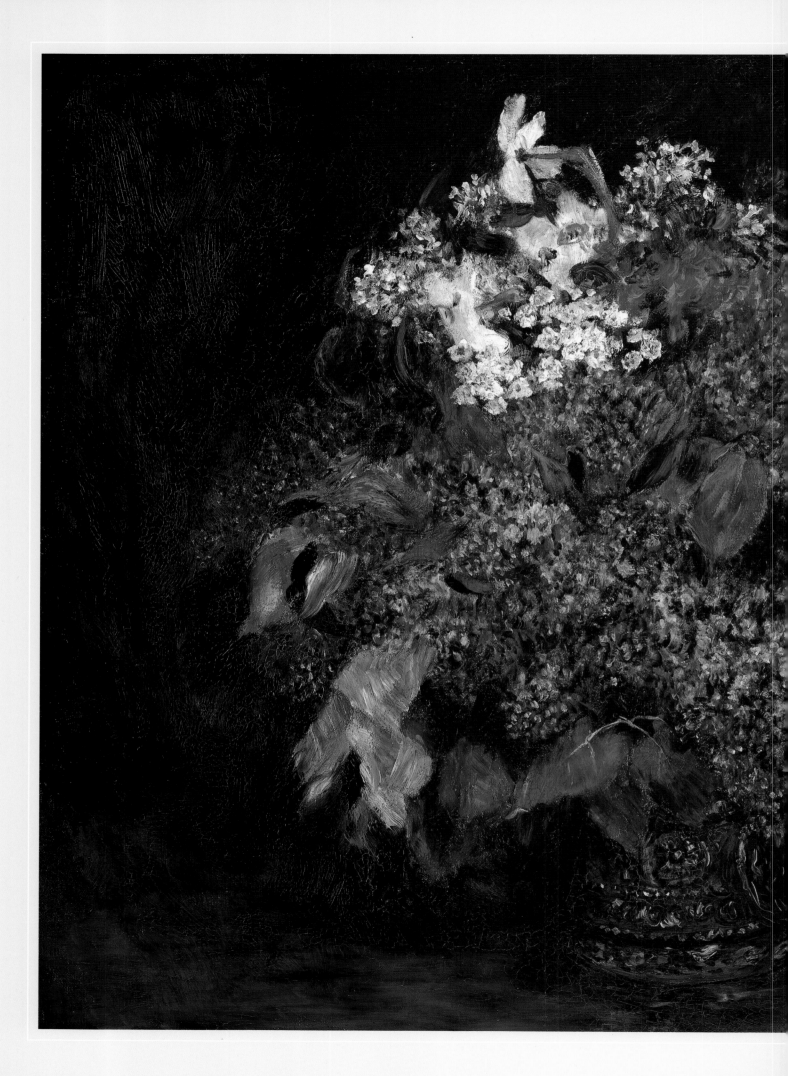

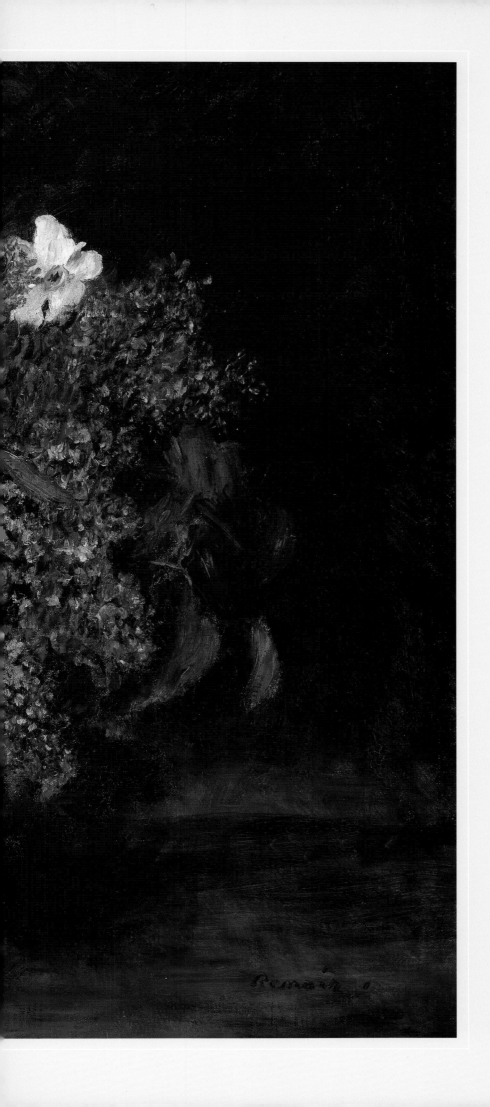

PIERRE-AUGUSTE
RENOIR
Bouquet of Lilacs, 1875
Oil on canvas, 21 1/2 x 25 3/4 inches
Norton Simon Collection, Pasadena,
California

Frédéric Bazille

was born into a wealthy family in Montpellier in 1841. He reluctantly acceded to his family's wishes that he study medicine, but, in 1861, having agreed to continue his medical studies, he entered Gleyre's studio, where he met Monet and Renoir. In 1865 he joined them in Chailly, near Barbizon, to paint landscapes; while there, the tall and handsome young artist also posed for one of the figures in Monet's *Déjeuner sur l'herbe* (Luncheon on the Grass). When they all returned to Paris, Bazille shared his studio with Renoir and Monet, as they could not afford studios of their own.

Although Bazille was primarily a painter of portraits and of landscapes, some of the latter peopled by rather sculptural figures, he is known to have painted at least seven floral canvases. Two versions of *African Woman with Peonies* are in existence; the National Gallery version seems to have been painted first, for its flowers include tulips and narcissi, which, of course, bloom earlier than the irises that appear in the other version.

At the outbreak of the Franco-Prussian War in '70, Bazille enlisted in a regiment of Zouaves. He was killed on November 28 of that year, at the battle of Beaune-la-Rolande. Had he lived, he would certainly have played an important role in the Impressionist movement.

FRÉDÉRIC BAZILLE
African Woman with Peonies, 1870
Oil on canvas, 23 1/2 x 29 inches
National Gallery of Art, Washington, D.C.
Collection of Mr. and Mrs. Paul Mellon

Lilac

Narcissus

Peony

Rose

Tulip

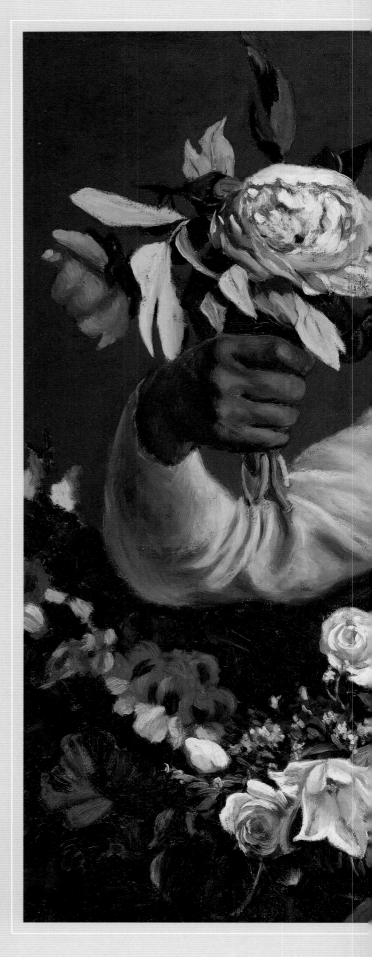

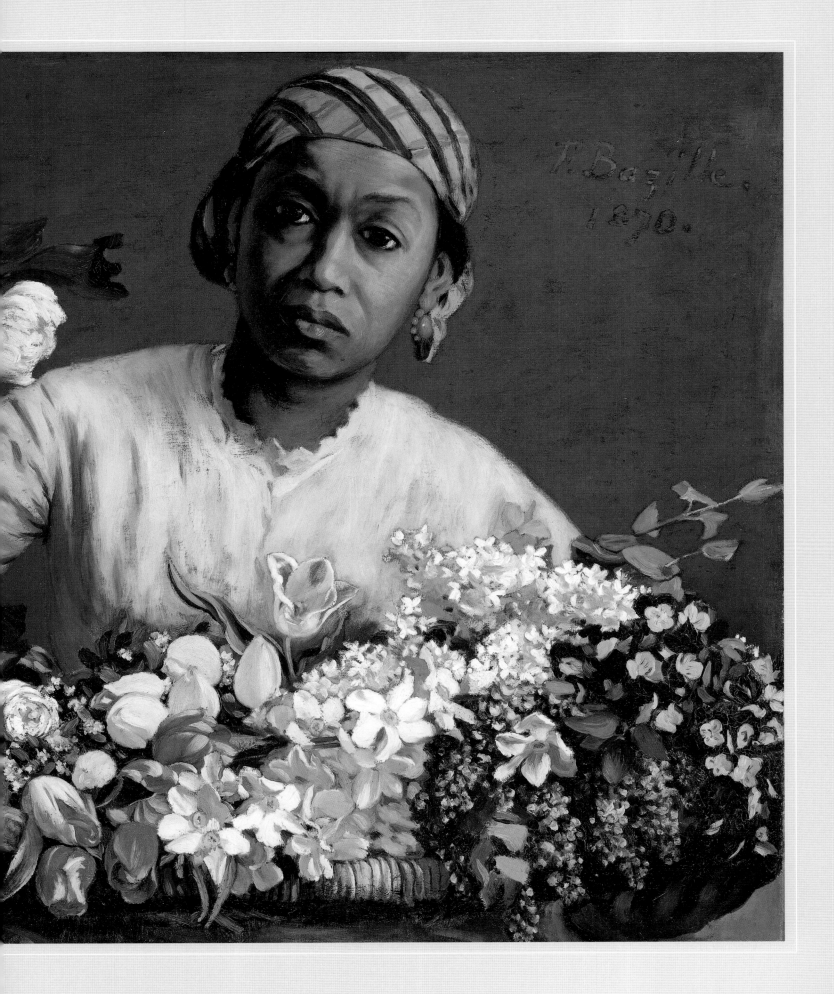

Claude Monet

was born in Paris in 1840, the eldest son of a grocer. Five years later the Monets moved to Sainte-Adresse, near Le Havre, headquarters of the family's lucrative ship-chandlering business. Claude sold some caricatures when he was fifteen, and he studied drawing with a local artist, but his true artistic awakening came only when he met Eugène Boudin, in 1858, and spent a day painting with him in the open air. In 1859 Monet went to Paris, angering his family by refusing to enroll at the Ecole des Beaux-Arts, and instead working at the Académie Suisse, where he met Camille Pissarro. After military service in Algeria, where he was delighted by the milieu similar to that which Delacroix had painted in Morocco, Monet returned to Sainte-Adresse, where he renewed his acquaintance with Boudin and met the Dutch marine painter Jongkind.

Resuming his Parisian studies in 1862 in the studio of the Swiss academic painter Gleyre, Monet met Renoir, Bazille, and Sisley. After disagreements with Gleyre, the four young painters left his studio, and Monet and Renoir settled in Chailly, near Barbizon, in the forest of Fontainebleau. During the later 1860s Monet pioneered large-scale outdoor painting of figures in a landscape. Late in the decade he and Renoir worked together, and it was in that friendship that Impressionism was born.

After a stay in England to avoid the Franco-Prussian War of 1870–71, Monet spent some months in Holland and then returned to Le Havre, where he painted *Impression: Sunrise*, the canvas that would give its name to the movement when it was exhibited in 1874.

After the death of his wife, Camille, in 1879, Monet married a woman whose modest fortune enabled him to travel in France and the Netherlands in search of subjects, and also to buy a pleasant farm at Giverny, about fifty miles north of Paris, where the artist would cultivate a magnificent garden.

During the 1890s Monet painted his superb series of subjects observed in the changing light of different times of day —haystacks, the façade of Rouen cathedral, poplars, and so on. He devoted the last twenty-five years of his life to paintings of water lilies in the pond that he had created across the road from his house. He died at Giverny in December 1926.

CLAUDE MONET

Jerusalem Artichoke Flowers, 1880

Oil on canvas, 39 1/4 x 28 3/4 inches

National Gallery of Art, Washington, D.C.

The Chester Dale Collection

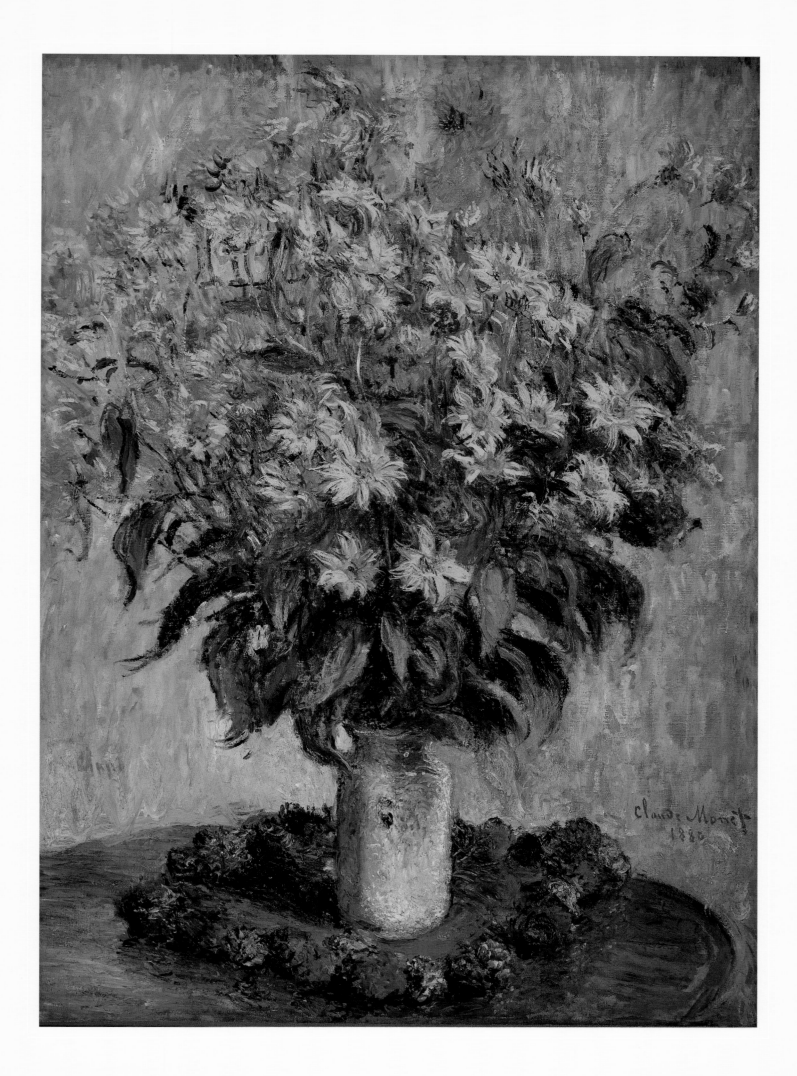

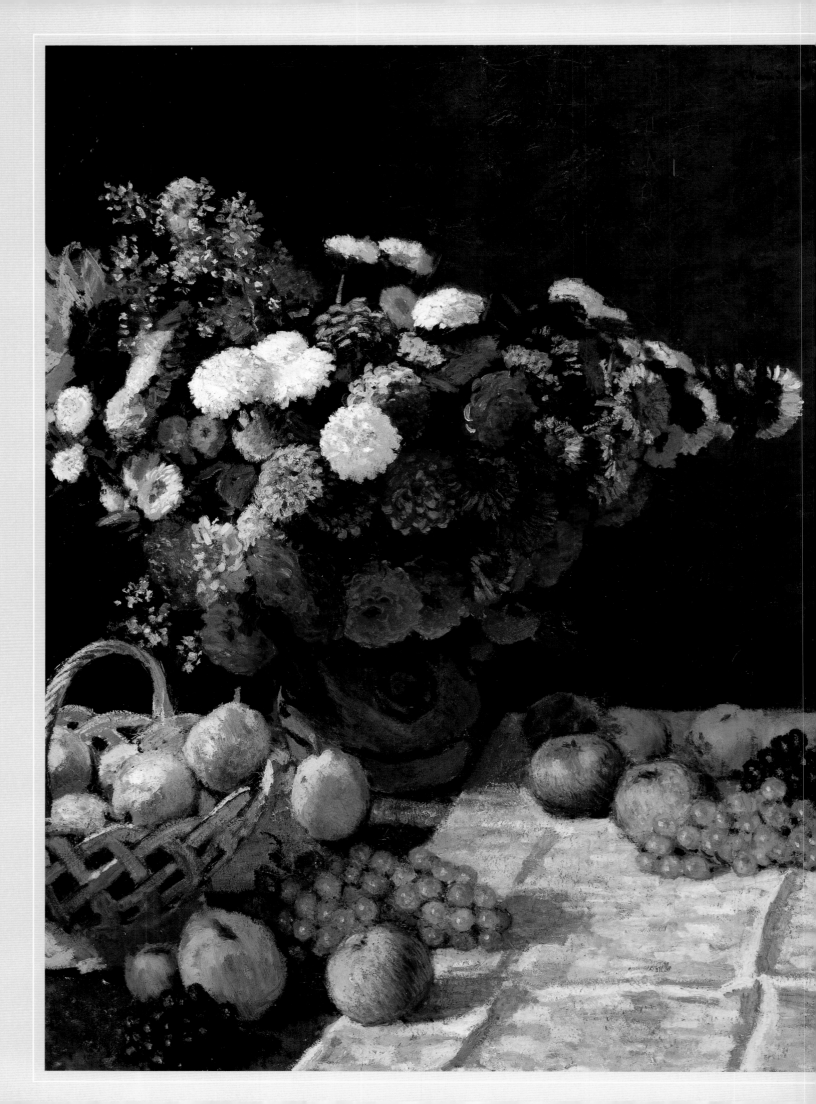

CLAUDE MONET
Flowers and Fruit, 1869
Oil on canvas, 39 3/8 x 31 3/4 inches
The J. Paul Getty Museum, Los Angeles

(This is the same bouquet as that in the Renior on page 77)

Aster

Chrysanthemum

Cornflower

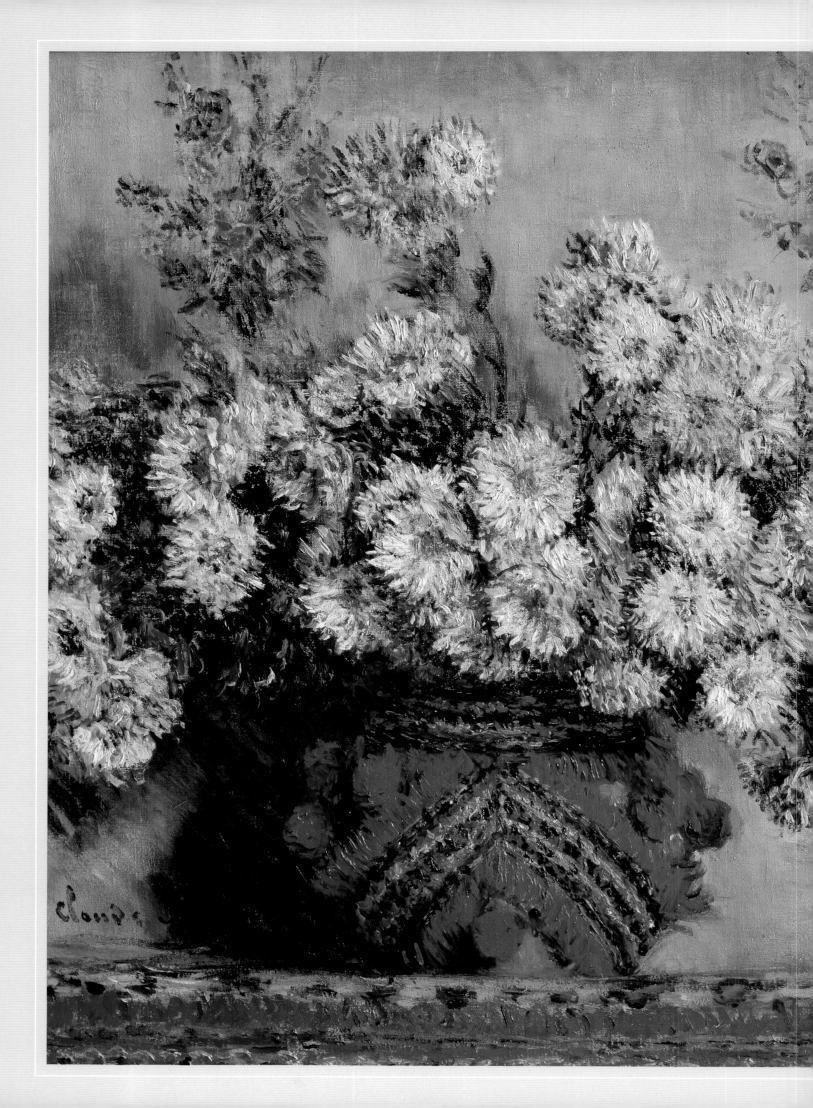

CLAUDE MONET
Chrysanthemums, 1878
Oil on canvas, 35 1/2 x 25 1/2 inches
Musée d'Orsay, Paris
Courtesy Art Resource, New York

CLAUDE MONET

Spring Flowers, 1864

Oil on canvas 45 x 34 1/2 inches

The Cleveland Museum of Art

Gift of the Hanna Fund, 1953.165

© The Cleveland Museum of Art, 1997

Begonia *Bugloss* *Hydrangea*

Lilac *Peony* *Tulip*

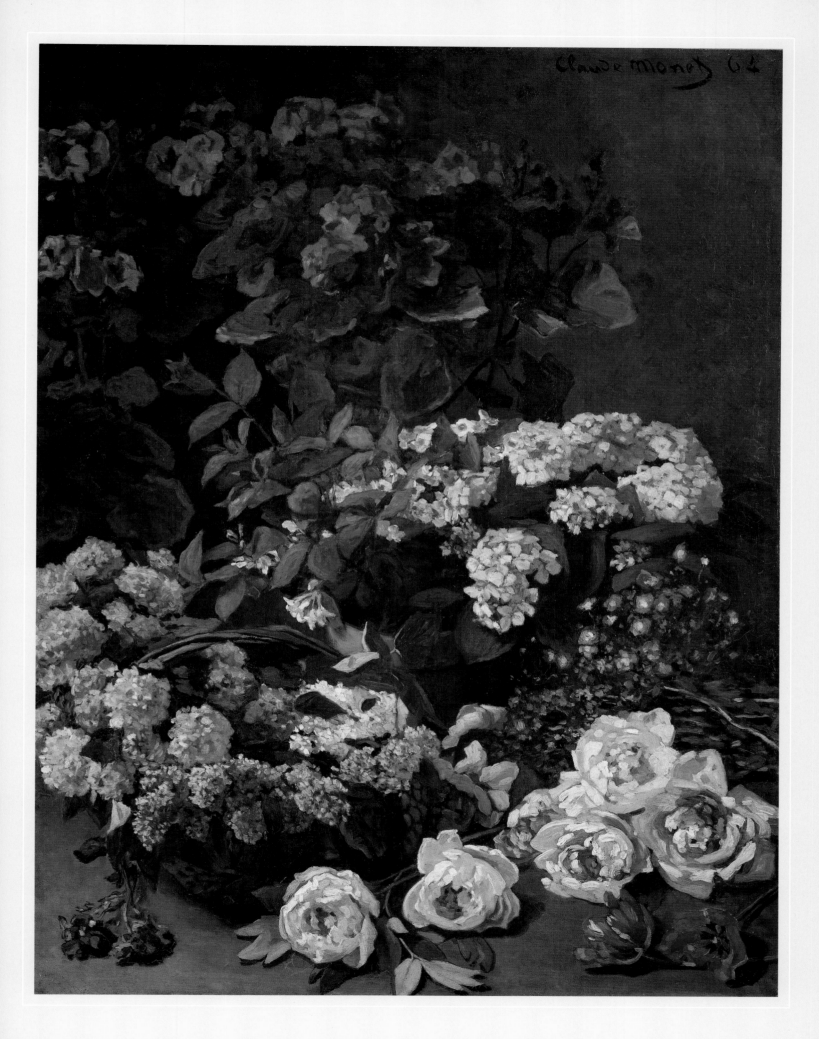

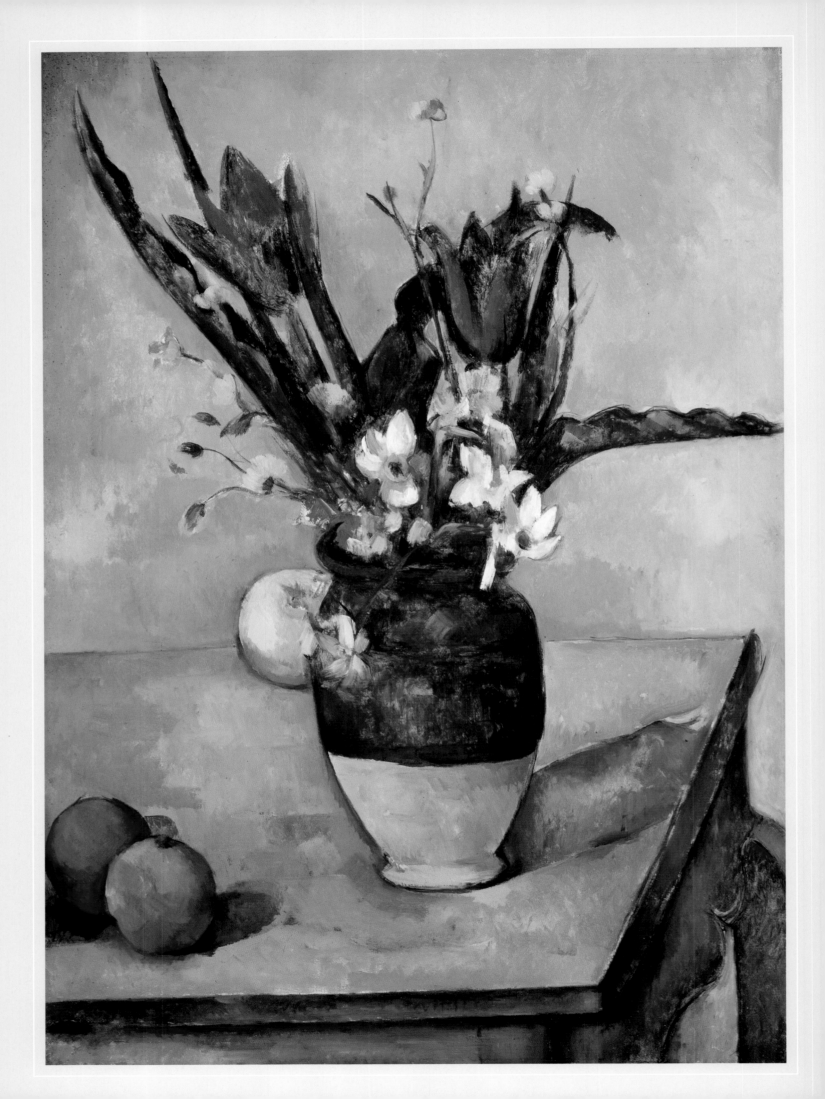

Paul Cézanne

was born in Aix-en-Provence in 1839, the acknowledged illegitimate son of a prosperous hatter who soon became a banker and landowner. Paul's father and mother were married in 1844. At the age of thirteen, Paul entered a local boarding school where he befriended Emile Zola. Five years later, having decided on a career in art, he began three years of drawing classes in Aix while reluctantly attending law school.

In 1861, Cezanne finally made his way to Paris to study at the Acadamie Suisse, but after only five months, his technical inferiority to most of his fellow students, which resulted in his rejection by the Ecole des Beaux-Arts, threw him into such a depression that he returned home to Aix. Late the following year, he went back to Paris and again failed to gain entrance to the Beaux-Arts, though this time he remained for a year. He became friendly with many of the future Impressionists whose work had impressed him at the Salon des Refuses in 1863. Soon the troubled and shy young man began to paint not only portraits and still lifes but also scenes of sexual violence in a heavily impastoed style that owed much to Delacroix.

In 1872, Cézanne settled in the town of Pontoise, not far from Paris, to work with Camille Pissarro. Until the end of 1874 they spent much time together engaging in the then still radical practice of painting outdoors. In that latter year, Cézanne was included in the first Impressionist exhibition where his works were the most ridiculed of all in that vilified show.

During the late 1870s and early 1880s Cézanne divided his time between Paris and Provence, concentrating on landscapes, portraits, and still lifes, many of which include flowers, though perhaps more because of the formal challenges they posed than because of any particular love of flowers. His goal was increasingly to capture on canvas the perceptual and emotional essence of what he observed. Both because of his vulnerable temperament and because of his humiliation at having to plead for his father's financial support, Cézanne became increasingly anti-social.

In 1886, Cézanne finally married his companion of many years, Marie-Hortense Fiquet. Six months later, the artist's father died and left him financially independent. In 1888, they and their son settled permanently in Aix. During his last decades, Cézanne's meditative solitude raised his work to the pinnacle of painterly integrity, in which no mark could be made on canvas or paper unless it was deeply felt. This sublime and immensely influential painter died in Aix in 1906.

PAUL CÉZANNE

The Vase of Tulips, 1890-94

Oil on canvas, 23 1/2 x 16 5/8 inches

The Art Institute of Chicago

Mr. and Mrs. Lewis Larned Coburn Memorial Collection

PAUL CÉZANNE

Flowers in a Glass Vase, 1872–73
Oil on canvas, 16 3/8 x 13 1/8 inches
The Putnam Foundation
Timken Museum of Art, San Diego

Anemone *Gloxinia*

Peony *Tulip*

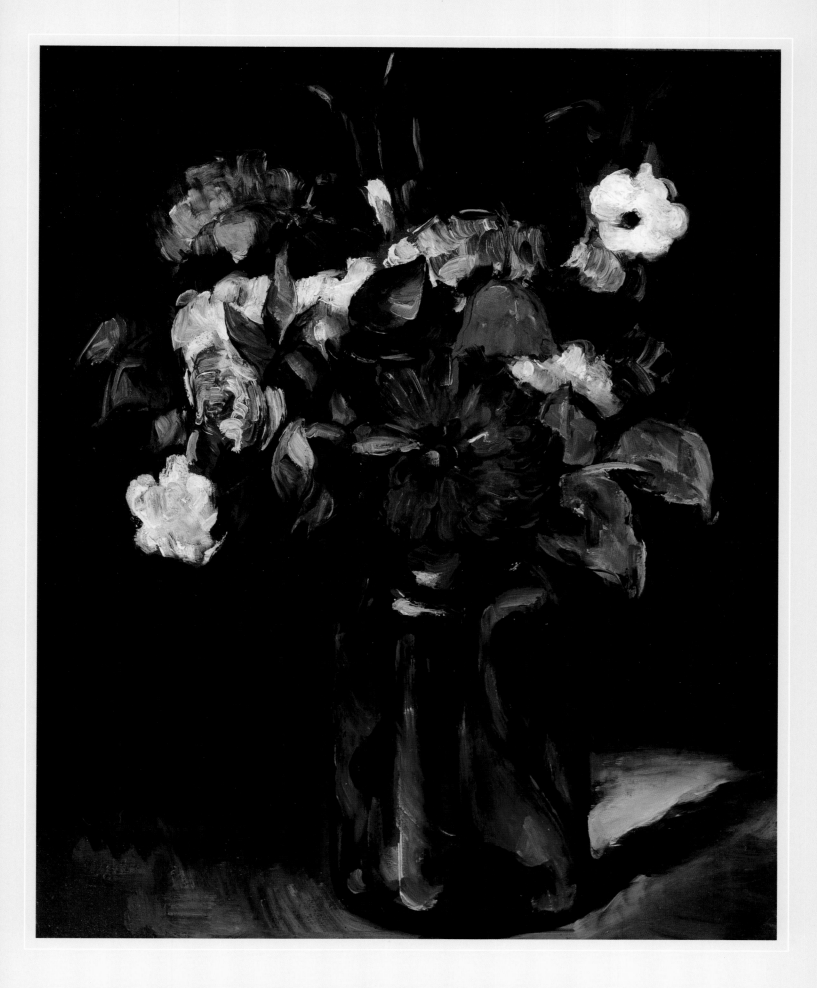

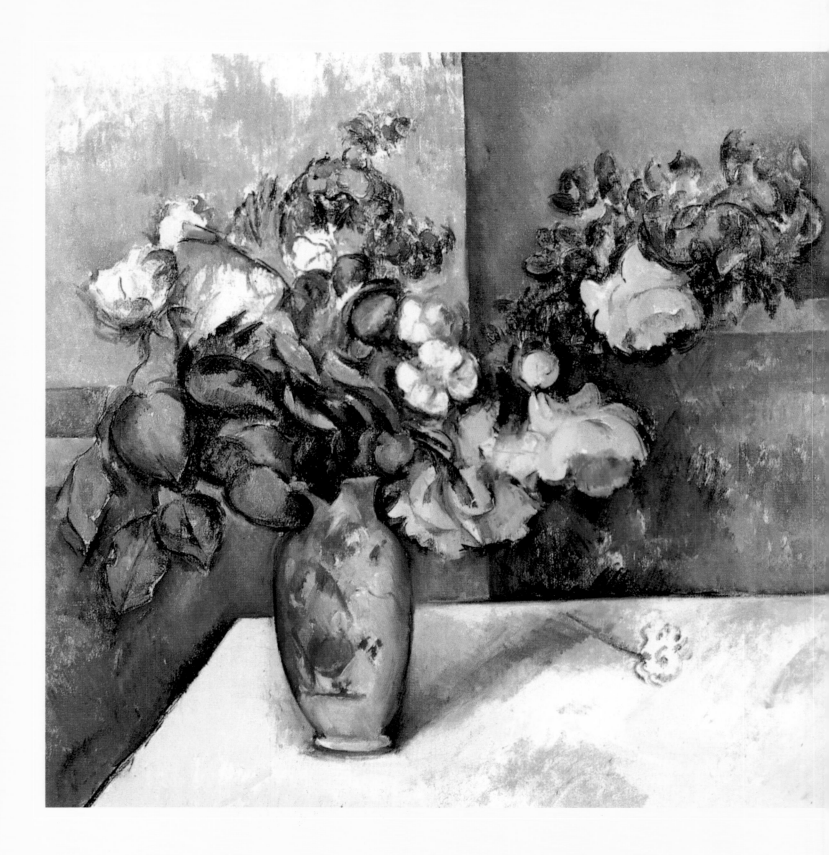

PAUL CÉZANNE
Flowers in a Vase, 1885–88
Oil on canvas, 18 1/4 x 21 7/8 inches
Private collection

Carnation *Iris* *Rose*

PAUL CÉZANNE

Vase of Flowers, 1900/1903

Oil on canvas, 39 3/4 x 32 1/4 inches

National Gallery of Art, Washington, D.C.

Gift of Eugene and Agnes E. Meyer

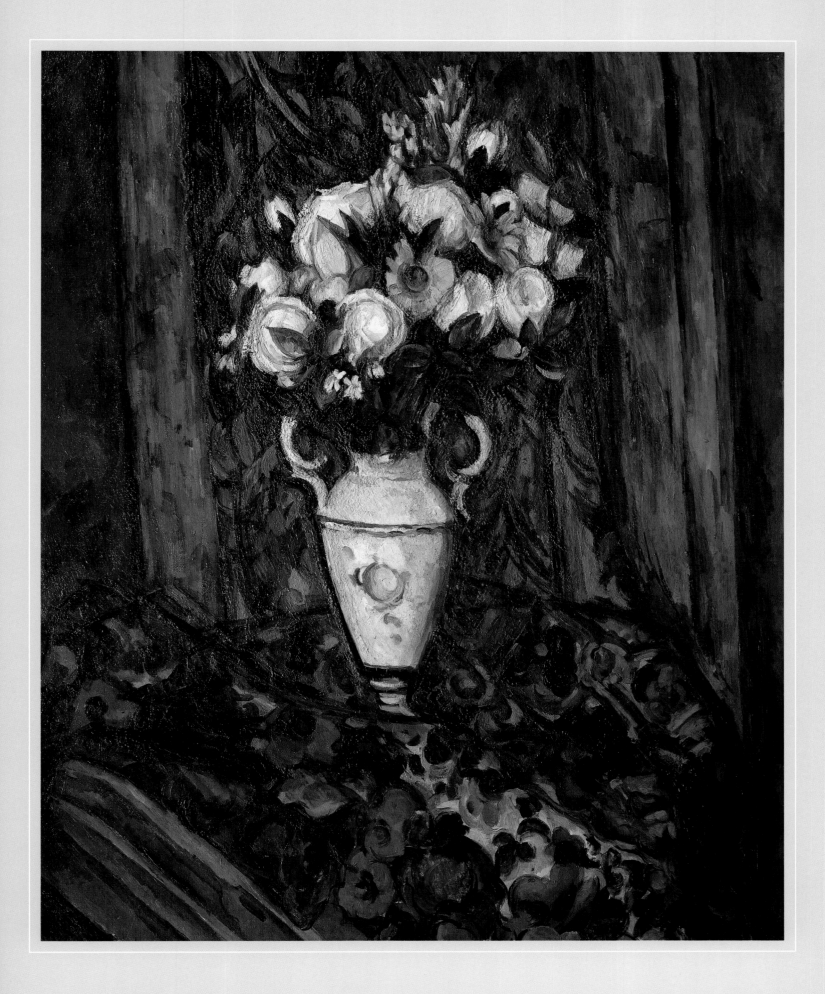

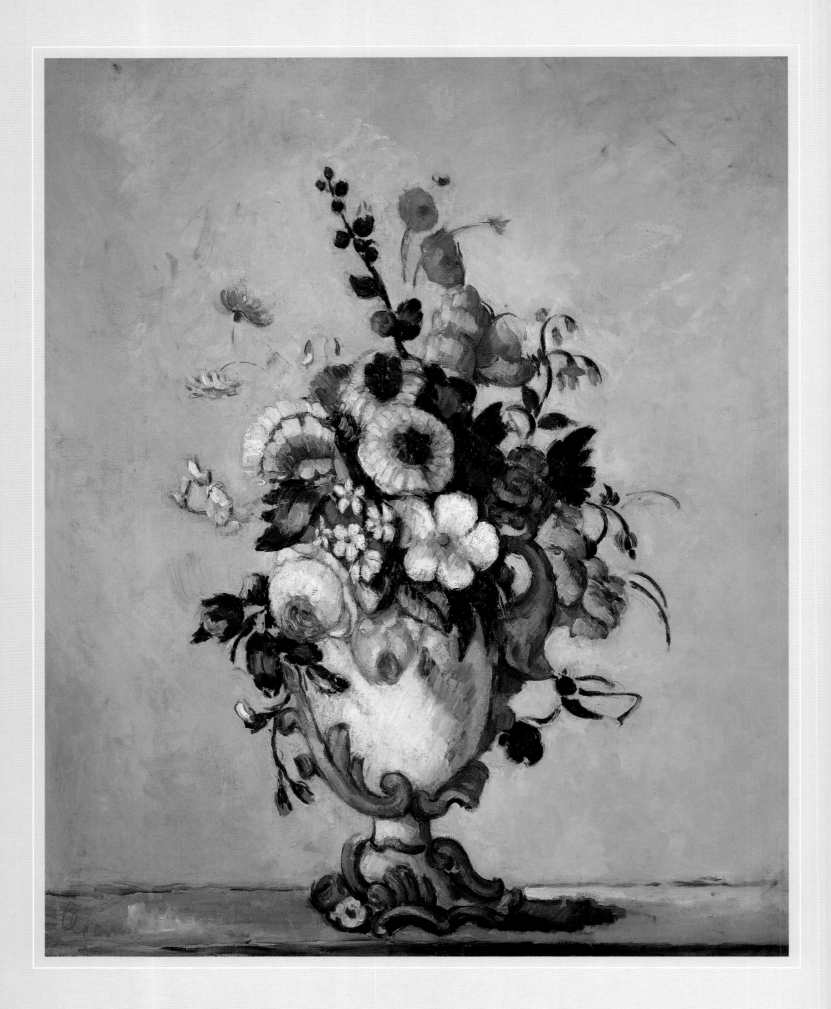

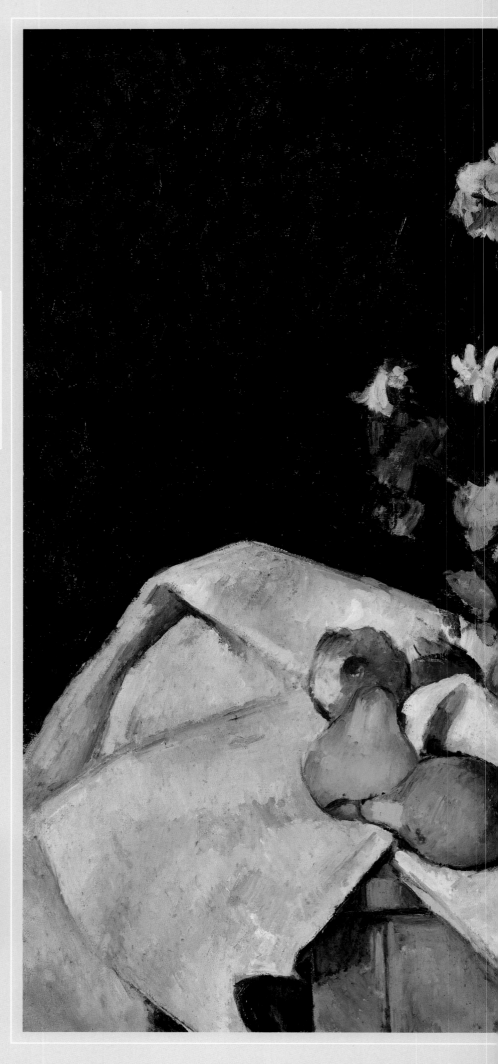

PAUL CÉZANNE

Still Life with Flowers and Fruit, c. 1888–90
Oil on canvas, 26 x 32 1/8 inches
National Gallery, Berlin
© Bildarchiv Preussischer Kulturbesitz, Berlin

Daisy

Poppy

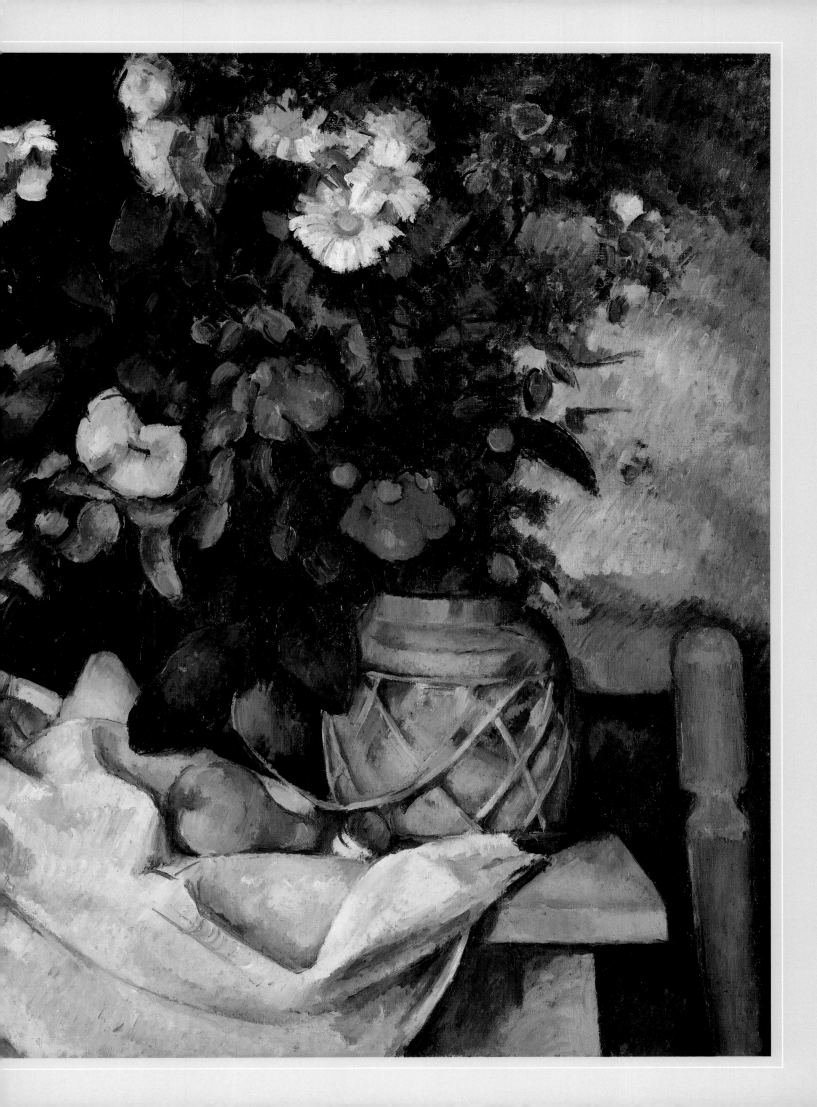

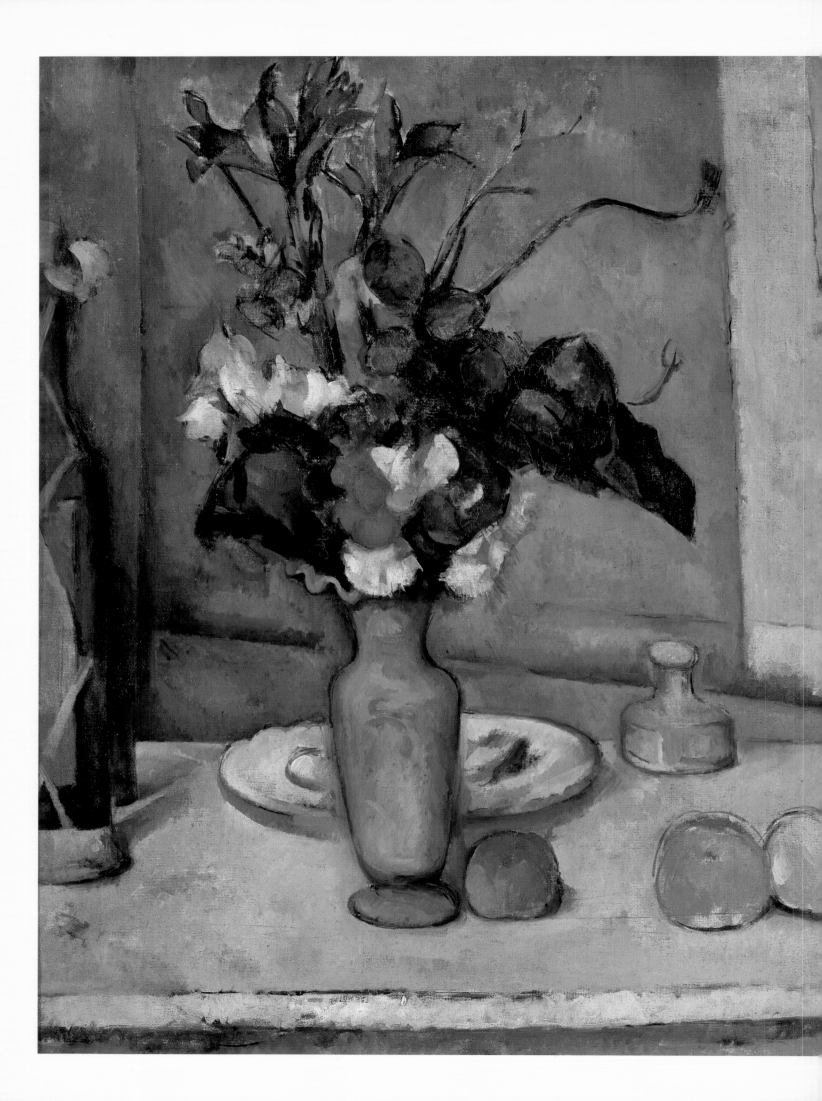

PAUL CÉZANNE

The Blue Vase, C. 1885–87

Oil on canvas, 24 X 18 3/4 inches

Musée d'Orsay, Paris

Bequest of Count Isaac de Camondo

Courtesy Art Resource, New York

Paul Gauguin

was born in Paris in 1848. His father was a French journalist, his mother a Peruvian Spaniard. After Louis Napoleon declared himself emperor, in 1851, the Gauguins fled to Peru. The father died on the voyage, and the family spent four difficult years in Lima, returning to France in 1855 and settling in Orléans. At the age of seventeen Gauguin entered the merchant marine as a pilot's apprentice and made a voyage to Rio de Janeiro. In 1871, after three years in the navy, he got a job with a Parisian stockbrokerage firm. Two years later, enjoying prosperity, he married a Danish woman.

About 1874 Gauguin began to paint on Sundays. He soon met Pissarro, who introduced him to the other Impressionists. He spent the summer of 1879 working with Pissarro in Pontoise, and two years later began his regular participation in the Impressionist exhibitions.

In 1883 Gauguin suddenly quit his job and announced that he would dedicate himself to painting. Soon after moving to Copenhagen, he quarreled with his wife and returned without her to Paris, where he met Degas and van Gogh. In 1887 he worked for a month as laborer on Ferdinand de Lessep's abortive Panama canal and then went to Martinique. After making his way back to Paris, he went to Brittany the following year, where he spent some months in Pont-Aven and developed a style in which the mostly religious subjects were in constant tension with the flatness of the areas of color with which they were rendered. That fall he spent two months in Arles with van Gogh.

Because of the opportunities they provided for experimentation with expressionistic and coloristic abstraction, Gauguin was drawn to painting bouquets throughout his career. The most sumptuous are certainly those he painted of the exotic flowers of the South Seas, often placed in vases that he had made himself.

In 1891 Gauguin sailed for Tahiti, where he lived and worked productively for two years. After a trying stay in Paris, during which the Javanese woman with whom he was living stole all of his possessions, he returned to Tahiti in 1895. He painted some of his most important works there, despite poverty, illness, despair, and even a brief imprisonment for his protest against French treatment of the natives. He died in Tahiti in 1902.

PAUL GAUGUIN
Still Life, 1885
Oil on canvas, 25 5/8 x 22 7/8 inches
Private collection

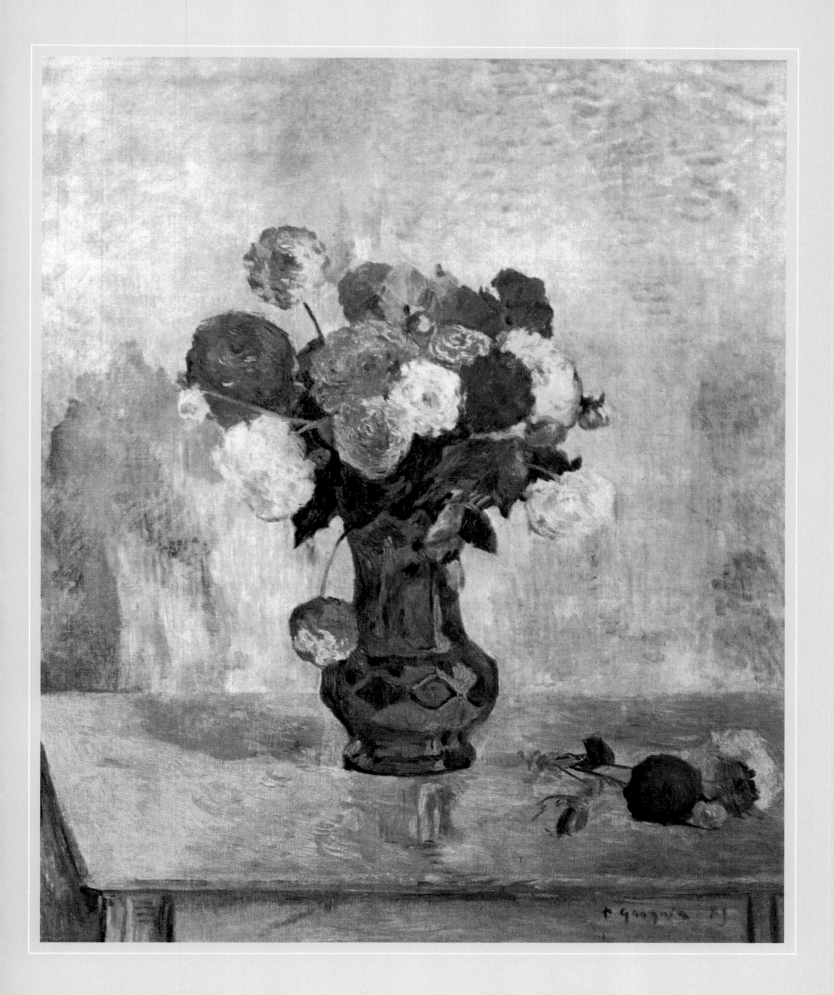

PAUL GAUGUIN

Flower-piece, 1896

Oil on canvas, 25 1/2 x 29 1/2 inches

© National Gallery, London

PAUL GAUGUIN

Still Life with Flowers, 1891

Oil on canvas, 37 1/4 x 24 1/2 inches

Private collection

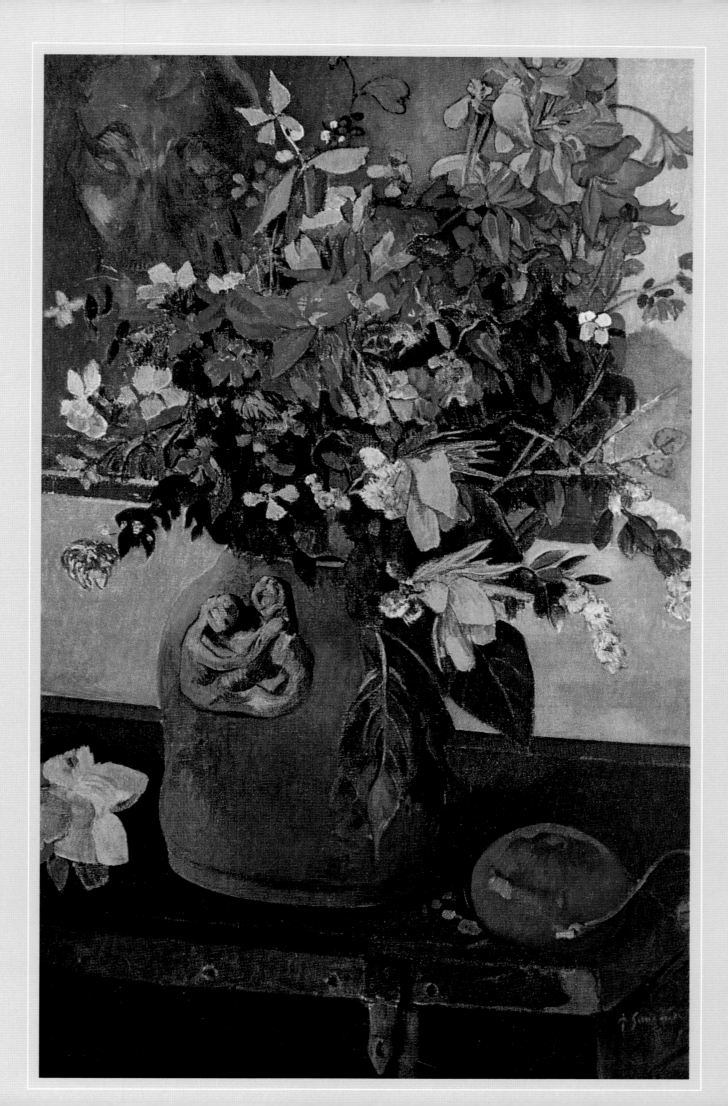

PAUL GAUGUIN
Still Life with Moss Roses in a Basket, 1886
Oil on canvas, 19 11/16 x 24 7/8 inches
Philadelphia Museum of Art
Bequest of Charlotte Dorrance Wright

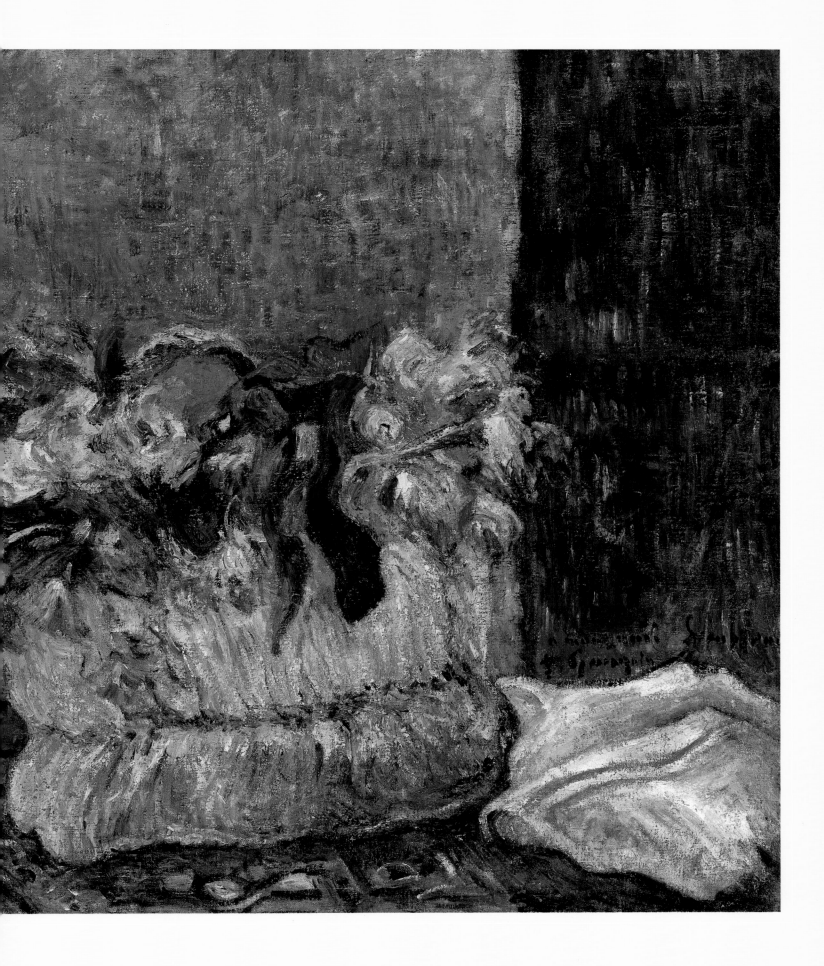

PAUL GAUGUIN

Still Life with Mandolin, 1885

Oil on canvas, 25 x 21 inches

Musée d'Orsay, Paris

Courtesy Art Resource, New York

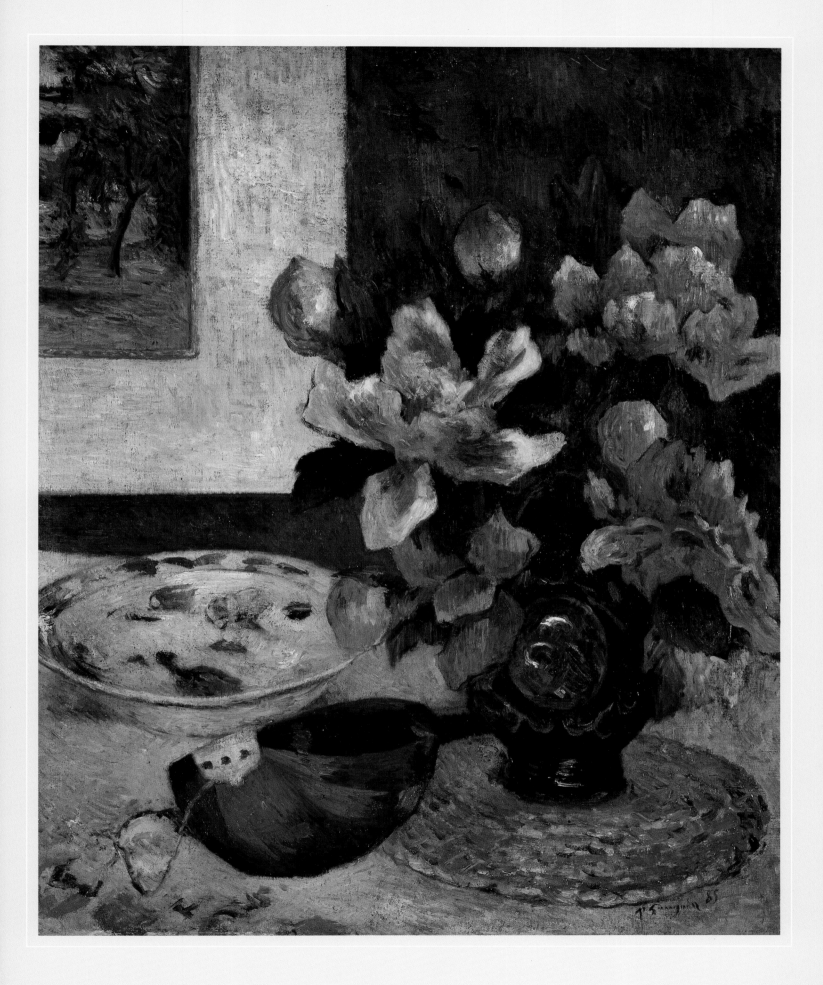

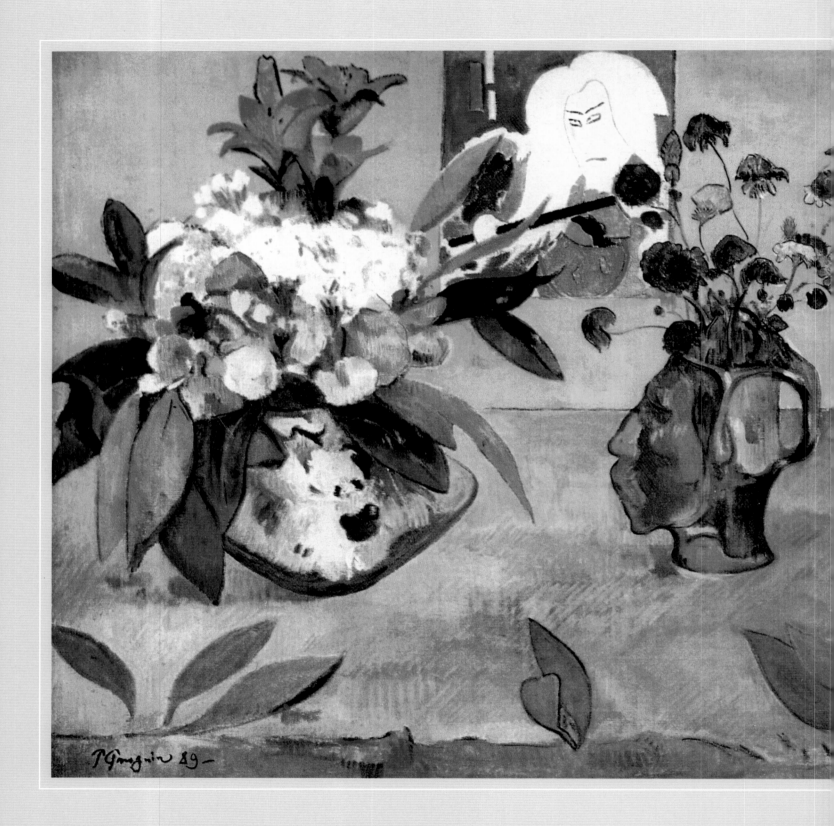

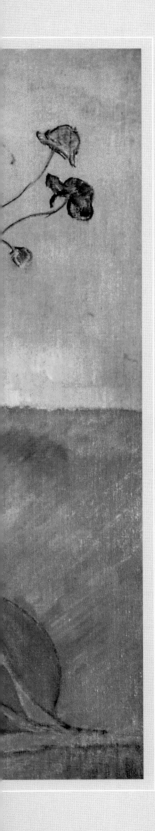

PAUL GAUGUIN

Still Life with Japanese Print, 1889

Oil on canvas, 28 1/2 x 36 1/2 inches

Collection unknown

Vincent van Gogh

was born in the southern part of the Netherlands, near the Belgian border, in 1853. He was the eldest of a Protestant pastor's six children. His brother Theo, who would play a vital role in his life, was born in 1857. At the age of sixteen Vincent was apprenticed to the Hague branch of the international art-dealing firm of Goupil and Company, in which one of his uncles was a partner. After four years in The Hague, he transferred to the firm's London branch for two years and then, in 1875 to its Paris headquarters for a year. His increasing obsession with religion diminished his diligence at work and led to his dismissal.

Having decided to become a minister, Vincent moved to Amsterdam in 1877 to prepare for the university entrance examinations. After a year he was so discouraged by this preparatory work that he left for Brussels, where he took a three-month course in missionary work. He spent that winter as a lay-evangelist in the coal mining district of the Borinage, in southern Belgium, where the desperate poverty of the miners moved him to give away his belongings, and even most of his clothes. He was dismissed for taking Christ's teachings too literally.

In despair during the summer of 1880, Vincent turned to drawing and decided that his true vocation was to awaken humanity to the divine through art. Despite a few months of instruction at the academy in Brussels and an equally brief period working with the well-known Dutch landscape painter Anton Mauve, to whom he was related, van Gogh was essen-tially self-taught, copying the works of Millet and painting from nature.

In 1886 he went to Paris, where his brother Theo worked for Goupil's; there he was inspired by the Impressionists and by Japanese prints. It was at that time that he painted the first of his many floral still lifes, the most exuberant being *Vase with Poppies, Cornflowers, Peonies, and Chrysanthemums*.

Astoundingly, van Gogh did most of the work for which he is best remembered during a period of two and a half years. His epiphanic and pantheistic style blossomed in the intense light of the Provençal city of Arles, where he settled in February 1888. It was there that he painted his great series of sunflowers. In May 1889 the deterioration of his mental health—which had brought about the ear-cutting incident during an extended visit from Gauguin—led him to commit himself to the asylum in nearby Saint-Rémy. There he painted not only the hospital's beautiful garden but also magnificent bouquets, first of irises and later of roses. After a year in Saint-Rémy, van Gogh returned to Paris and settled in nearby Auvers-sur-Oise for treatment by a homeopathic doctor. Lonely, frustrated by the unsaleability of his work, fearing that his mental condition was incurable, and feeling guilty about his financial dependence on Theo, who now had a wife and child, van Gogh shot himself on July 27, 1890, and died two days later. Only six months afterward, Theo died of chronic nephritis.

VINCENT VAN GOGH

Still Life: Vase with Fourteen Sunflowers

Arles, January 1889

Oil on canvas, 37 1/2 x 28 3/4 inches

Van Gogh Museum (Vincent van Gogh Foundation)

Amsterdam, the Netherlands

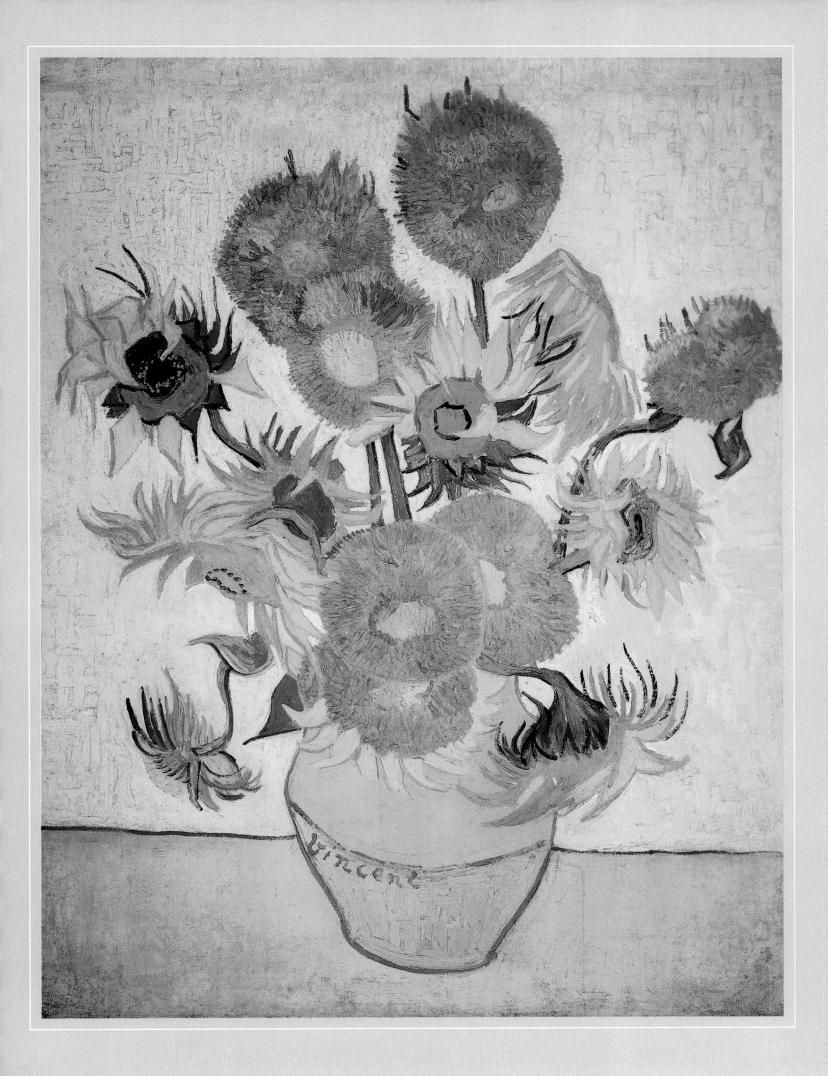

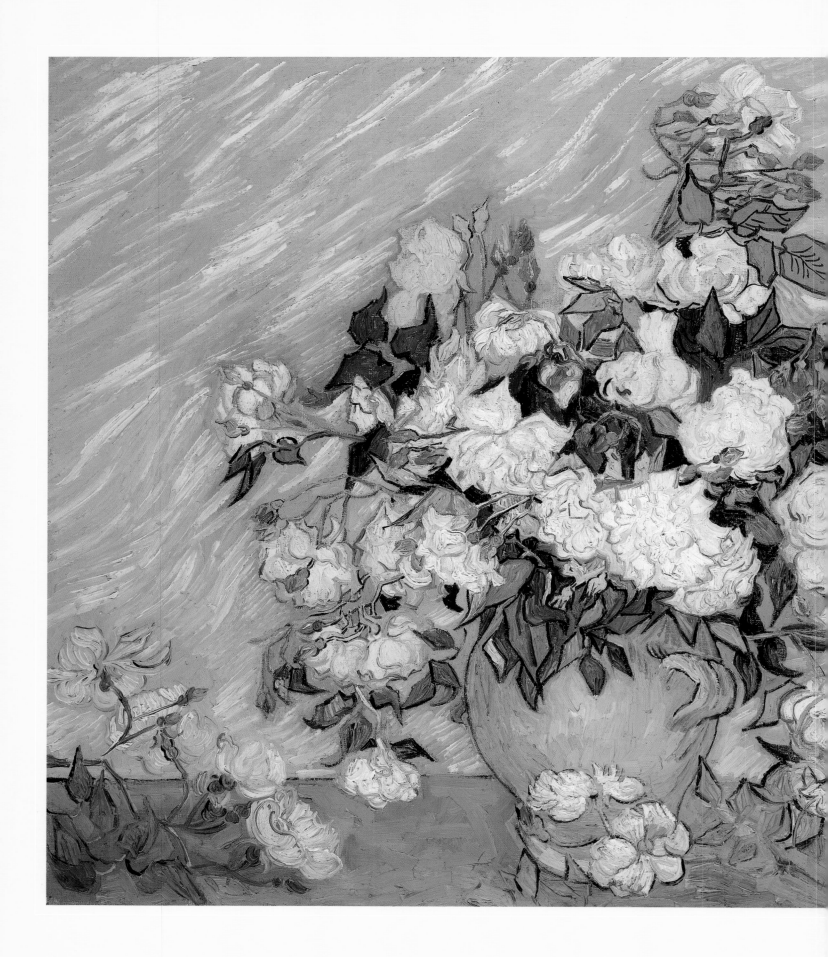

VINCENT VAN GOGH
White Roses, 1890
Oil on canvas, 28 x 36 1/2 inches
National Gallery of Art, Wahington
Gift of Pamela C. Harriman in memory of
Averell Harriman, and in Honor of the 50th Anniversary
of the National Gallery of Art

VINCENT VAN GOGH

Vase with Poppies, Cornflowers, Peonies, and Daisies, 1886
Oil on canvas, 39 x 31 1/8 inches
Kröller-Müller Museum,
Otterlo, The Netherlands

Cornflower *Daisy*

Peony *Poppy*

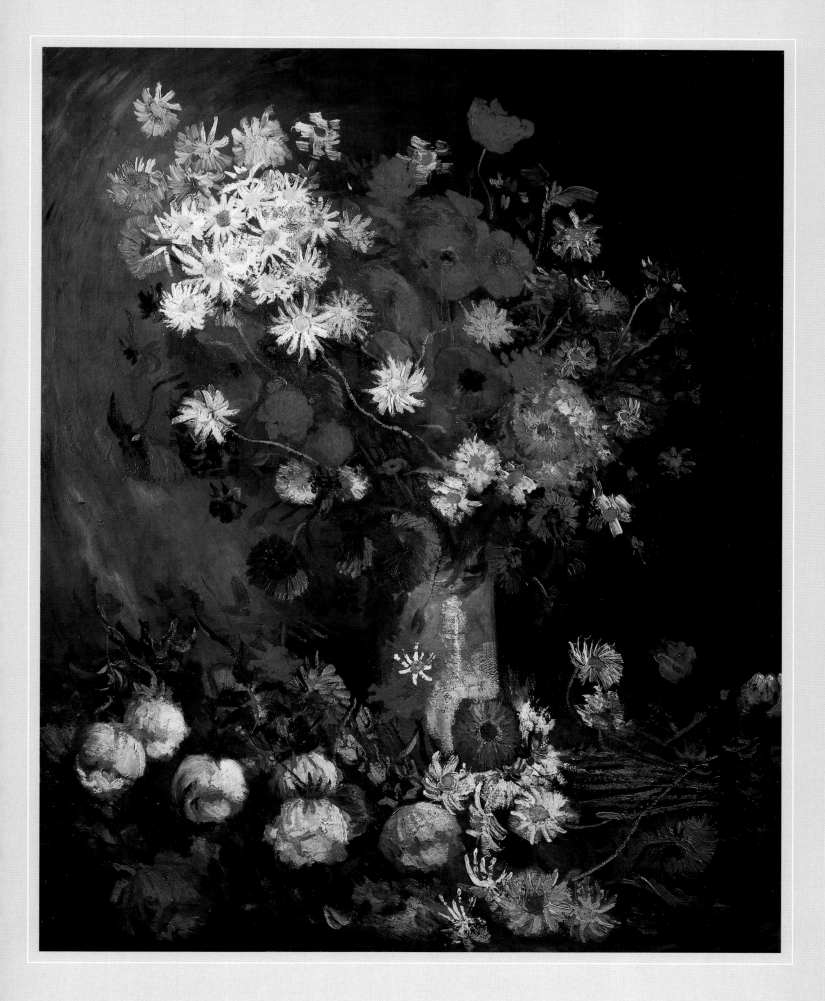

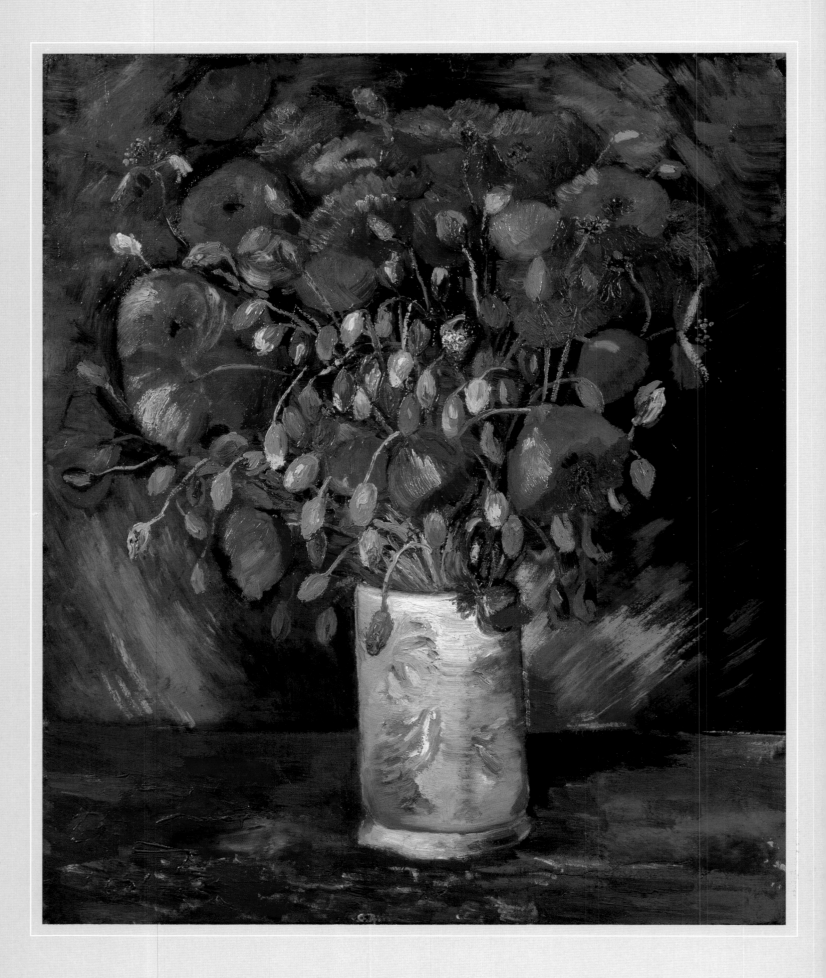

VINCENT VAN GOGH

Poppies, 1886–1887

Oil on canvas, 21 1/2 x 18 3/4 inches

Wadsworth Atheneum, Hartford, Connecticut

Bequest of Anne Parrish Titzell

VINCENT VAN GOGH

Daisies and Anemones in a Blue Vase, 1887

Oil on canvas, 24 x 15 inches

Kröller-Müller Museum,

Otterlo, The Netherlands

Anemone

Daisy

Daisy

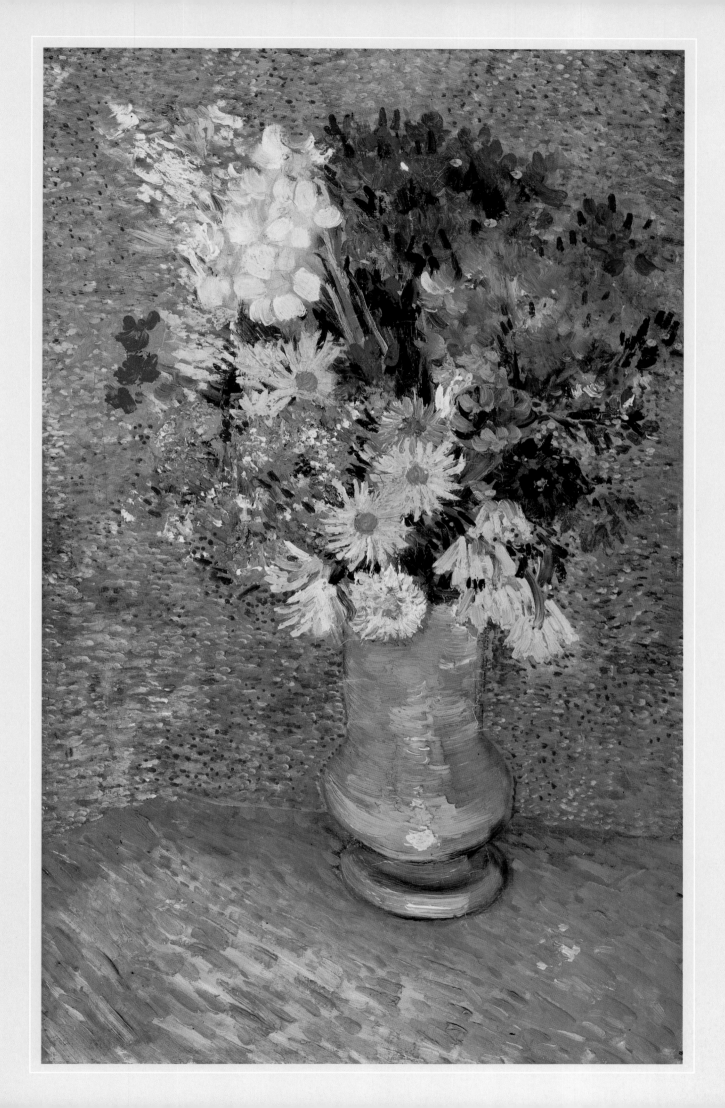

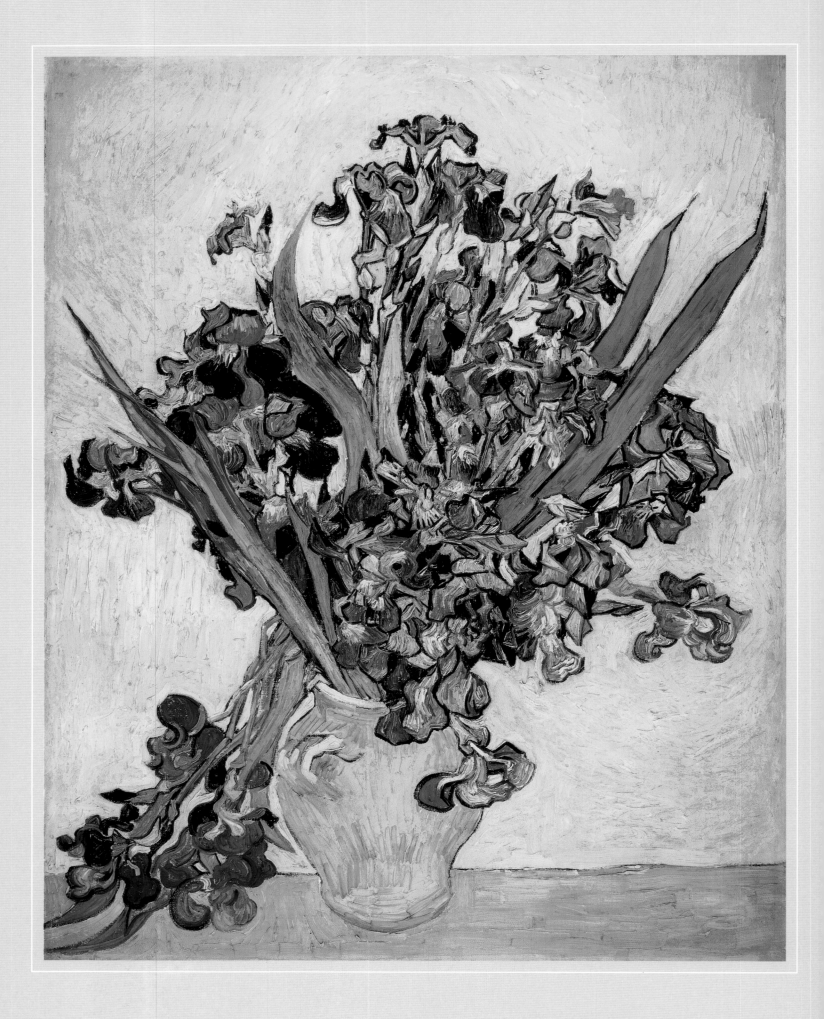

VINCENT VAN GOGH

Still Life: Vase with Irises against a Yellow Background, 1890

Oil on canvas, 37 x 29 1/2 inches

Van Gogh Museum (Vincent van Gogh Foundation),

Amsterdam, The Netherlands

VINCENT VAN GOGH

Imperial Crown Fritillaria in a Copper Vase, 1887

Oil on canvas, 28 3/4 x 23 3/4 inches

Musée d'Orsay, Paris

Bequest of Count Isaac de Camondo

Courtesy Art Resource, New York

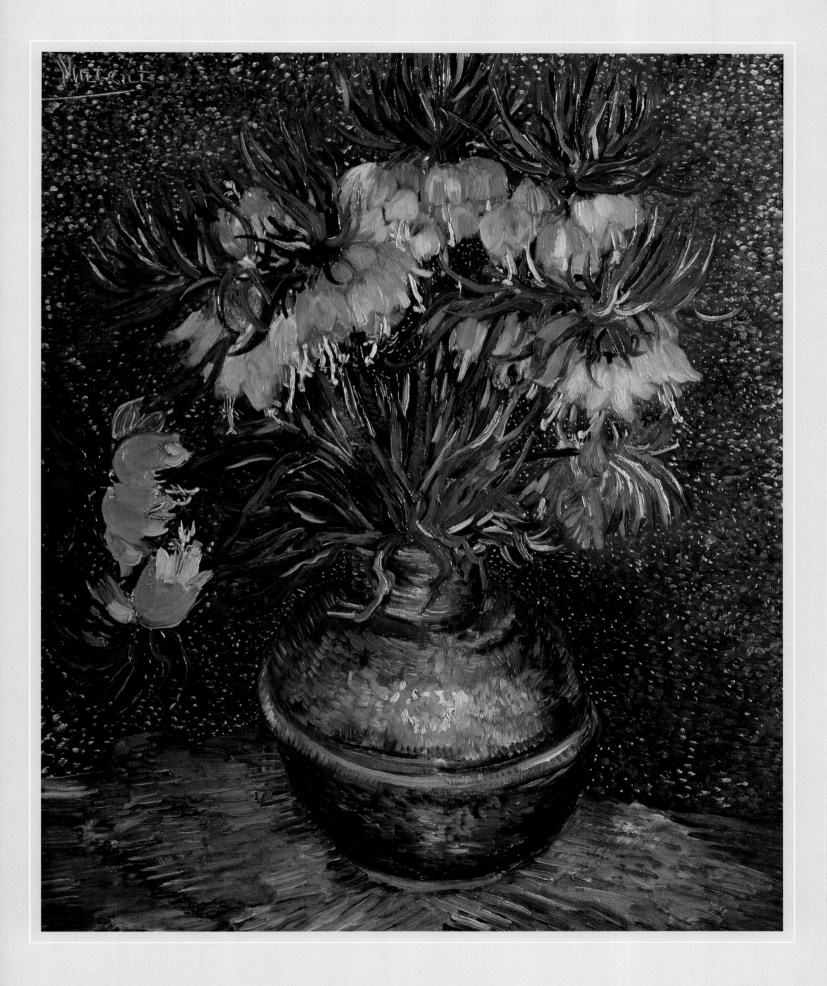

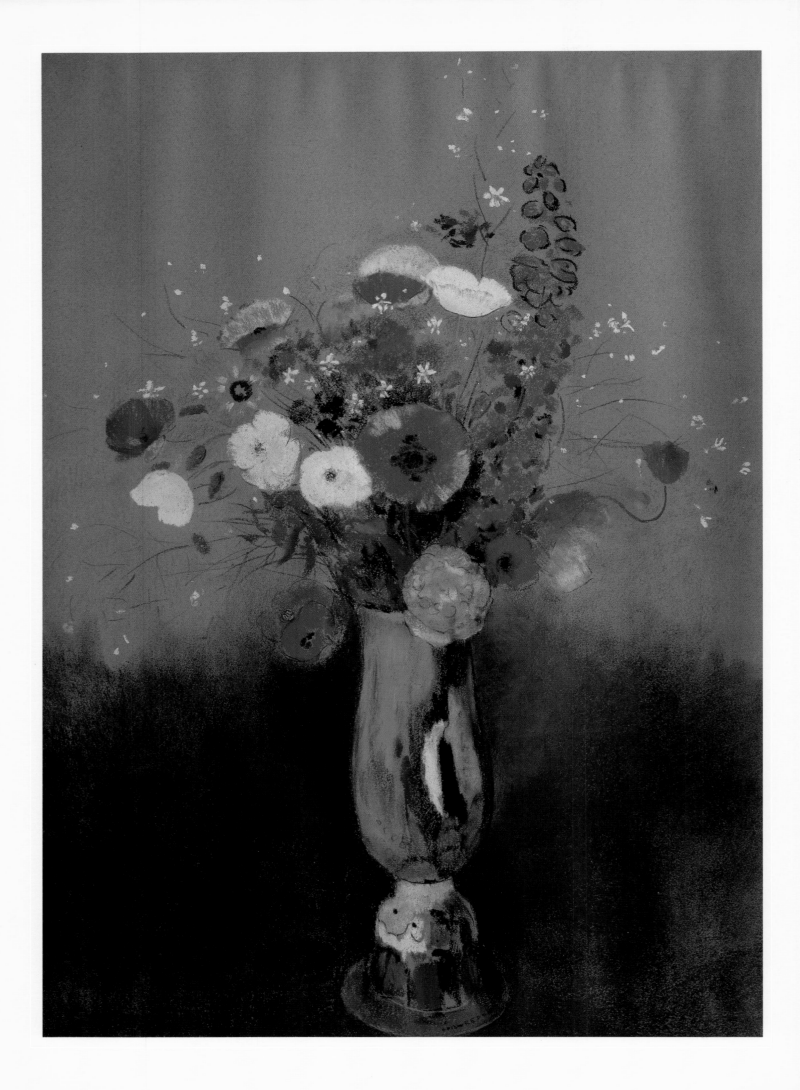

Odilon Redon

was born in Bordeaux in 1840, the son of a modest wine-grower. The rather frail child was a solitary dreamer who turned to drawing in order to enter more fully into the world of his fantasies. In 1862 Redon went to Paris to enroll in the architectural program at the Ecole des Beaux-Arts but did not pass the entrance examination. He then decided to cultivate seriously his talent for painting and in 1864 began life-drawing classes under the prominent history-painter Jean Léon Gérôme. These proved to be torture for the young Romantic, as the unyielding Realist insisted upon academic rigor. In the fall of 1865 Redon returned to Bordeaux.

There he met a new neighbor, Rodolphe Bresdin, a visionary etcher and lithographer, whose plates are filled with almost pathologically obsessive richness of detail. Bresdin initiated the young man into the mysteries of the graphic media, for which the poetic dreamer's temperament was well suited. It is ironic that Redon, whom we celebrate here for his chromatically dazzling bouquets, was distinguished during the first several decades of his career for his masterfully atmospheric use of black, especially in his haunting illustrations for Shakespeare, Baudelaire, Flaubert, and Edgar Allan Poe.

Redon disdained Impressionism as misguidedly bound to observable reality. In his opinion the entire point of painting was to make visible worlds, visions, and thoughts that would otherwise be inaccessible.

During the last decades of the nineteenth century Redon's family finances were devastated by the phylloxera epidemic that ravaged French vines. It was then partly out of a need to make money that Redon turned, about 1900, to making hundreds of floral still lifes in oil and pastel. He and his wife rented a house with a garden in the Parisian suburb of Bièvres, and cut flowers from it became his subjects, often arranged in richly glazed ceramic vases made by his friend Marie Botkin. Eschewing the realism of his old acquaintance Fantin-Latour, Redon sought to paint his bouquets as if he had seen them in a vivid dream.

Redon's work became very popular—so much so that he was represented by more paintings than anyone else in the famous Armory Show held in New York in 1913, and many of his paintings were bought by an eager public. Redon died in Paris in 1916.

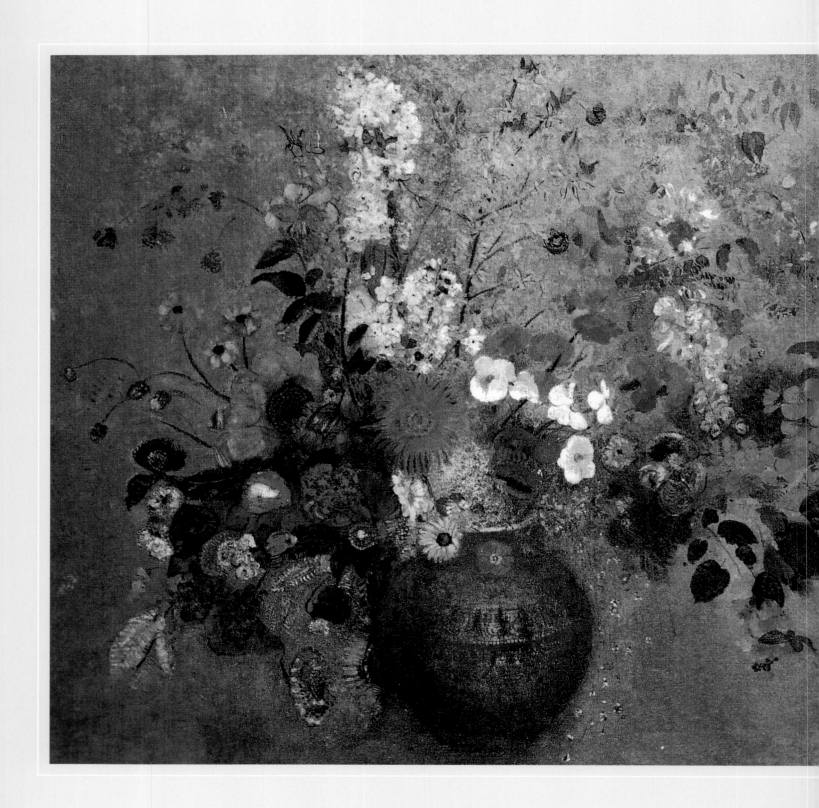

ODILON REDON

Flowers, 1909
Oil on canvas, 32 x 39 1/2 inches
Private collection

Anemone *Carnation* *Cherry*

Forsythia *Narcissus* *Poppy*

Anemone *Daisy* *Rose*

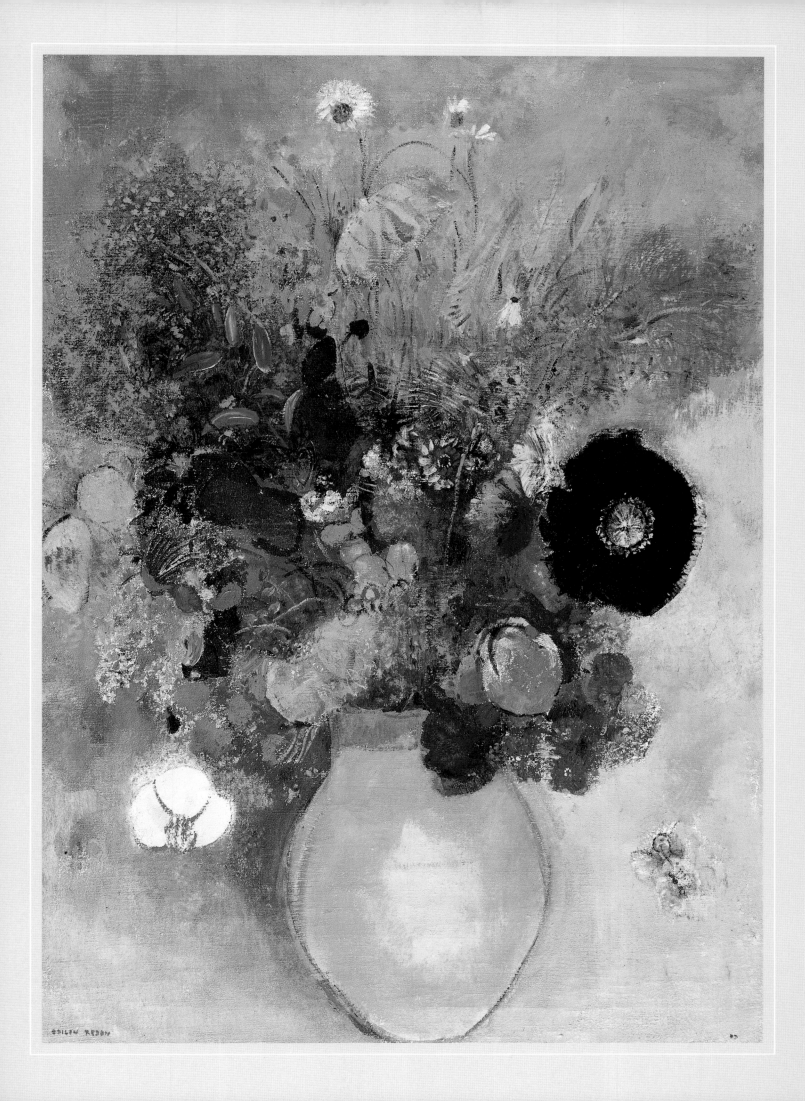

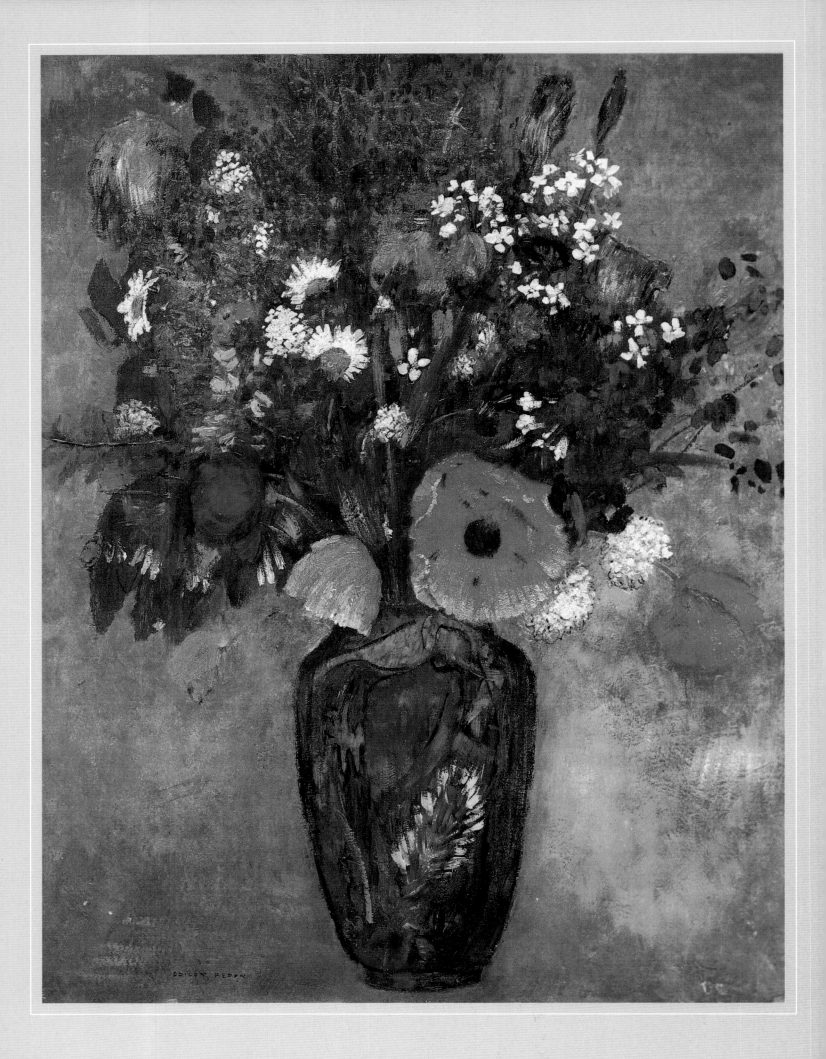

ODILON REDON

Bouquet of Flowers in a Vase, N.D.
Oil on board laid down on cradled panel,
27 1/2 X 21 1/8 inches
Private collection
Courtesy Christie's Images

Daisy

Iris

Mustard

Poppy

ODILON REDON

Vase of Flowers, 1914

Pastel on paper, 28 3/4 x 21 1/8 inches

The Museum of Modern Art, New York

William S. Paley Collection

Photograph © 1998 The Museum of Modern Art

Black-eyed Susan

Cornflower

Daisy

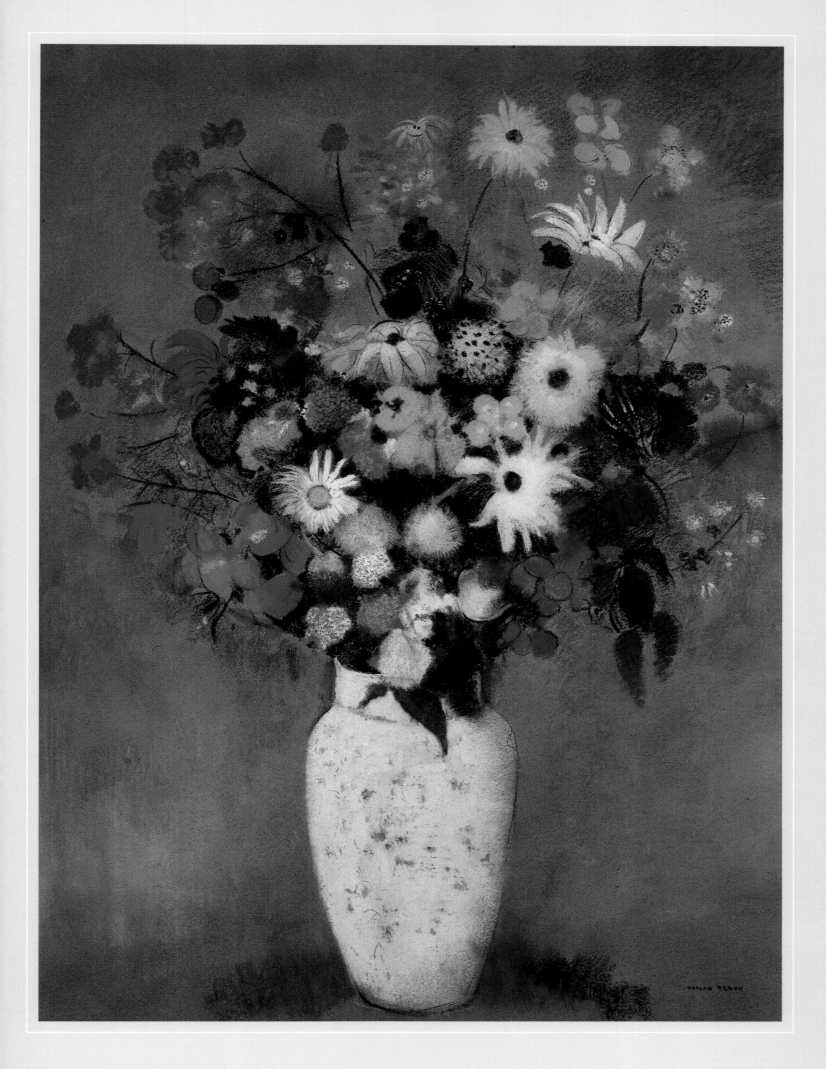

Pierre Bonnard

was born in a Parisian suburb in 1867. At his father's insistence he studied law but simultaneously attended the Ecole des Beaux-Arts. In 1887, after failing to win the Prix de Rome, he transferred to the Académie Julian, where he met Edouard Vuillard, Maurice Denis, Paul Sérusier, and Félix Vallotton. The following year he received his law degree and joined with his friends to form the Nabi group, taking the name from the Hebrew word for "prophet." An exhibition of Japanese prints in 1890 took the work of the rather timid and myopic young artist in the direction of daring graphic exaggeration. His finest accomplishments during the 1890s were superb and highly innovative book illustrations, posters, and decorative panels.

In 1893 Bonnard met a woman who introduced herself as Marthe de Méligny, but who had been born Maria Boursin. She became his model and his companion; the eroticism and domesticity of their life together would provide Bonnard with subject matter for decades to come. For the next seventeen years he painted nudes, portraits, interiors, and family scenes, enjoying a measure of success.

The great divide in Bonnard's work came in 1910 with his first visit to the Riviera, whose brilliant light and shimmering colors utterly transformed his palette. He did not, however, settle there at once, instead buying a house in Normandy. There he was forced to turn ever more inward, as the increasingly paranoid and demanding Marthe strove to isolate him from his friends. Having painted a few bouquets early in his career, Bonnard now returned occasionally to that subject during this difficult period. Surely the greatest of these works is the *Interior with Flowers* painted in 1919; it not only conveys a vivid sense of a radiant room but also approaches abstraction, as the actual bouquet merges with the floral wallpaper, and the forms tend to become simply areas of color.

In 1925 Bonnard married Marthe, and the following year they bought a house at Le Cannet, on the Riviera, where they would live without interruption until Marthe's death, in 1942. At Le Cannet, Bonnard embarked on his great series of bathing nudes, and he continued to paint luminous interiors, still lifes, and landscapes. He died there in 1947.

PIERRE BONNARD
Bouquet of Flowers, c. 1930
Oil on canvas, 27 5/8 x 18 5/8 inches
National Gallery of Art, Washington, D.C.
Ailsa Mellon Bruce Collection

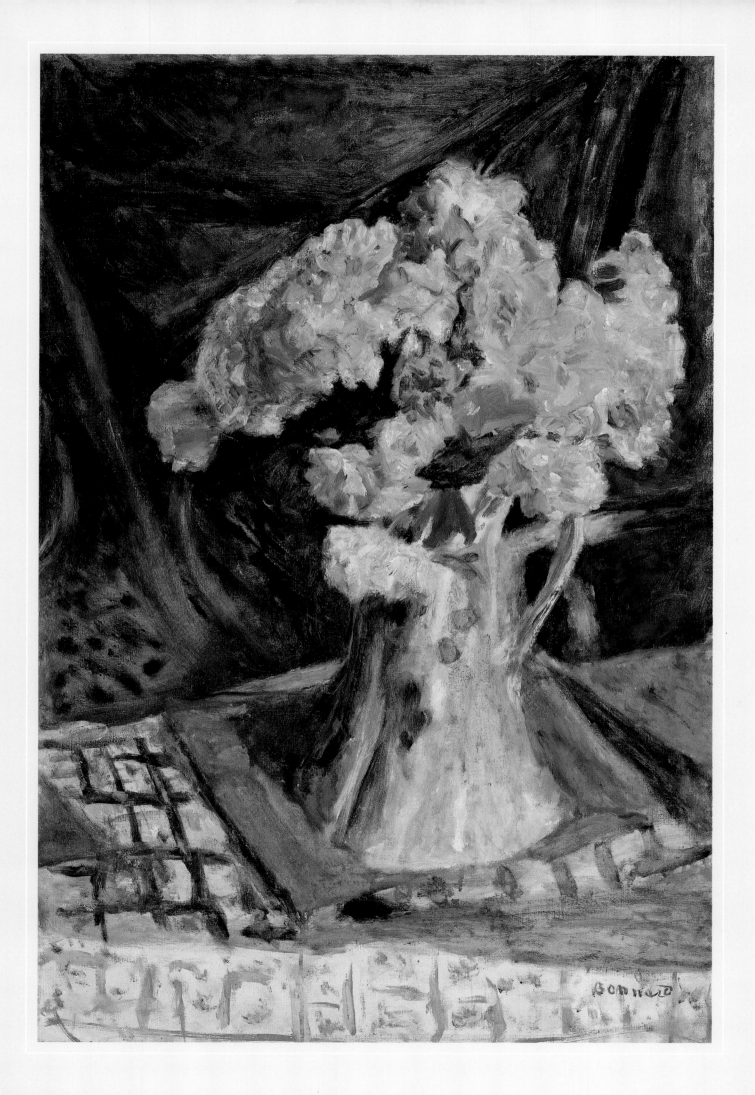

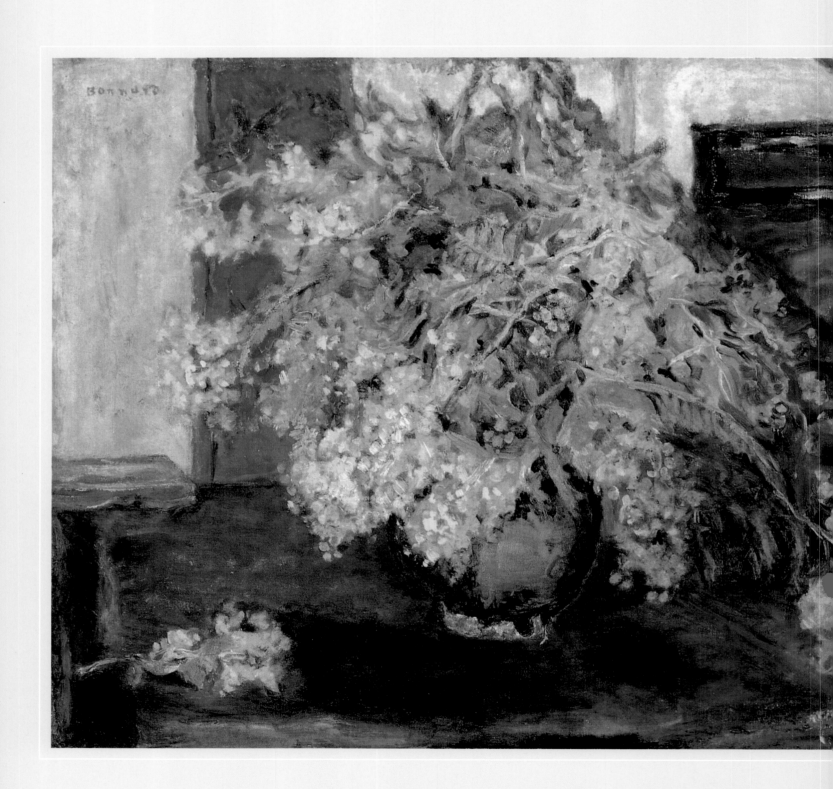

PIERRE BONNARD

Mimosas, 1915

Oil on canvas, 21 1/2 x 26 inches

Courtesy Christie's Images, New York

PIERRE BONNARD
Interior with Flowers, 1919
Oil on canvas, 45 3/4 x 35 1/8 inches
Private collection

Morning Glory

Poppy

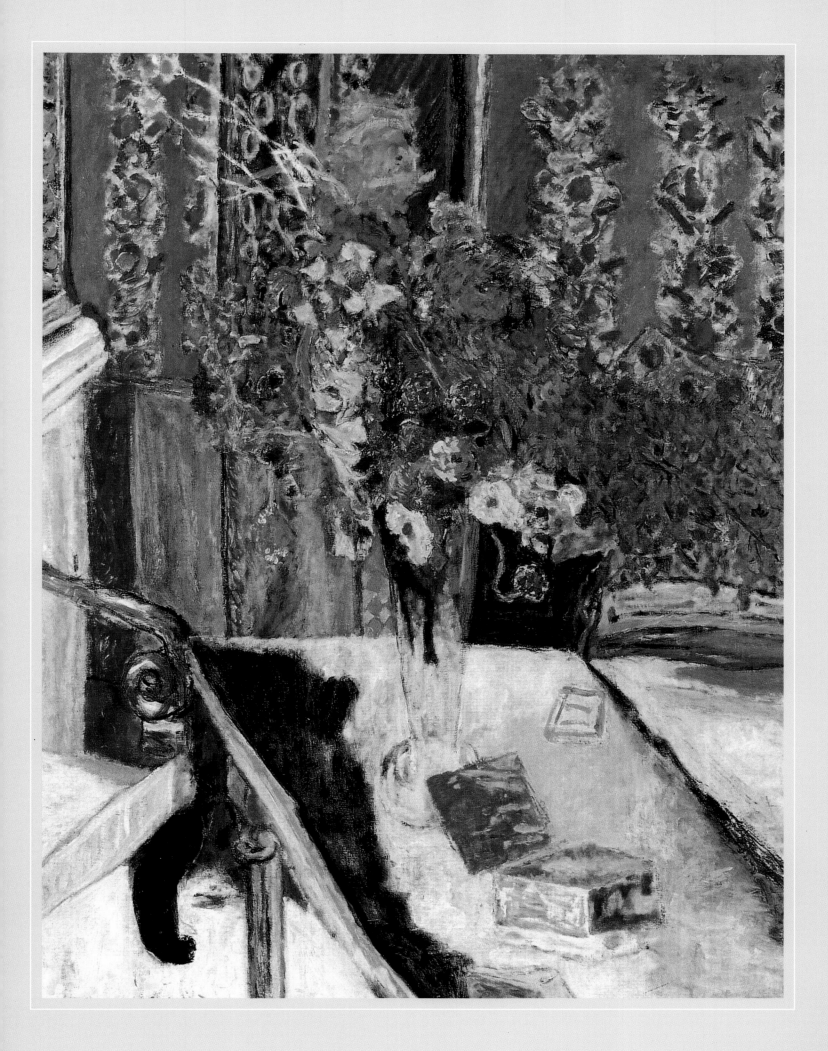

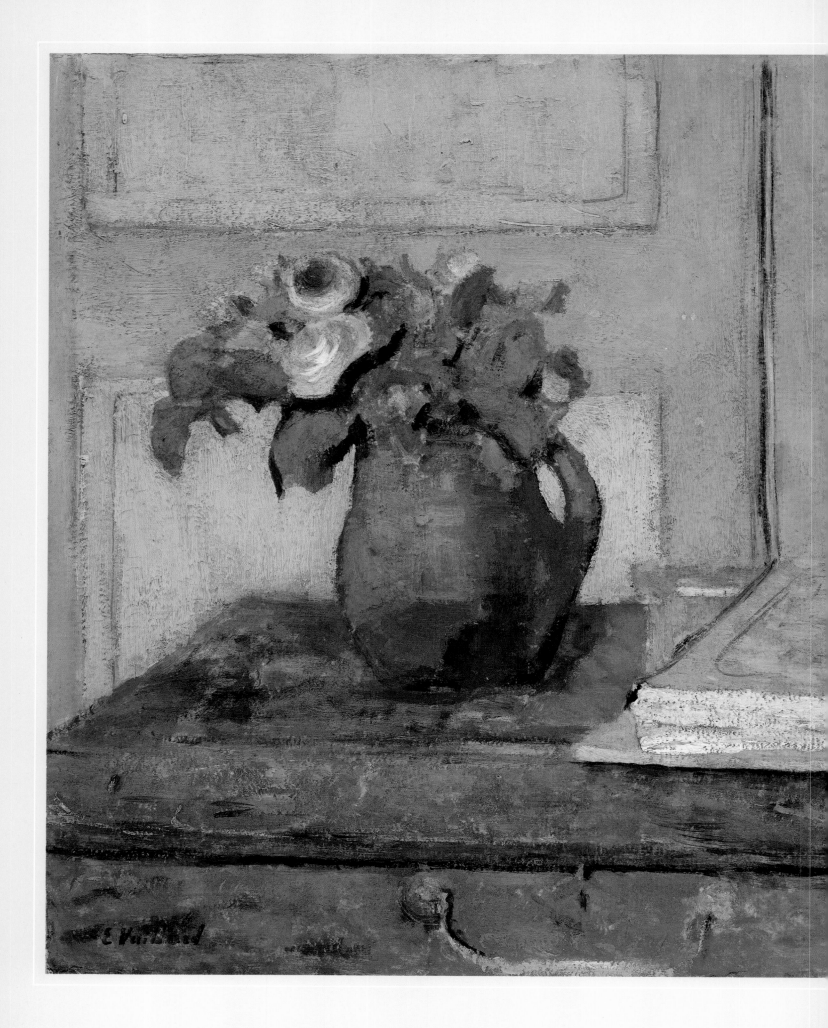

Edouard Vuillard

was born in the foothills of the Jura mountains in 1868. His father, a retired army officer, was the local tax collector. When Edouard was ten, the family moved to Paris, where he began attending the prestigious Lycée Condorcet. In 1884 Edouard's father died, leaving the family in financial distress. Madame Vuillard then began a corset-making business in their apartment. Edouard, who never married, would live with his mother, whom he called his muse, until her death, in 1928.

When Edouard was nineteen, his friend Ker-Xavier Roussel, who was soon to become his brother-in-law, convinced him to abandon his plan of enlisting in the army and instead to join him in cultivating their talents as painters. At the Académie Julian they met Pierre Bonnard and Paul Sérusier. The latter had just returned from working with Paul Gauguin at Pont-Aven, where the young man had painted, on a wooden cigar-box cover, a nearly abstract landscape that became known as the "Talisman." Maurice Denis—spokesman of the group to which Vuillard and Bonnard belonged, known as Nabis, from the Hebrew word for "prophet"—declared after seeing Sérusier's revolutionary masterpiece, "It must be recalled that a picture, before being a warhorse, a nude, or any other anecdote, is essentially a flat surface covered with colors arranged in a certain order." That manifesto liberated Vuillard to experiment throughout the 1890s with intimate paintings of interiors in which the complex interplay of layered patterns is often as important as capturing a moment of revealing domesticity.

Among the many artists with whom Vuillard was friendly were Toulouse-Lautrec and Redon. The latter's floral still lifes inspired the younger man around 1900 to paint a few bouquets himself. They could not have been more different from Redon's. Indeed, the almost Zen-like simplicity and concreteness of Vuillard's modest bouquets could be construed as a reproach to the great Symbolist's poetic extravagance.

After about 1905 Vuillard turned increasingly to high-society portraiture that does not live up to the promise of his early work. He lived a pleasant social and artistic life, often visiting wealthy friends and traveling with them, until his death in 1940.

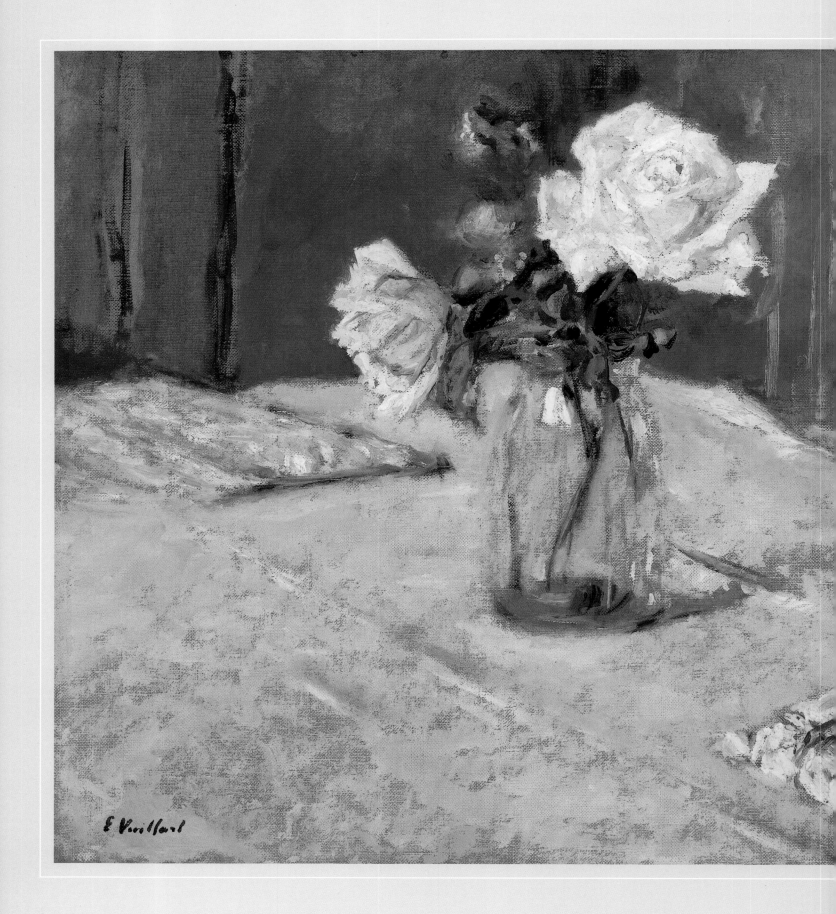

EDOUARD VUILLARD
Roses in a Glass Vase, c. 1919
Oil on canvas, 14 5/8 x 18 1/2 inches
Museum of Fine Arts, Boston
Bequest of Mrs. Edward Wheelwright, by exchange,
and Paintings Department Special Fund

Henri Rousseau

was born in Laval in 1844, the son of a tinsmith who declared bankruptcy seven years later. At the age of nineteen, having been an average student, Henri began working as a clerk in an attorney's office. After stealing a small sum of money, he enlisted in the army. Following his father's death, in 1868, he was granted a discharge in order to support his widowed mother. He then married and got a job as a bailiff's clerk. Three years later he began working as a bureaucrat for the Parisian toll-collection agency; it was on account of this position that he would become known as Le Douanier (the customshouse officer)—a misnomer, since his agency did not collect customs duties.

Rousseau took up the hobby of painting, and by the mid-1880s he was working in a style that made up in poetic mystery for whatever it lacked in conventional technical mastery. He soon came to take himself very seriously as an artist, and he first exhibited publicly at the Salon des Indépendants in 1886. Seven years later he retired from his job in order to devote himself entirely to painting. His canvases delighted many avant-garde artists, including Picasso; and sophisticated critics began to write appreciative articles about Rousseau.

Beginning in the 1890s, he painted a number of canvases depicting scenes set in a dense jungle. Rousseau, a man of great imagination, had never been outside France. He based the lush foliage and the disproportionately large flowers of his jungles on his observation of exotic plants at the botanical garden in Paris.

Not until the late 1890s did Rousseau paint an occasional still life, usually of flowers in a basket or vase. Many of them seem to have been based not on actual bouquets but on color plates illustrating books on the subject of "the language of flowers," popular works explaining the emotional and symbolic associations of each variety of flower. One of Rousseau's favorite flowers was the pansy (seen at the bottom center of his *Bouquet of Flowers* in the Tate), his love for it probably due in part to its name in French: pensée (thought).

In 1907 the painter was drawn marginally into an attempt to swindle the Banque de France. He was arrested along with the other conspirators and imprisoned for several weeks, but he was at liberty during the long trial, at the end of which he was given a two-year suspended sentence. The episode broke Rousseau's health, and despite the spirited friendship and acclaim of the avant-garde, he declined quickly. He died in September 1910.

HENRI ROUSSEAU
Bouquet of Flowers, 1909–10
Oil on canvas, 24 x 19 1/2 inches
Tate Gallery, London
Courtesy Art Resource, New York

Mimosa

Zinnia

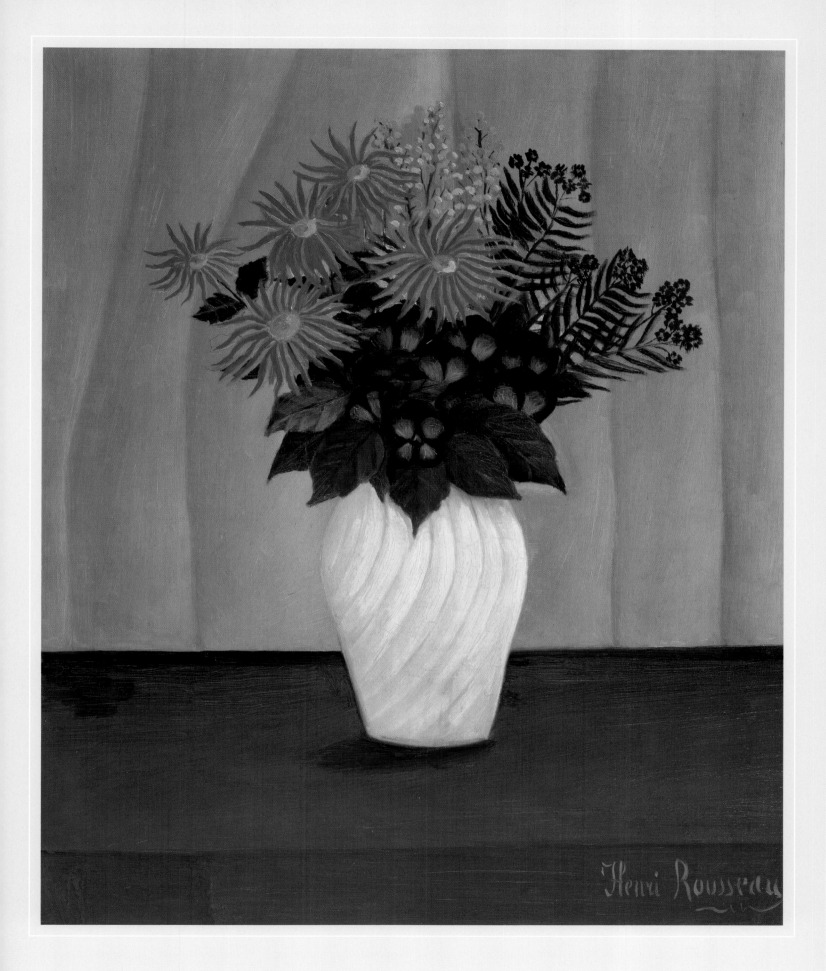

Henri Rousseau

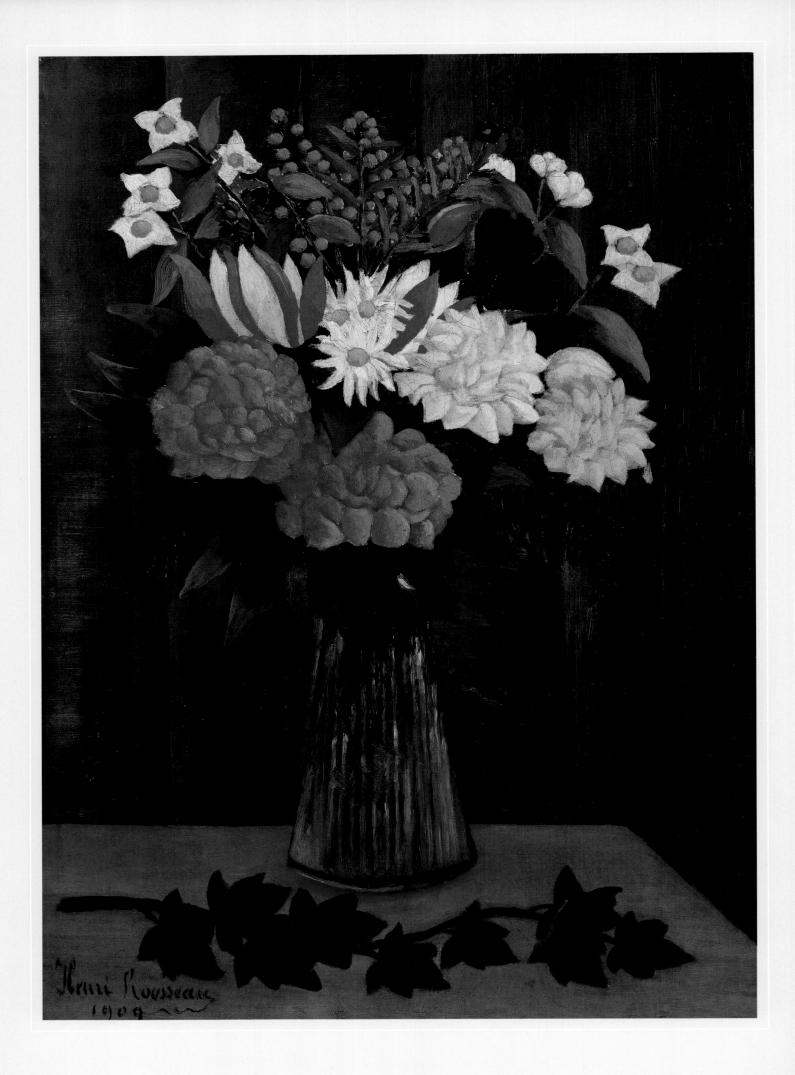

HENRI ROUSSEAU

Flowers in a Vase, 1909

Oil on canvas, 17 7/8 x 12 7/8 inches

Albright-Knox Art Gallery, Buffalo, New York

Room of Contemporary Art Fund (1939)

Daisy

Dogwood

Mountain Ash

Rose

Tulip

HENRI ROUSSEAU
Flowers in a Vase, c. 1909–10
Oil on canvas, 16 1/4 x 13 1/8 inches
Museum of Art, Rhode Island School of Design
Gift of Mrs. Murray S. Danforth
Photography by Erik Gould

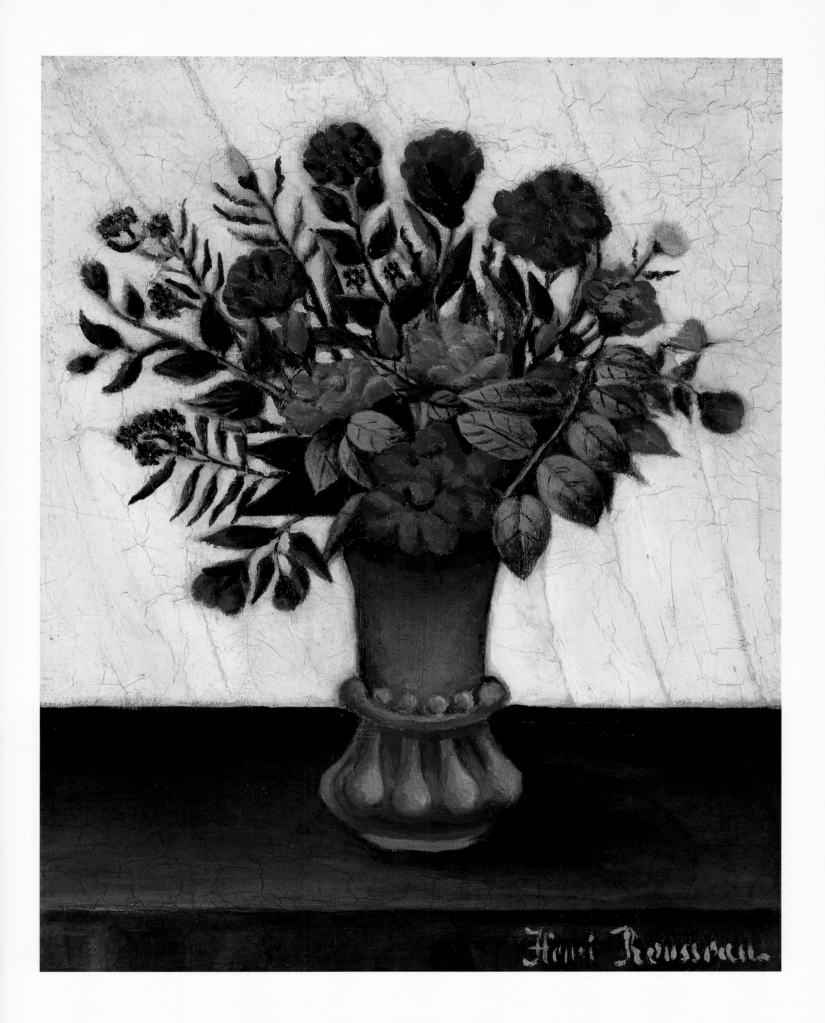

Paul Signac

was born in Paris in 1863, the son of a prosperous sadler who had a talent for drawing—and who detested Impressionism. This conservative bourgeois gentleman died in 1880, leaving Paul in the hands of his mother, who hoped he would become an architect. Having been inspired by the Impressionist group exhibition in 1879 and by Monet's solo show the following year, Signac embarked on a career as a painter. From the very beginning his landscapes were masterful.

In 1884 he participated in the Salon des Indépendants, met his fellow exhibitor Georges Seurat, and recognized as a work of genius his great painting of bathers along the Seine at Asnières. Soon, close friendship with Seurat drew Signac personally and artistically into the avant-garde. After seeing Seurat's painting *La Grande Jatte* he adopted its Pointillist style, working with discrete dots of color to create a scintillating luminosity. The two artists prided themselves on a scientific and mathematical approach to painting, in reaction against the intuitive methods of the Impressionists—and so they called themselves Neo-Impressionists.

The great difference between Signac and Seurat was temperamental. The latter was reserved, cerebral, and rather frail; he would die at the age of thirty-one, in 1891. Signac, on the other hand, was warmly outgoing, self-confident, and sturdy. He was a fundamentally happy man whose greatest passion, after painting, was sailing his seaworthy boat. His work is pervaded by a sense of joy that often seems to be straining to escape from the corset of Pointillism, to which he adhered perhaps out of loyalty to his departed friend. Once in a while, as in *Anemones* (about 1910) Signac's energy burst its bonds and erupted into a painterly and coloristic style closer to Fauvism than to Neo-Impressionism.

Signac enjoyed the comfortable life of an artist and yachtsman, sailing extensively around Europe and painting his ports of call, until his death, in 1935.

PAUL SIGNAC

Anemones, c. 1910

Oil on canvas,

Private collection

Courtesy Art Resource, New York

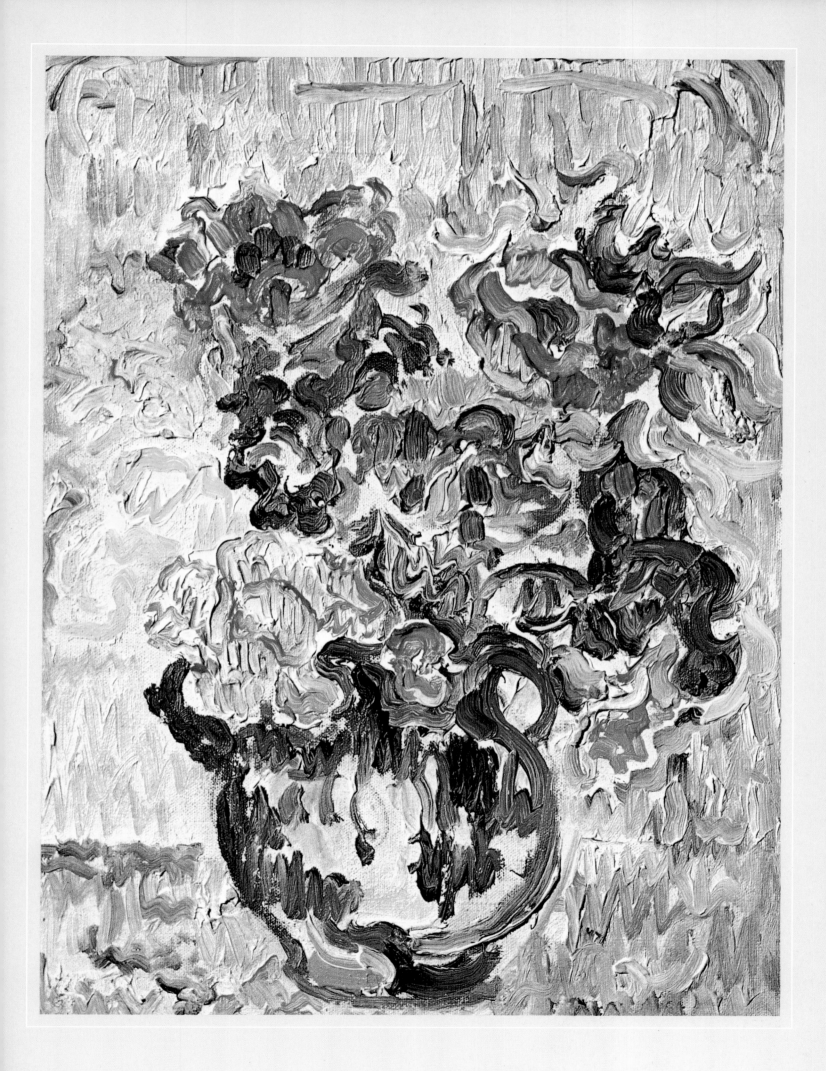

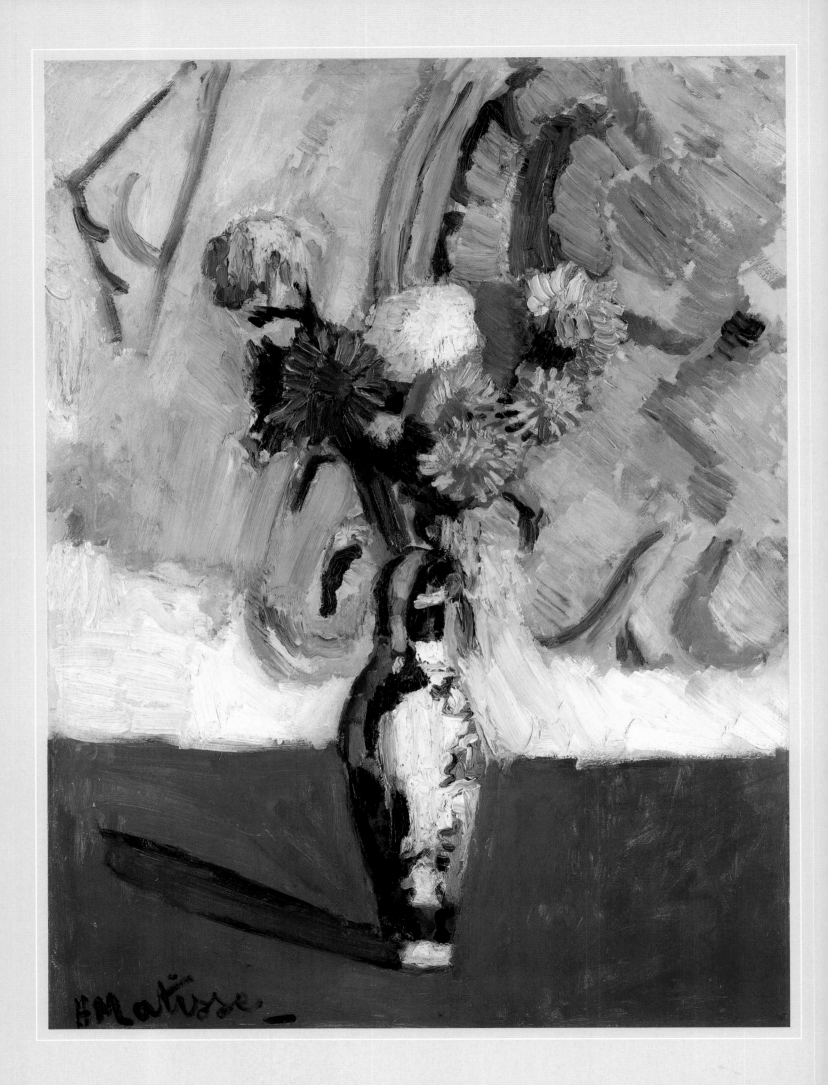

Henri Matisse

was born in Picardy in 1869. During the first twenty years of his life he had little interest in art. After studying law in Paris during 1887–88, he returned home and worked as a lawyer's clerk in nearby Saint-Quentin. In 1889 he began attending evening drawing classes at the local school, and while recovering from appendicitis the following year took up painting. In 1891 he abandoned his legal career and returned to paris, enrolling in the Académie Julian. Soon he began studying with the Symbolist painter Gustave Moreau and copying old masters in the Louvre. By 1895 he had developed an Impressionist style, but over the next few years he was led toward greater coloristic daring by Signac's writings, by seeing Turner's work, and by a trip to Corsica, where his eyes were opened by the intensity of light and color. He was also greatly impressed by the work of Cézanne, Gauguin, and van Gogh.

Matisse spent the summer of 1904 painting in Saint-Tropez with Signac and briefly embraced the Pointillist style in which he painted a bouquet of parrot tulips the following spring. The decisive turn in Matisse's development came in the summer of 1905, spent with André Derain in the Mediterranean fishing port of Collioure, where they began to use fiercely bold colors in so radically unconventional a way that the style was dubbed Fauvism, from the French word for "wild beasts." Although landscapes with red tree trunks and pink foliage outraged the public, bouquets of intensely colored flowers painted in the new style were relatively naturalistic—and so more acceptable.

A trip to Morocco during the winter of 1912–13 took Matisse further along the road of formal experimentation, but by 1917 he was beginning to settle into a comfortable style for treating his preoccupation with the *luxe, calme et volupté of haute bourgeois* life. Decorative bouquets were as much a part of his pleasant interiors as were languid nudes.

Only during the last seven years of his life did Matisse return to making dramatically innovative work—a great series of images, many of them nearly abstract, constructed from elaborately cut pieces of colored paper. These masterpieces engaged Matisse from 1947 until his death, in 1954.

HENRI MATISSE

Chrysanthemums in a Chinese Vase, 1902
Oil on cradled board, 28 x 21 1/4 inches
Courtesy Christie's Images

HENRI MATISSE
Parrot Tulips (II), 1905
Oil on canvas, 18 x 21 3/4 inches
Private collection

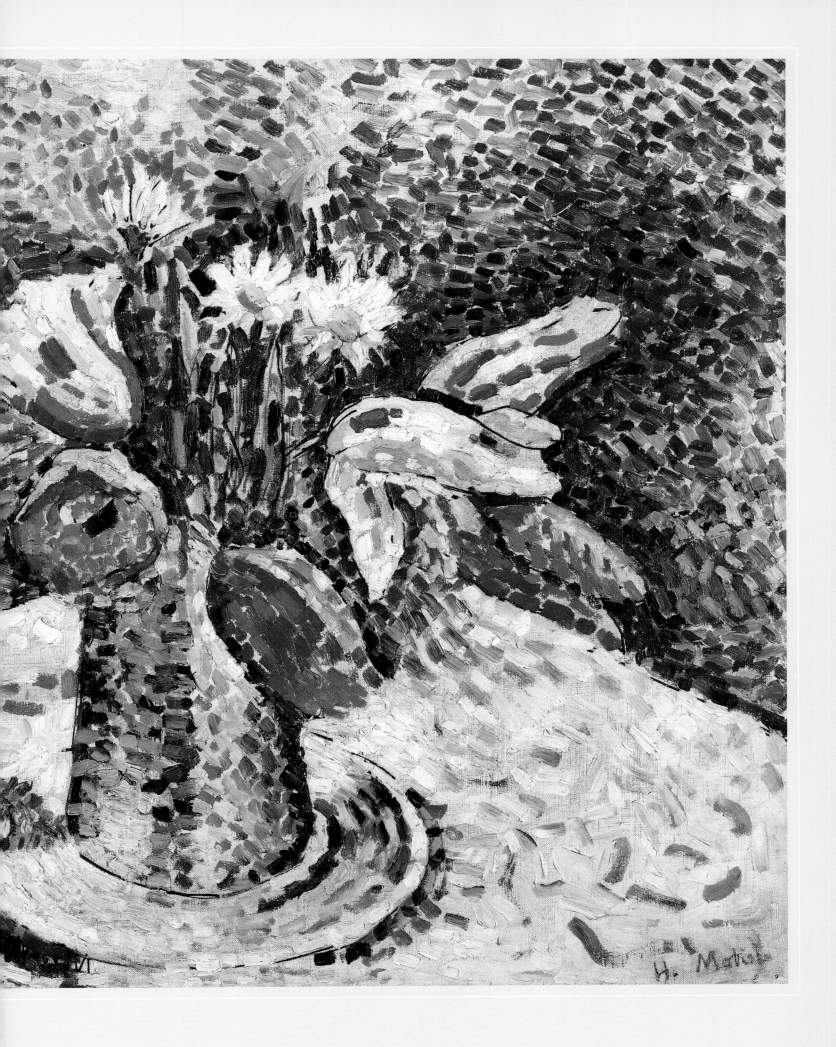

HENRI MATISSE

Bouquet (Vase with Two Handles), 1907

Oil on canvas, 29 1/2 x 24 1/2 inches

Hermitage, St. Petersburg

Courtesy Art Resource, New York

Anemone

Daisy

Snowball Peony

Rose

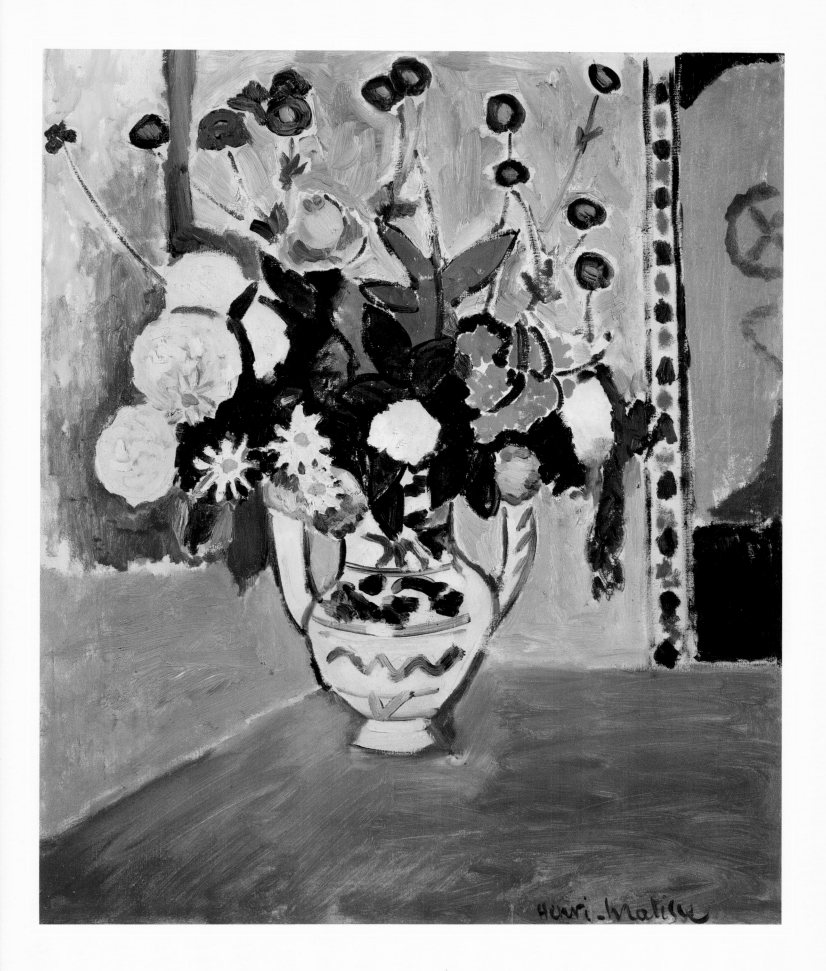

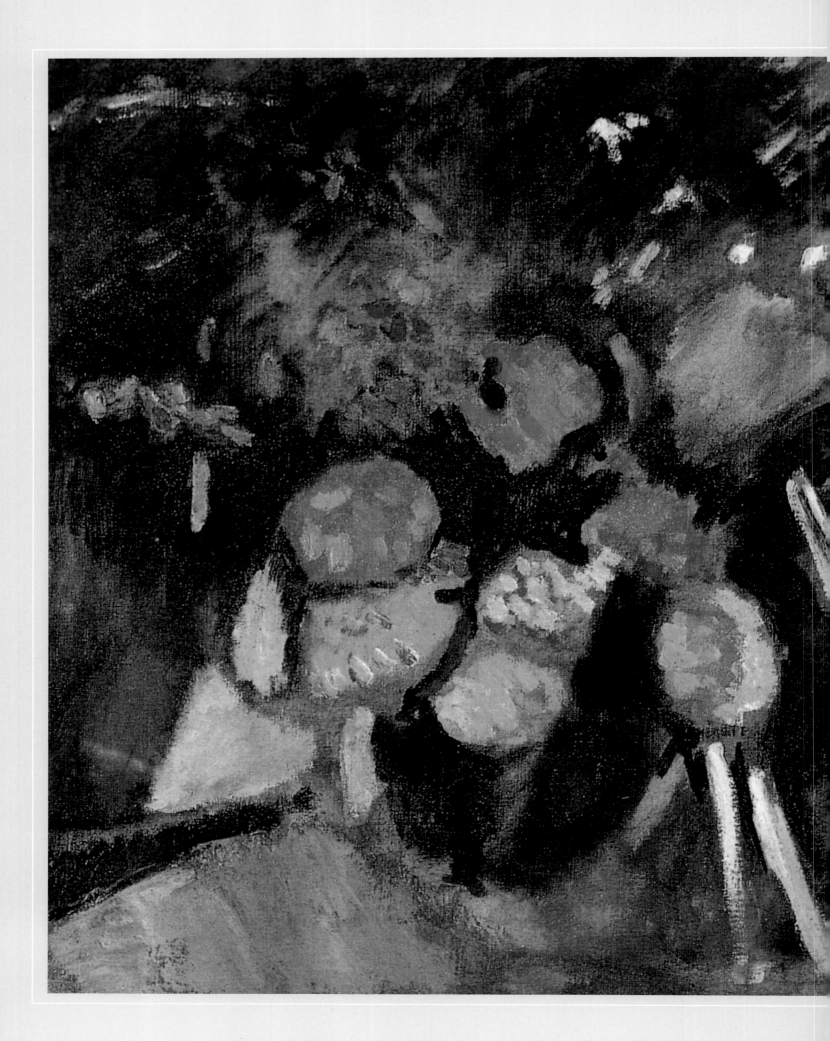

HENRI MATISSE
Flowers, 1906
Oil on canvas, 23 x 28 1/4 inches
Collection of the Duke of Roxburghe

HENRI MATISSE
Bouquet of Flowers in a White Vase, c. 1909–11
Oil on canvas, 33 x 40 inches
Pushkin Museum of Fine Arts, Moscow

Anemone *Chrysanthemum* *Rose*

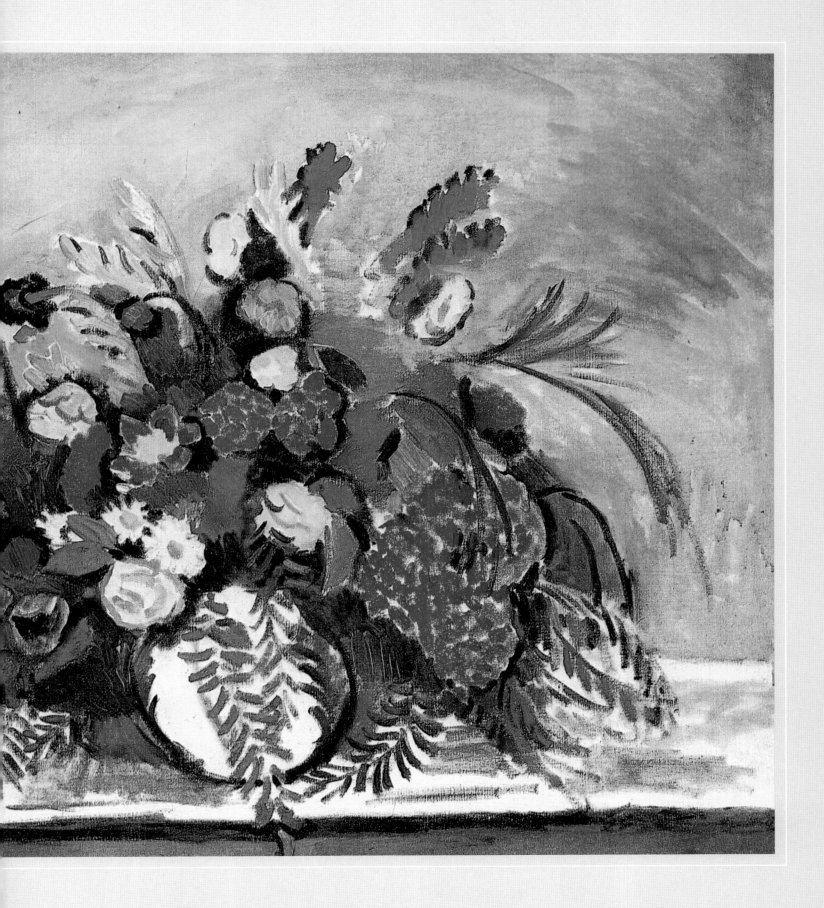

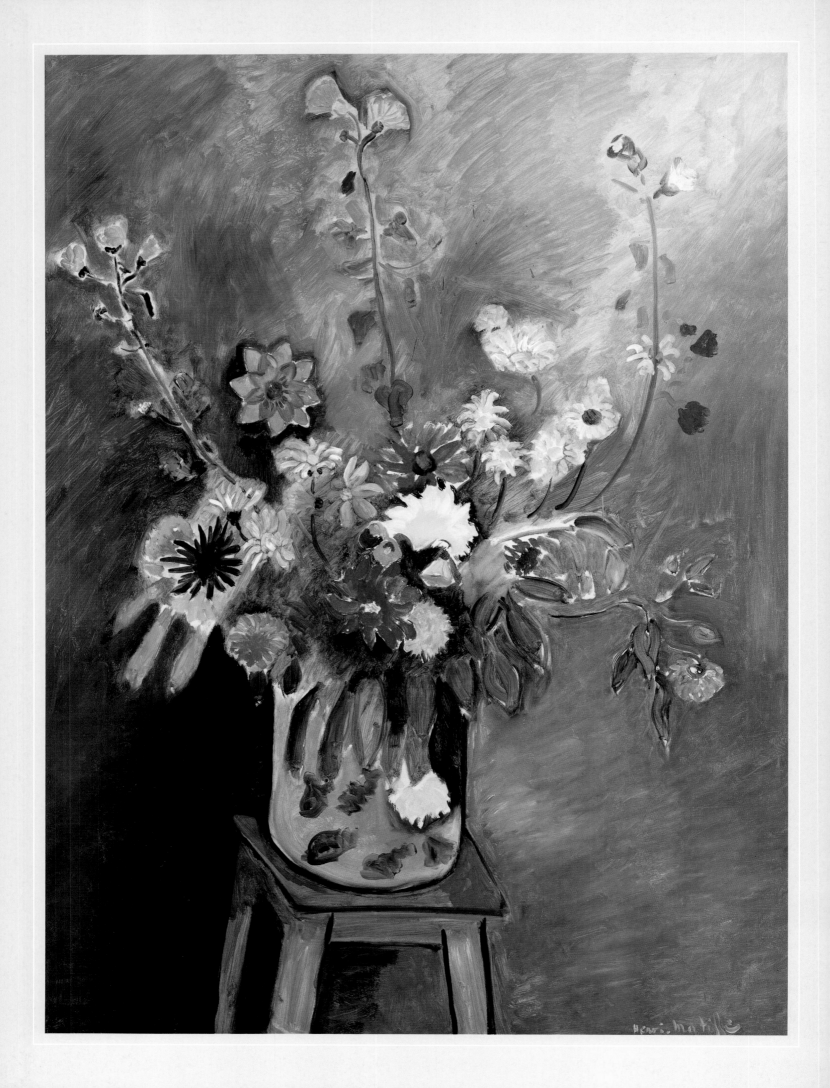

HENRI MATISSE
Bouquet, c. 1916
Oil on canvas, 55 x 40 1/2 inches
San Diego Museum of Art
Gift of M. A. Wertheimer from the collection
of his late wife, Annetta Salz Wertheimer

SELECTED BIBLIOGRAPHY

Adler, Kathleen, and Tamar Garb. *Berthe Morisot*. London: Phaidon, 1987.

Boggs, Jean Sutherland, et al. *Degas*. New York: Metropolitan Museum of Art, 1988.

Brettell, Richard, et al. *The Art of Paul Gauguin*. Washington: The National Gallery of Art, 1988.

Cachin, Françoise. *Paul Signac*. New York: New York Graphic Society, 1971.

_____, and Charles S. Moffett. *Manet*. New York: Metropolitan Museum of Art/Abrams, 1983.

_____, et al. *Cézanne*. Philadephia: Philadelphia Museum of Art, 1996.

Druick, Douglas, et al. *Odilon Redon: Prince of Dreams, 1840-1916*. Chicago: Art Institute of Chicago/Abrams, 1994.

Elderfield, John. *Henri Matisse: A Retrospective*. New York: Museum of Modern Art, 1992.

Faunce, Sarah, and Linda Nocklin. *Courbet Reconsidered*. Brooklyn: The Brooklyn Museum, 1988.

Fell, Derek. *The Impressionist Garden*. New York: Carol Southern/Crown, 1994.

Frédéric Bazille: Prophet of Impressionism. Brooklyn: The Brooklyn Museum, 1992.

Georgel, Pierre. *Tout l'Oeuvre Peint de Delacroix*. Paris: Flammarion, 1984.

Gordon, Robert, and Andrew Forge. *The Last Flower Paintings of Manet*. New York: Thames and Hudson, 1986.

Hardouin-Fugier, Elisabeth, and Etienne Grafe. *The Flower Painters: An Illustrated Dictionary*. North Dighton, Massachusetts: JG Press, 1996.

Henri Rousseau. New York: Museum of Modern Art, 1985.

Matthews, Nancy Mowll. *Mary Cassatt*. New York: Abrams, 1987.

Preston, Stuart. *Edouard Vuillard*. New York: Abrams, 1974.

Rewald, John. *The History of Impressionism* (4th ed.). New York: Museum of Modern Art, 1973.

_____, *Post Impressionism: From van Gogh to Cézanne* (3rd ed.). New York: Museum of Modern Art, 1978.

Tinterow, Gary, and Henri Loyrette. *Origins of Impressionism*. New York: Metropolitan Museum of Art/Abrams, 1994.

Walther, Ingo F., and Rainer Metzger. *Vincent van Gogh: The Complete Paintings*. 2 vols. Cologne: Taschen, 1993.

Watkins, Nicholas. *Bonnard*. London: Phaidon, 1994.

Wildenstein, Daniel. *Monet: Catalogue Raisonné*. 4 vols. Cologne: Taschen, 1996.